How to Sell Your Art and Crafts

Also by Loretta Holz
TEACH YOURSELF STITCHERY
MOBILES YOU CAN MAKE

HOW TO SELL YOUR ART AND CRAFTS

A Marketing Guide for Creative People

LORETTA HOLZ

Photographs by the Author

Charles Scribner's Sons
New York

Copyright © 1977 Loretta Holz

Library of Congress Cataloging in Publication Data

Holz, Loretta.
 How to sell your art and crafts.

 Bibliography: p. 238
 Includes index.
 1. Art—Marketing. 2. Handicraft—Marketing.
I. Title.
N8600.H65 381'.45'74550973 76-25904
ISBN 0-684-14818-8

1 3 5 7 9 11 13 15 17 19 C/C 20 18 16 14 12 10 8 6 4 2

Printed in the United States of America

To George W. and Amelia E. Holz,
my generous, loving, and wonderful parents-in-law

Contents

The Benefits of a Cooperative • Ozark Opportunities • The Benefits of a Guild • The Handcraft Guild of Central Jersey • Other Cooperative Ventures • A Cooperative Exhibition and Sale • Cooperative Galleries • A Cooperative Studio-Shop • The Craftsmen of Chelsea Court

Chapter 11/ Resource Sections 230

A. Volunteer Lawyers • B. Art and Craft Show Directors • C. State Arts Councils • D. Periodicals with Marketing Information • E. Art and Craft Periodicals • F. Books for the Selling Artisan • G. Government Publications

Index 261

Preface

The "craft boom" which occurred in the late 1960s and is still going on coincided with a general public revolt against trends in our society toward conformity, mass production, and ecological waste. Although many associate this revolt with the "hippie" movement, the fact is that its effects were felt throughout the "establishment." One of the great changes in public attitudes that occurred during this period was a new appreciation for artistic and handmade items, rather than manufactured ones. Not only did the public develop a taste for individually created items showing the mark of the individual artisan who made them; many people discovered that they could actually make things themselves. Moreover, they found that artistic effort and creating through crafts were enjoyable and satisfying.

The new widespread appreciation for handmade and artistic items means that there is a far larger market for them than existed a decade ago. The craft boom and the resurgence of interest in art have resulted in a growing number of producing artisans who wish to find an outlet for their work. Bringing these two, the producing artisan and the prospective buyer, together is not a task to be approached by standard business procedures. The artisan is at once manufacturer, salesman, and business manager. The nature of his work requires that he be primarily a producer while still finding ways of marketing which will not interfere too much with the time his art or craft demands of him. Like his products, his marketing problems are unique.

There are many kinds of arts and crafts, just as there are diverse ways of selling them. To undertake the writing of a guide to marketing art work and crafts requires a thorough knowledge not only of the problems of production but also of the complexities of marketing methods. It demands a knowledge and understanding of the individual artisan and of guilds, cooperatives, promoters, and other groups and individuals involved. It also demands skilled research and organizational ability. Loretta Holz, who has written many articles for *Creative Crafts* on a variety of crafts, has repeatedly demonstrated her knowledgeability on the subject and her capabilities as a researcher. Articles she has written on marketing have led her into correspondence with craft organizations

and personalities throughout the country. Research that she has done in writing articles on craft cooperatives has given her insight into the ways in which artisans can join efforts for their mutual benefit. More importantly, the integrity with which she approaches any subject always results in thoroughly researched, comprehensive information.

Those who have discovered the joys of creating and who have reaped the psychological rewards of producing work admired by others can, with the right kind of guidance, reap financial rewards as well. This book tells how.

Sybil C. Harp
Editor, *Creative Crafts*

Acknowledgments

So many people have given me their time in person, by phone, or by letter to help me gather the information in this book that I feel it is not the work of one but hundreds. There is simply not room here to thank everyone.

I want to thank Elinor Parker of Scribners for her patience, understanding, and encouragement. I also want to give special thanks to Sybil Harp, editor of *Creative Crafts,* who gave me my start in writing and has encouraged and helped me so much all along the way.

These editors have also helped me: Frank Coggins of *Lady's Circle Home Crafts,* Geoffrey Wheeler of *Craft, Model and Hobby Magazine,* Marilyn Heise of *The Working Craftsman,* Nelson Brown of the *Regional Art Fair List,* Clay Anderson of the *Ozark Mountaineer,* Christopher Weills of *The Goodfellow Review of Crafts,* Stan Bianco of *Sunshine Artists,* Bud Pisarek of *Westart,* and Bill Jacobsen of *Midwest Art Fare.*

And the following artisans are just a few of those who have helped: Betty Carpenter, Polly and Frank Reilly, Jack Franklin, Lilien Foster, Bev Baker, Eileen Schwartz, Geri Offerjost, Marion Albury, Ann Kinaszczuk, Barbara O'Malley, Diane Claxton, Lorraine Wood, Irene Westbrook, Sue Viders, Joe Silva, Betty Winslow, Carollynn Stranahan, Lottie Hack, Arden Newsome, June Adams, Ruth Wilson, Vera Watrous, Joyce Oppenheimer, Lesli Berghahn, Lois Kenkare, Betty Esposito, Jon Pieja, Irene Fazzino, Betty Ruth Curtiss, Penny and Roger Preuss, Ted Plume, Pat Mark, Fenn Vogt, Lew and Bonnie Watters, Rip Bodman, Pat Wehr, Alexandra Wilkinson, and Lois Stromberg.

Others who have contributed much to the book are: Gordon Gattone of Art Craft Associates, June and Ron Richardson of J and R Productions, Wayne Nelson and James McCarthy of General Business Services, Harry Devlin of Pettit, Higgins and Devlin, Betty Legg of Logos International, Alice Sproul of the Westfield Woman's Exchange, Judith Glassman of the National Guide to Craft Supplies, Mimi Freedland and Grace Gutman of the Sisterhood of Temple Emmanu-El, and Tom Aageson of the Candle Mill Village.

Finally, I must also thank my husband, George, and my sons, Andrew

and Matthew, for their patience with a very busy family member. How can I thank my mother, whose clerical help has been priceless? For helping with the children I need to add thanks to my good friends, Angela Stuehler, Pat Pieja, and Donna Joy Paoli, and also the Grandparents Holz.

Introduction

Following on the "craft boom" that occurred in the late sixties came a second phenomenon arising out of the first—the boom in people not only making things but also selling what they have made. Young people who had dropped out of college or the "nine to five rat race" found in arts and crafts a way to express themselves and at the same time to make a living. They found working with leather, dyes, clay, fibers, and other natural, earthy substances very satisfying and remunerative.

While the "flower children" made the first sales, these young people have been followed by a wave of artists and craftsmen of all ages and descriptions. Many retired people have found a fulfilling second career in making and selling. Many housewives, no longer content with keeping the house and children clean, are expressing themselves through arts and crafts and surprising their husbands with their success. Men too have joined the ranks of the artisans, some on a part-time basis, as a relief and diversion from their regular jobs, others on a full-time basis.

At first perhaps this selling was random and amateurish. The leather-craftsman might lay out a blanket in the park and display a dozen of his belts, hoping those strolling past would stop and buy. As time passed, better shows were organized and more good shops opened. While the "street" artisan continues to operate, even his efforts have become more professional and organized. Marketing considerations such as display and pricing have grown in importance. This book is designed to help you to approach selling professionally, so that you can be more effective and efficient in selling what you have made.

You can get into selling at many different levels: some artisans make their whole living through their work, while for many others making and selling are part-time, almost leisure activities. Whether you want to sell your work full time or part time, there are a variety of ways you can do it. There is no one right way for everyone nor one single way for you as an individual. Instead, there are many options, each with its own advantages and disadvantages, as this book tries to point out. And the market is not a static one. New opportunities are constantly opening up and the market constantly expanding as more and more people become aware of the value of what is made by creative hands.

Basically, I have tried in this book to introduce and explain the marketing alternatives to you, so that you can choose the one most appropriate to your situation; if you are already involved in selling, the book may help you to develop your markets still further. In addition to chapters on specific marketing methods, there are sections on producing your product and pricing it, and on the legal and financial aspects of running a business—all of which should help you to run yours more efficiently and in accord with government regulations. The chapter on publicity should teach you how to promote yourself and your product.

This book is meant to be helpful to you, whether you spend a few hours a week or full time on your work, whether you have been professionally trained for it or have informally taught yourself to make something saleable. If you are already an artisan in business for yourself, you may find that you know much of what is being presented here; but you certainly should find helpful advice and much valuable information. (Note that the prices, postal regulations, legal and tax requirements are those of the time of writing and therefore subject to change.)

If on the other hand you are a beginner, some of what is presented here may be too ambitious for you to undertake right now. Use that part which applies to you; and as your business grows, this book will continue to be of service to you.

One final explanation should be added on the use of the term "artisan." What do you like to call yourself—are you an artist? a craftsman? a craftswoman? or do you prefer to be called a craftsperson? a designer-craftsman? a production-craftsman? a master-craftsman? an instructor-artist? an artist-craftsman? Can art and craft really be separated?

After thinking about these various titles, I found they excluded rather than included. I wanted a term that everyone in all of these groups would feel comfortable with—and I hope that artisan is it. By "artisan" I mean anyone who uses his hands to create something beautiful which he will sell.

How to Sell
Your Art and Crafts

Chapter One

Your Product and Its Market

If you have decided to go into business selling your artistic and handcrafted items, there are two basic steps to take. First, you must develop a product, or a line of products; then, you must do some research to find appropriate markets for your work. This chapter will get you started on both of these steps.

WHICH ART OR CRAFT?

Perhaps you already have a skill which you can use in making your products. If not, then your first move is to choose an art or craft, and teach yourself or take lessons to develop your skill. In choosing, keep in mind that while many arts and crafts lend themselves well to making products which will sell, a good many others do not—or not to any great extent. If it takes hours to produce a product and only a small price can be charged, this art or craft is a poor choice.

If you are planning to invest time in learning, and money in equipment and materials, you will be concerned that the art or craft you are learning has a future. Some are of course perennially popular; others are fads and again the current fad is usually a poor choice for anyone who wants to build up a business.

If you wish to learn a new skill or learn more about one you already have practiced, the best way is either to participate in workshops or courses, or to find a master of your craft with whom you can work. If the instructions and conditions are good, you can benefit by becoming more adept at your technique and more creative in your design. You also benefit from the creative impulse you receive from working side by side with others.

Information on art schools all over the country can be found in the *American Art Directory* and the *Art Career Guide*. For craft schools, look for the *American Crafts Guide* and *By Hand—A Guide to Schools and a Career in Crafts* by John Coyne and Tom Hebert, or the *National Guide to Craft Supplies* by Judith Glassman. (See Resource Section F at the back of this book for more information on these.)

Check with your local college, junior colleges, and art schools—and don't overlook courses at county vocational schools and adult schools. Check especially with the state-run schools as these are usually less ex-

1

pensive. The majority of colleges and junior colleges have art departments; many also have courses on weaving, pottery, print making, photography, and so on. You can work toward a college degree or an associate degree, or take courses on a non-credit basis.

Even after you have your training or skill, you should keep up with developments in your field of expertise. Read the magazines devoted to it (see Resources Section E) and any books that are published on the subject. To keep up with trends, read some of the more general publications like *Design, Creative Crafts, Lady's Circle Home Crafts,* or *Woman's World Family Crafts.* This constant development of your skill is very important.

WORKING ON SPECIFIC PRODUCTS

As you are learning your art or craft and gaining expertise, you will be considering what you could make that would sell. Experiment to find what products you enjoy working on and how these products might appeal to customers.

No one can tell you specifically what you should make, but a few general comments on what to look for in products might help. Good design, materials, and workmanship are essential. As an artisan you stand on your own merits—the quality of your work represents you. If you worked for a big company, you would be pooling your work with that of so many others that the responsibility for success or failure is usually hard to pinpoint. But in a one-man or one-woman operation there is no doubt on the question of accountability.

Quality should be the basis of your reputation. Some customers will give your product a quick inspection before they buy it; many others will inspect it carefully. The first thing that will attract them will be the design. If that appeals to them, they will go on to inspect the materials and workmanship.

Some customers understand the techniques involved in your work and will appreciate your skill. The majority, however, will only be conscious of your workmanship if it is either spectacularly good or bad. Untrimmed ends, spots of glue, crooked lines, and smudges of dirt are some of the evidences of sloppy workmanship which the ordinary customer will notice. Unless the price is extremely low to compensate for this lack of quality, the item will not sell.

Quality materials are also very important: a shoddy frame can take away from the most impressive painting. Of course you do not have to use the most expensive materials available, but rather the least expensive ones of good quality.

If you as an artisan do shoddy work, this represents you. People who buy your products will not be back if they have been disappointed by poor workmanship. On the other hand, having found work of good quality, they will be back for more and perhaps will think of you when they need a gift or special item. This repeat business is a big boost psychologically as well as financially, because you have the satisfaction of knowing that the customer was truly pleased with your work.

Uniqueness can also contribute to your sales. The more unusual the art or craft, the more likely it is to grab the attention of the customer. This does not guarantee sales, but if your product has great appeal as well as being unusual it should sell.

Try to keep your expenses down so that the price is appealing—the lower the price, the more items you are likely to sell. However, *do not* sacrifice quality to price.

Many artistic and handcrafted items are meant to be merely decorative; others are intended to be functional as well. In fact, if the product you choose to make is useful as well as decorative, it may have a better chance of selling. Note that if the product is meant to be practical as well as beautiful, you must be sure that it does fulfill the demands that will be made of it when in use. If it is a poncho, it should be warm as well as beautiful; if it is a pitcher, be sure that it holds water and pours well.

Try to develop products that will appeal to many different people—especially those you expect to reach with your sales campaign. Be aware of the fact that tastes vary in different geographic areas. In some places you will find that customers lean toward realistic and representational designs, completely ignoring the abstract; elsewhere, the opposite is true. While you do not want to compromise your artistic judgment, you must take taste into consideration and try to make what your customers will buy. Remember there is much competition for the customer's dollars. In order to make a sale you must provide what the customer wants, when he wants it, and for the price he is willing to pay.

Try to avoid items which can be better made by industry. Instead, select items which show a distinct handmade quality. If industry provides a very similar product to yours, people are generally not willing to pay the higher price to obtain the handcrafted item, unless it has some special appeal.

If you are doing a traditional or ethnic craft, choose items that are true to the mood of the craft. Perhaps at first you will copy traditional designs. Study the work of other artisans both traditional and contemporary, so that you can be aware of these traditions and developments while creating and developing your own original work.

Another consideration is the estimated life of the demand for your specific product. The popularity of a specific product or design, as well as the craft itself, can be very temporary. If it is part of a current fad, or made with a design that is currently popular, your product may soon become dated and no longer saleable. However, as long as you do not build up a large inventory, this should hardly bother you because you will be able to switch quickly to new items—a facility which big business envies.

PRODUCTION VS. ONE-OF-A-KIND ITEMS

There are two main categories of products, known as one-of-a-kind and production items. The former are expensive to produce and much more difficult to sell because the high price means the market is small and extremely competitive. This high cost stems from the time necessary for planning, experimentation, and the development of your idea. For a "production" item, the designing cost can be spread over a number of pieces, so that the per-item cost remains quite small and the price one which a larger market can absorb.

While most artists and craftspeople prefer to do the one-of-a-kind items, the majority find that they must product in quantity in order to make the constant sales they need to support themselves. These "bread-and-butter" items make their business economically feasible and often the production work helps them to develop facility with their technique. If they cannot bear up temperamentally under the repetition, they usually turn to another means of support.

Think of the potential market as a pyramid. At the top are the expensive one-of-a-kind items, where the market is small and the competition keenest. As the price goes down, the potential market widens considerably until you reach the bottom where, for inexpensive items, there is a huge market.

A very small number of artists and craftspeople who have made a name for themselves can make a full-time living doing one-of-a-kind items. These lucky few need only sell a small number of items in order to support themselves. The great majority of artisans have to make a much larger number of items and sell them at the lower prices the ordinary person can afford.

If you wish to produce the one-of-a-kind gallery items, you can probably do this full time only if you have another means of support, that is, if you are independently wealthy or have a husband, wife, parents, or a pension supporting you. Many people who would like to earn their living by creating gallery-type pieces simply cannot be successful because the

market for such items is small. In her book *The Artist's Guide to His Market,* Betty Chamberlain—founder and director of the Art Information Center, Inc., in New York, and a person who has had years of experience in the art field—says: "Only a handful of top-name artists are able to live by their creations; indeed many who are well known still must do something for livelihood." Instead she advises you as a budding artist to get a job teaching, doing commercial art, or working for a museum, and to do the fine art in your spare time. She says that it is wishful thinking on the part of "any fine artist to believe that he is going to earn his living by his works of art. Should it happen in the course of time, it will be a great bonanza—but don't count on it."*

LABELING

From the beginning you should realize that your business is different from the usual types of businesses. One of the big reasons is the human interest involved: each artisan is unique and has his own story to tell. This personal touch is part of every product you make, and here big business cannot compete with you. But how can you send this story along with every item sold? A label can be the answer and can add immensely to your product.

Your label can be a small card or folder, which contains information about the product and about you. It should be simple, neat, and well designed, and fit in well with the products in appearance and quality. You can make the labels yourself, printing them by hand or using a silkscreen, typewriter, or copy machine. Or you may want to have them made by a professional printer.

The label should tell something about the product to which it is tied or stuck. It should in no way distract from the item itself but rather enhance the customer's enjoyment of it. Let the label point out the item's best features and tell your story. If you are an artist who has created your own methods or materials, your label might describe these. Explain why your product is special and impress the customer with the quality and value of your work. You should not be shy or modest in writing the label, but neither should you make exaggerated claims.

If your work is being sold by mail order, you should put your name and address on the labels. If it is to be sold through shops, then most likely you will only use your name. The manager may want to add the shop's name so that customers will have that information if they wish to make additional purchases.

*Betty Chamberlain, *The Artist's Guide to His Market* (New York: Watson-Guptill, 1973), p. 20.

Should the label give general information about you and your products, you can use it in other ways: you can have copies available as a general handout at shows, or give a copy to a buyer to introduce your products. Indeed, you can hand out copies to anyone interested in you and your products.

Figure 1 shows the outside and Figure 2 the inside of the label which Penny Preuss of Scotch Plains, New Jersey, attaches to her distinctive owls. She and her family collect stones, driftwood, and lichen which she uses to create engaging owl figures, no two of which are exactly the same. She sells her owls through shops and at shows. To each she attaches one of these labels, to tell her story to her customers.

Owls created by Penny Preuss

Figure 1 (outside of label). This is the whimsical label which Penny Preuss attaches to each of her individually created owls.

Figure 2 (inside of label). This text on the inside of the label tells about Penny's owls and what makes them so special.

Penny's owls combine the art of nature with the art of man. As in nature, no piece is ever duplicated and each is the artist's rendition of an authentic specie from around the world. The owls of North America are favored, with the Snowy being a striking specialty.

Stones are selected along the New England coast with great attention given their shape, so when complete the very life and breath of the owl is captured. Driftwood is collected from the New Jersey shore for an appropriate perch. A final touch of lichen, gathered atop the Adirondack Mountains, is often added to further enhance the realism and overall design.

Each piece is then signed and labeled as to specie. Some say, if you listen very carefully, you may even hear a faint whoo... But only at night!

Owls created by Penny Preuss

Penny Preuss with her stone owls

Attach the label so that it will stay in place as long as possible. It can be sewn directly onto fabric items—usually in an inconspicuous place underneath or inside, where it can remain as a permanent reminder of who made it. For non-fabric items, attach the label any way you can without damaging them. A small piece of string is often a good solution.

For fabric items the label can be printed or woven (woven labels look much better but are far more expensive). For other items, a colorful paper card or folder can be attractively printed. In all cases the unit cost of the label drops, the greater the number ordered.

In addition to your own label, if you are making items to be worn, you are required by the Federal Trade Commission to attach a permanent label to the item giving instructions on its care and maintenance. You have doubtless seen such labels in fabric stores and of course on the garments you have bought. Your fabric supplier will probably have them available. For further information on the requirements, contact your local Federal Trade Commission office.

PRODUCING IN QUANTITY
Once you have designed some products and begun to actually sell them, it is time to begin to produce them in quantity. If you do this in an organized, logical way, you should increase your production and sales considerably.

In setting up to work on a particular item, think through the production sequence. Some steps must be done in sequence, but others can be switched around. What are the advantages of each order of steps? Can any operations be simplified or combined? How can you rearrange your materials and equipment to make the process more efficient?

To speed up the time it takes to make each particular item, work on a group. If each item takes five steps, you would do step one on the whole group at once, and so on, assembly-line style. By repeating the same action you establish a rhythm that makes it faster and more efficient. This technique saves time, especially if you have to set up for each operation, and can be most helpful, for instance, if you must wait between operations for the paint to dry.

Even if the items are not exactly alike you can save time by working on a group at a time; for example, if you are matting a group of water-color paintings, you need only gather, set up, and put away the necessary equipment once for the entire group rather than for each individual painting. While working on a group keeps you from wasting time jumping from one job to another, the repetition can become boring and you can lose efficiency. Try to steer the middle path so that your work continues to be enjoyable.

YOUR OWN COTTAGE INDUSTRY

If you are making a handcrafted item in very large quantities and feel you could use the help of other artisans, you are a prime candidate to set up your own "cottage industry." This method speeds up production; obviously you would only undertake it if you were having no problem in getting orders for your items. Right now this may seem very ambitious; if so, read through this section anyway, and keep it in mind for the future.

"Cottage industry" as a means of craft production is popular in Europe. In the Bavarian Alps, for example, it is quite common to see a small truck going from house to house. At each stop the driver takes a box out of the truck and brings it up to the door, where he finds a similar box which he carries back to the truck. He is the vital link between artisans who are producing handcrafted items. The people work in their own homes, often with the whole family pitching in. If the group as a whole is making painted wooden figures, the first family gets the wood and cuts it to the correct sizes and forms the parts; the next family paints each part; and the last family assembles, glues, and packs the completed items.

Would this system work for your product? Could you break down the process so that several expert artisans could help you to produce? You

could arrange for the work to be done cooperatively as in Germany. Or perhaps you could have local people make complete items for you according to your design. It would take time and effort on your part to organize the process and keep it running, but you can increase your sales greatly and should find the arrangement quite beneficial both to you and to your artisans. If you intend to set up a cottage industry, you should design your items with this process in mind, figuring out as you go along who should complete each operation and how it should be done. Perhaps your artisans will have some suggestions. They may help you to improve the design and possibly the methods too.

Recruiting people to help should be a fairly easy task unless some special skill is needed which requires extensive training. Many house-bound people, especially young mothers and disabled workers, are anxious for the chance to earn money. Senior citizens and teenagers will also be anxious to help. Once you have a few workers, others tend to hear about your project and come to ask for work.

Show your workers what must be done and explain exactly what you expect in the way of quality. Give them a chance to practice and experiment, but explain that if their work does not meet your standards it will have to be rejected. Control over quality is very important. If you do not do the finishing work on each piece, you should personally inspect each one or have a trusted helper do this since the items are to bear your label.

Unless the burden is too much on the workers, try to have them come to you rather than taking the responsibility for bringing the work to them. If they live nearby there is no problem; but if they live some distance away, it may take too much of your time to do the pick-up and delivery. Each artisan will probably work at his own pace unless you need to speed up the process because you have a deadline. Maybe you will find that they are asking for work and you have to hurry to provide it.

If the project requires natural materials (acorns, sticks, pine cones, etc.), the artisan may go out to collect his own materials. If so, be sure to consider his time in collecting when setting your price scale. Presumably you will want to supply all other materials as this is the most economical way to operate since you can buy the materials in quantity at wholesale prices.

FINANCIAL ARRANGEMENTS

As each artisan who is working for you is working in his own home at his own pace, it is probably best to pay by the piece. You must figure out a pay scale—the amount you will pay for each completed task. In order to do this you should time yourself on a group of items, then divide the

time by the number of completed items to figure out how long it takes for each. Then set up the pay scale for your workers accordingly.

You will have to keep accurate records of the work that each artisan performs for you. If the artisans need the money, you could pay them on delivery or shortly after the delivery of each group of items. Or you might want to set up certain times when you will make payments; in this case you write a check for each worker to cover all of the work done in the last quarter, the last month, or whatever time period is most convenient.

For income tax purposes you must, of course, keep good records of what you pay your artisans. There are two ways to handle the situation financially. If you consider the workers as your employees, you will have to do withholding statements and provide Workman's Compensation among other obligations as an employer. If you prefer not to get involved as an employer, you have another choice. Each artisan can be considered an independent contractor, that is, he is self-employed and must report his own income, pay income tax on it, and self-employment tax. (This process is explained in Chapter 5, where you will find an explanation of Form 1099 Misc., to be made out for each person who subcontracts work from you.) This is the much easier way to operate, especially if the amounts the workers earn are not large.

ONE COTTAGE INDUSTRY

One person who has used the idea of a cottage industry to great advantage is Dick Schnacke. Dick's business is making handcrafted folk toys. A few years ago he was a mechanical engineer designing and building furnaces for a large aluminum firm; today, he is reigning director of the whimmydiddles, flipperdingers, and whirlygigs. He is also the founder and director of the Mountain Craft Shop at Proctor, West Virginia, which is said to be the largest producer of authentic American folk toys. But Dick is not just involved in his own business, he is very much interested in all artisans. He was one of the organizers of the West Virginia Artists and Craftsmens Guild and was elected its first president. He is constantly involved in the Guild, as well as being very active in many civic enterprises.

Dick had long been interested in crafts but had not specialized. Then, in 1963, he helped to organize the Mountain State Art and Craft Fair, and realized that there were very few toys for sale.

He remembered some of the toys he had been making and playing with back in the twenties and thirties, and decided to set to work. He and his son began by making some whimmydiddles. The toys sold so well and

aroused so much interest among the fairgoers that Dick was "hooked." At that first fair he sold $60 worth of toys, which he thought was a fortune. Today he and over forty craftsmen who work with him produce over $200,000 worth of toys each year!

In the first few years, Dick and his family made all the toys he sold. In 1968 he arranged with a neighbor artisan to help him. Since then he has been constantly adding to the number of people who produce. Many of his artisans are low-income individuals who have benefited greatly by the toymaking; in some cases their lives have changed drastically for the better because of the employment Mountain Craft Shop has given them.

The artisans who supply Dick with toys are mainly self-taught. Each one has several items he can make satisfactorily and sell to Dick. They are independent producers who sell their work to Dick but they are free to sell elsewhere. Because his reputation has grown locally, he has no trouble finding artisans—now they come to him. Dick encourages them with their work and helps them to evaluate and improve it.

The artisans use all their own tools and equipment. Since the materials are mainly natural ones, Dick supplies only what is hard to get. He finds that the easiest way for him to handle this generally is to have the artisans buy the materials they need at cost from him; they are then free to use these both in the toys they make for him and in toys they sell to others.

A price is established for each item. When the artisan delivers his work, the paperwork is completed. Then a "receiving report" is sent by mail, usually within three days, accompanied by payment. The receiving report includes a notation of which items are needed next.

Each artisan works in his own home, as Dick does, so he has a genuine "cottage industry." The Mountain Craft Shop is actually an amazingly neat room tacked onto the back of Dick's home. For storage and packaging there is another huge room 24 by 85 feet, which was tacked onto the first as a result of Dick's expanding business.

Both men and women supply him. The women mainly make the dolls, the bean bag clowns, the corncob dolls, the rope girls, rag dolls, arm puppets, and other items which require sewing. The men concentrate on the wooden items. They go out in the woods to find just the right-sized branches for the whimmydiddles. They use jigsaws to cut the skyhooks, the "do nothing machines," the "ox-yoke" puzzles, and the climbing bears.

Dick creates the prototypes for each new toy and finds that this is one of the most rewarding parts of his work. He enjoys doing the research in books, in antique shops, and among the local residents who "remember when." He creates a prototype for each toy and begins production. After

he has experimented with making the new toy in quantity, he turns the new designs over to some of his artisans. He admits they sometimes improve on his design and/or his method.

Having worked part time on his business for almost ten years, Dick retired as an engineer in 1972 to become a full-time artisan. In addition to designing the toys and making some of them himself, he handles incoming orders and does the corresponding, shipping, and record keeping.

Dick also designs the labels to accompany each toy. These give background information on the toy as well as directions and suggestions for using it. And he designs his own catalog. This single sheet of colorful paper, 17 by 22 inches, is cleverly geared to give information on the toys. It also has details on ordering (both retail and wholesale), a price list for both, and an order blank which can be cut off without taking away any of the information on the sheet. Despite its ingenious design, the catalog has a folksy look in tune with the folk toys it sells. The whole thing can be folded down to fit in a regular business-size envelope for easy mailing.

Dick has written a book, *American Folk Toys: How to Make Them,** which gives background information on each toy, plus complete instructions with diagrams for making the toy and directions for using it. There has been a good deal of publicity on the folk toys. He has appeared on *To Tell the Truth* and *The David Frost Show,* and his book was reviewed on *The Today Show.* An article on his business appeared in the December 1974 *Smithsonian Magazine.*

Dick's business is certainly a unique and extremely successful one. He says, "We have grown already to over $100,000 a year without ever asking anyone to buy anything! In fact, we're afraid to ask because everyone *would* place orders." And he is right.

The key to his success is the toys themselves—so ingenious and intriguing and yet so inexpensive. They are authentic folk toys which would be recognized with nostalgia by older folks. Those interested in ecology would appreciate the fact they are a return to simpler days—toys without plastic!

MARKET RESEARCH
No one can tell you which of the items you make will sell the best. Some market research on your part may show that there is a market for what you have to sell. Certainly, before you build up an inventory you

*New York: G.P. Putnam's Sons; paperback ed., Baltimore, Md.: Penguin Books, Ltd.

should be reasonably sure that people will want what you have to sell and that you can price it to make a profit.

Because your product and business are so personal you will not aim to sell to everyone, or use big advertising campaigns. Rather, you will work to develop the markets where your ability and products will be appreciated—markets that fit you and your product.

Finding the best markets for your work, if indeed it is saleable, is very important. If you have already started selling, no doubt you did some market research before you started. Perhaps you did not call it that but did the research proceeding instinctively so that you assessed the necessary information in order to decide which direction to take. Maybe you were lucky and found your best market without research; or you might have been much more successful had you done such research.

Market research can be very important in helping you to avoid later disappointment. If you investigate beforehand, you will find that your efforts at marketing will have a much better chance for success. When you know what is happening in your field, you can see how your products fit into the picture and make changes accordingly. A customer or retailer will ask you about your products and you can briefly tell him what research you have done on the subject; you will be able to say quite truthfully that yours is the best of its type available, or the only one available, or the only thing like it sold in the area.

When you do marketing research you are trying to figure out the answers to a variety of questions. First, you want to discover who your potential customers are and how large this potential market is. You also want to discover the best way to reach it, and whether a specific item is saleable. So you will investigate the current demand for the type of products you make, or whether a demand could be generated when these items become available. And of course you will want to know what the competition is doing.

In investigating your potential customers, you must consider how your product is to be used. You need to find out who is most likely to buy it so that you can design, make, and market it specifically to reach that customer. If, for instance, you are making a toy for a toddler, you know immediately that the toddler is not your initial customer because he will not buy it himself. Instead the customer will be a doting grandmother or other relative. You aim to please the adult with your toy, as well as have it be fun and practical for the toddler who receives it as a gift.

The next problem you must study is how you can reach the greatest concentration of potential customers. Where do they live, shop, work, or spend their leisure time? If your product would appeal especially to

young adults, perhaps you could find stores and other outlets in college towns.

If you are selling your work directly to the customer, after a while you should be able to describe your typical customer in terms of income level, age group, background, living conditions, etc. Once you know to whom your product is appealing, you can cater to the taste of this typical customer and seek the best ways to reach him or her. Or, if you are selling through shops, galleries, or stores, you can look for the ones that cater specifically to this customer. Each shop, gallery, or store has a target audience and caters to the desires and taste of this group.

You will learn more about what is selling where, to whom, and at what prices by carefully observing the competition. Once you have an idea of what you want to make, attend as many shows, go to as many stores, and seek out as many other points of sale as you can for the same type of product as you wish to market.

Compare carefully. Are the competing products better than yours? How do they rate price-wise? Will you be able to make a profit charging a similar price? Are these competing products more attractive? Are their designs better? What about the craftsmanship and materials? Unless your product compares favorably with those you have found, rethink what you intend to do.

Once you are selling your work, market research does not stop. The market for artistic and handcrafted items changes from season to season and from year to year. Some designs or items will continue to be popular while others will be so only for a short time. You must keep abreast of developments if you are to be successful at selling your products. Some arts and crafts like pottery or weaving seem to be always selling, but even here new trends, new methods and uses of color are constantly introduced.

The chapters which follow will tell you how to go about using a variety of markets, including selling through shows, shops, and mail order. You may choose to use one or more of these markets. Perhaps you will develop from one market to another as your production and marketing capacity grow.

Once you have done some marketing research and considered your possible volume of production, you can decide which of the possible markets would be best for you. Concentrate on selling to markets which suit your production and working temperament—in other words, those markets which will buy in the quantity you are able and want to produce.

If you want to build up a large production, you will seek those markets which can absorb this production. However, if your production is small

and likely to remain so, you may want to concentrate on a few good shows, a limited number of shops, or a single gallery.

In choosing your market, consider your own desires and abilities. What do you prefer to spend your time doing? Would you rather work by yourself, undisturbed, leaving the sales as much as possible to others? Then you might work through shops and galleries (see Chapter 8) or with one or more agents or wholesalers who will take care of all of your sales. Instead you might prefer to sell your work by mail order (see Chapter 9).

If you like to meet your public as well as work, you will have many opportunities to do this if you sell through craft fairs or mall shows (Chapter 7) or have your own boutique (Chapter 6). To make your sales efforts more productive, you might join a cooperative or guild (Chapter 10). No matter which method of sales you choose, you should be aware of the opportunities and take advantage of them as you need them.

ONE SUCCESSFUL ARTISAN

One artisan who has developed a successful craft business is Jack Franklin, who started by teaching himself the craft of woodcarving. He developed a few products and started to market them. Then he tested new markets and continued to make more sales. Perhaps this account of his business will give you some ideas as to how you might proceed in developing your own products and markets.

Jack's business is called "Country Carvin'" and is located on Ascutney Boulevard in Windsor, Vermont. Jack started by selling his carvings at country fairs and his business has grown rapidly. He has a workshop and retail store in which he teaches woodcarving and sells his own work, as well as items made by other artisans. He also goes on the road to mall shows, and has sold both wholesale and by mail order.

Jack learned woodcarving when he was the youngest First Sergeant in the U.S. Army. On leave from Vietnam he picked up carving tools and experimented with simple designs. After leaving the service, he went back to New England and got a job as a lab technician. Carving was his hobby and he continued to learn through self-instruction. He made a few clocks for friends and taught woodcarving at the local high school.

Then he began turning his hobby into a business. He brought carvings of owls, and deer and bas-relief clocks to the Mystic Art Festival in Connecticut. This was the turning point. He says, "I saw that my products were marketable. People admired and bought my work and with every piece they bought they took home a part of me, the craftsman."

Jack went to county fairs. Despite the fact that people do not come to

such events expecting to buy handcrafts, he made sales and was encouraged. Then he began looking for art and craft shows which he could attend, and became more and more involved with selling his work as he learned more about marketing through experience.

He enjoyed his work so much more than his regular job that he decided he wanted to become a full-time carver. He was uncertain about taking the step, however. As he says, "I had family obligations. To survive financially I would be forced to make and sell a certain number of carvings for a certain number of dollars every week and that thought frightened me at first."

It was not an easy decision for a man with a wife and three small children to make. But his wife felt that Jack would be very happy with his own craft business so she encouraged him to make the break, even though it would mean a great squeeze on the budget.

Once he was on his own, just the fact that he had to earn spurred Jack on. As he says, "Necessity to provide is a great impetus." But his fear of being "forced" to carve just did not work out that way. He continues to enjoy his work and to grow in his ability. Boredom is not the problem; rather it is how to find the time to do all he wants. He enjoys carving even when he works twelve hours a day, every day of the week, as when he is trying to finish orders before Christmas.

In April 1971, Jack started with a shop in his own home. He wanted to establish himself and get more marketing experience by operating at home without the additional overhead of rent on a shop. The following year he rented a store over the state line in New Hampshire. Here he started selling not only his own carvings but handmade items from other artisans. He had a display room in the front and his workshop in the back.

Jack expanded again when a shop became available just outside the town of Windsor, Vermont, where he lives. The shop was exactly what he was looking for and the rent quite reasonable. He has 16,000 square feet, which is divided into three sections. One section is the sales room, the second is a workshop, and the third section he uses for lumber storage and finishing.

Because Jack lives in a small town in rural New England, he needs a larger market for his handcarved items than the immediate area offers. While the store and shop is a good business, its sales do not keep up with Jack's production. Therefore he continues to go out to sell. He attends a limited number of shows a year, heading south often as far as Maryland. He is on the mailing list for several professional craft show directors (see Chapter 7) and chooses carefully among the shows they are presenting.

He usually arranges several selling trips a year, attending a number of shows on each trip. At the shows he sells some of the standard items he makes. He also gets custom orders which he completes at home and mails out.

At craft shows Jack builds up his mailing list by asking all customers to sign their names and addresses. He sends his catalog to all the customers on this list. In this way he has built up a growing number of satisfied customers who mail in orders when they need a gift. These return customers are very valuable, not only because it gives him a boost to know customers like his products enough to reorder, but also because they supply orders without further sales effort on his part.

Jack has also tried mail order advertising. He says that for his type of product he needs to advertise in a good magazine like *Yankee* or *Early American Life.* This is very expensive: a single ad might cost $300, which is a large amount for him to have to invest in the possibility of future sales. Actually Jack has not concentrated too much on mail order advertising because he is so busy with work from other sources.

In addition to carving and selling, he takes the time to keep up with the craft through his membership in the National Woodcarvers Association. He is the state representative to the National Carvers Museum, a nonprofit organization dedicated to the preservation of woodcarving. And in the slow months after the Christmas rush, he does some teaching in his shop.

Jack does wildlife carvings, bas-relief clocks, coffee tables, eagles, one-of-a-kind signs, and other custom work. While he repeats some of his designs, each item is unique, never exactly the same as the one before. As he sells the ones on hand, he keeps making more of the items which have sold well in the past (his best sellers are the bas-relief clocks and the carved eagles).

One popular item he makes is a clock decorated with an animal carving—people often want the animal to resemble a family pet. Jack will work from a photograph if the customer desires. He will attempt nearly any subject with the exception of family portraits. He has also done many carvings of coats-of-arms. He has sets of huge books jammed full of drawings of coats-of-arms, including just about any family name no matter how unusual.

Before delivering his custom pieces, Jack photographs them. He keeps these photos in a notebook so that customers can browse through it for ideas of what they might want to order. If they see a carving that they like, Jack will do a similar one according to their preferences and directions.

But no matter which product it is that he has made, Jack stands behind

it. He feels that the artisan must back his work and speak through his products. He attaches his business card with his name, address, and phone number to each item he sells. "If anyone has a complaint he can reach me," as he says. His carvings will last virtually forever, but the clockworks he installs into his handcarved clocks can wear out even though they are unconditionally guaranteed for a year. If they do, he tells the customers to come back to the shop or write to him. He will sell them new clockworks for what he paid for them. He makes no profit on these sales but claims that the good will generated among his customers is more than worth the effort.

Another aspect of woodcarving which Jack has found very lucrative is working with a manufacturer of plaster cast items. He tells Jack what he wants and Jack carves the figure. The manufacturer pays much more than an ordinary customer because he is buying reproduction rights. He uses Jack's figure to make a mold from which in turn plaster copies are made. These can be painted to resemble the original but of course the material is quite different. In this way many copies can be made cheaply for people who cannot afford a genuine handcarved piece.

Jack works very hard and puts in many hours a week, much more than he would be putting in on a regular job. But he thoroughly enjoys his work. During the busy season he puts in even longer hours, sometimes working seven days a week. When he does so he often brings the whole family to the shop and his children enjoy that very much. His wife helps out, takes over in the sales shop when he is on the road, and does some of the bookkeeping.

With his successful shop and growing volume of sales, Jack has gained confidence in his ability as a carver and as a salesman for his own work. The doubts he had earlier about whether he should have quit his regular job and gone into business for himself are gone. Even in a bad year, when shortages and rising prices of materials and equipment have hurt him badly, he is still glad he took the chance.

When you talk to Jack and he invites you to stop by his shop if you are in the area, you know he is a very happy person who loves his work and derives much satisfaction from it. He feels that the business of producing artistic and handcrafted items is a good one for anyone who wants to be his own boss and to really become involved in creating with his hands.

"It's a lot of honest work," he says. "It's not the business for anyone who is looking for money and fast. If you do shoddy work it represents you as a craftsman. Once someone gets a bad deal from you he won't be back and word gets around, too. But as you have more and more satisfied customers and more and more contacts for marketing, you will

build up a business so that there is as much demand for your products as you care to produce.''

Handmade toys are always popular

Chapter Two

Pricing

Deciding what prices to ask for your products may be one of the hardest chores you face as a new artisan. Setting good prices is not easy and the first few times you might spend quite a while agonizing over exactly what to ask. This chapter cannot tell you what your prices should be, but it can tell you how to go about setting prices in a businesslike manner.

If you are a seasoned artisan, pricing may have become second nature to you, and you may never have really thought about how to do it. However, you may be losing money on an item without realizing it because you have never actually figured out your costs. If so, this chapter may benefit you by helping you to make the price-setting process a more conscious one.

The first thing to realize is that there may be, at least at first, an emotional aspect to the price-setting problem. Some artisans feel that no matter how much they get for their work, it can never be enough. Many others are always afraid that they are asking too much, even if their work is worth more than they are charging.

Try to overcome the emotional problem by realizing that the price you set for a particular item is not a judgment on your worth as an artisan. Instead, it is a judgment on the cost to produce the item and on what customers might be willing to pay for it.

There is no right answer to the question of pricing a specific item. Many artisans set up a pricing formula which they use quite successfully. What is important is that the method you choose works well. With experience you will find that pricing becomes easier. You will acquire or develop a "common sense" as far as this is concerned. Once you gain experience in costing, you will probably have your own short-cut way of judging costs and setting selling prices.

Bear in mind that your prices should allow you to be self-supporting. Even if you are doing your art or craft part time, you should aim at prices on which you could earn a living.

Another consideration is fairness to other artisans who must earn their living through their sales. If you undercut these full-time artisans, perhaps in a few years you will be on the other side of the fence and amateurs will be undercutting your prices.

In his column "Selling as a Professional" in *Craft/Midwest* (now called *The Working Craftsman*), Michael Higgins, a veteran craftsman himself, says of part-time artisans: "Those of us who are completely dependent on our work can only hope they will at least price their objects so that they *could* make an entire living if they crafted full time. As more and more craftsmen 'enter the market,' this may be a critical factor in the growth and integrity of our profession."*

FIGURING COSTS

The task of establishing prices which will cover your costs and give you a profit is one of the most difficult you face, especially if you are totally unfamiliar with the retail selling process. At first you might suppose that you will be doing fine if you cover the cost of your materials and make a little extra to cover the cost of your time. Your formula for pricing an item might be:

$$\text{Materials} + \text{labor} = \text{price}$$

Such a formula is fine if you do not intend to make any money with your project. If, however, you want to be self-supporting, this formula is totally unrealistic and may not even allow you to break even.

There are real dangers in costing incorrectly. If you set your prices too high, your work will not sell and your selling efforts will be wasted. On the other hand, if you set the prices too low, you may be making no profits and get yourself into a real bind. If you have not estimated your costs correctly and have accepted orders for a large number of items at too low a cost, you will have to fill these orders and may do so at a loss in order to maintain your name for reliability.

To begin with, there are actually two prices which you must figure out for a specific item. First, as the artisan, you must figure your wholesale price, which includes only the price of producing the item but none of the selling costs. Your formula might look something like this:

$$\text{Labor} + \text{materials} + \text{overhead} + \text{profit} + \text{(perhaps)}$$
$$\text{agent's commission} = \text{wholesale price}$$

If you do your own selling, then you will set a retail cost which takes the wholesale price and adds to it the cost of selling the item. As the retailer of your own products, your formula might look like this:

$$\text{Wholesale price} \times 2 = \text{retail price}$$

*Michael Higgins, "A Long, Hard Look at Art Fairs: The Economic Realities," *Craft/Midwest* (now *The Working Craftsman*), Vol. 2, No. 4 (Summer 1973), p. 6.

These are two very general formulas, but they do point up that there is more to the cost of your product than the materials and direct labor that went into it. Examining each of these costs mentioned in the formulas should give you a better appreciation of the complexities of pricing.

MATERIALS

Probably the most obvious cost of your product is the materials you use. Obtaining the materials you need when you need them, and at good prices, is vital to your pricing and your profits. You want the lowest prices for the best-quality materials.

If you need to buy only small quantities of an item, then you will be paying the full retail price. When you buy in larger quantities, look for a wholesaler from whom to buy at quantity discount. This price break on materials can determine whether your business is profitable or not; it can be all-important if you are competing closely as far as price is concerned. A wholesale supply source can mean the difference between success and failure because it can cut your material costs in half.

Unless you use a very small amount of a product, plan to do some comparison shopping and see where you can get the best prices for the items you will be buying in quantity. Once you have a good supplier, try to cultivate this working relationship rather than hopping from one supplier to another for small price breaks. However, keep information from other suppliers on file so that if there is a major problem with yours you know which supplier to try next.

Buying in quantity represents an investment. Can you afford to have your money tied up in materials? It is also a gamble. Prices often fluctuate and if you buy at the peak you have lost money; equally, if you buy at a low point and prices go up, you will be glad you made your investment when you did.

Buying in quantity also presents storage problems. Will the material deteriorate (lose color, texture, or whatever) after sitting on the shelf for a year or more? Do you have room to store it?

A wholesale business, which is set up very differently from a retail business, aims to sell in large quantities to retail businesses which will resell the items. The wholesaler does not charge sales tax; instead, all customers supply a tax-exemption certificate or number. The customers of a wholesale business usually have accounts with the company and are billed for their purchases periodically. The wholesale company may offer a discount for prompt payment, perhaps a 2 percent discount for bills paid within ten days. Otherwise the money is due within thirty days (2/10/30). The wholesaler does not have sales although he sometimes has close-out items, seconds, or irregulars at lower prices.

The main reason you want to deal with a wholesaler, not a retailer, is price. The wholesaler offers items usually at a 50 percent discount. This discount on materials is very important to your economic security. However, unlike the retailer, who is anxious to sell his products to you, the wholesaler wants nothing to do with you. This is nothing personal but purely a matter of dollars and cents. The wholesaler only wants very large quantity orders. Filling your modest order represents a loss of time to him for which the minimal profit he makes cannot compensate. He will usually try his best to avoid your business because the paperwork for a single order might cost him about $7.50.

I spoke to Mr. Melvin Cohen of Walco Products, Inc.—a large wholesaler of beads, trims, styrofoam items, etc.—about this problem of buying supplies wholesale. He claims that he receives letters quite frequently from artisans asking to buy at wholesale prices directly from his company, and points out that "we are just not set up for selling to them directly. In large cities like New York and Chicago I can name stores where they can get what they need in quantity for prices that are close to wholesale. For those who do not live near big cities I suggest large mail order houses like Lee Wards (1200 St. Charles St., Elgin, Ill. 60120) and Holiday Handicrafts, Inc. (Apple Hill, Winstead, Conn. 06098)."

FIGHTING THE MINIMUM ORDER

The wholesaler has rigid requirements for those he will deal with. You must show your resale certificate to convince him you really are in business, and there will be a minimum order set so that he can avoid very small orders. If your order is too small he will try to get rid of you by sending you to a retailer.

However, the discount at which he sells materials is so important to your economic success that you will find yourself going to the wholesaler and almost begging him to sell to you. Persistence and an affable personality are your best weapons, along with vague mentions of large future orders which may develop as your business grows. If you have been successful enough to get his ear, in order to convince him further to accept your business, offer to pay him immediately and take your order right with you or come back to pick it up so that he will not have to ship the order or bill you for it.

When you have found a wholesaler who can supply you with the necessary materials, the first thing to find out—after you know that his products and prices are good—is his minimum order. Sometimes the minimum is the smallest total order he will handle; or it might be the smallest number of a specific item he will sell to you.

If the amount you have to buy is just too much for you to handle at

one time, look for other artisans who need the same materials. It is perfectly legitimate to put your orders together and send them in as a single one, having the materials delivered to one name and address. Of course there is the problem of dividing up the order once it arrives, but this chore can be more than worthwhile if it gets the materials to you at wholesale prices.

LOCATING SOURCES

Looking for art and craft supplies can be a frustrating and time-consuming job, depending on what art or craft you are involved in. You may encounter difficulty just locating what you need, or you may be able to find what you need but the price is too high.

There are a variety of sources of help. If you are looking for local suppliers, try the Yellow Pages of your phone book. If possible, visit each supplier, browse, and take some notes, so that you will have an idea of who has what when you need it.

If you attend art and craft shows, most likely you will be talking to your fellow artisans and may get some good leads on suppliers. You might also contact local schools or art and craft centers which offer courses in your particular skill. Perhaps the teacher of the course would be willing to tell you what suppliers he or she uses.

For some items you may not be able to find suppliers locally and may have to rely on mail order. If so, you can find out about mail order suppliers in craft publications. General craft magazines like *Creative Crafts* have advertisements for a variety of different art and craft materials. Sometimes they include source lists also. Another excellent source of information is the magazine about your particular art or craft, for example, *Shuttle, Spindle and Dyepot* for weaving supplies (see Resource Section E). Magazines on marketing arts and crafts may also have advertisements for supplies (see Resource Section D).

Many advertisements say that a catalog is available. Sometimes it is free; other times a small fee is required. Actually the 50¢ or $1 charged probably does not pay for the cost of producing and sending out the catalog—especially if it is a large one or uses many color illustrations. However, requiring the fee does limit orders for the catalog to people who are more serious about ordering supplies.

Order a collection of catalogs. If you have these on your desk you can comparison shop right there. When you need a specific item, you merely open up the catalog and see who has it at the lowest price. Then check carefully for the minimum order requirements for the company.

Collect wholesale price lists for materials you will be ordering in large

quantities. Also collect retail mail order and store catalogs so that you will have information for those times when you are ordering in small quantities, and therefore have to buy at retail prices.

The catalogs may give you interesting information about the materials you use. You should become as knowledgeable about them as possible. Learn where your supplies or raw materials come from and how they are collected or produced. You should also be aware of any hazards involved in their use.

In locating mail order suppliers or craft materials, you might find one or more of the specialized guides helpful to you. The *National Guide to Craft Supplies,* by Judith Glassman, and Joseph Rosenbloom's *Craft Supplies Supermarket* are both excellent. Other publications which might be helpful are Margaret Boyd's *Mail Order Craft Catalog,* and *Craft Sources* by Paul Colin and Deborah Lippman. (More information on these books, as well as on Judith Glassman's special guide to craft supplies in the New York area, can be found in Resource Section F at the back of this book.)

Once you have discovered good sources and obtained the necessary materials, you will need to figure the cost of these in order to work this cost into your price. If you are pricing the materials for a one-of-a-kind item, you will have to estimate the cost for the amount of each material which went into the project. For a production item, it is easier and more accurate to figure the cost of the materials for a group. Perhaps ten is a logical number of pieces to work with. Once you have the total cost for this number, divide it by ten to arrive at the cost per item.

As you are figuring out the cost of materials for a production item, do not use the amounts you paid for materials when you are making your prototype or samples which were probably bought at retail price. When you start producing the item in quantity, you will be buying in larger, more economical amounts, and it is these economical prices which you would use in figuring your costs.

In listing the materials for a particular item, remember that even "found materials" cost money. "Found materials" include whatever you can obtain without cost: pine cones, sea shells, driftwood, rocks, and other natural materials which you can gather in the woods or at the seashore. While you pay nothing for them, they are not really free because your time is worth money.

To estimate the cost of these "found materials," figure out how many items you find on the average per hour. Set a wage for yourself and divide the number you found into this wage. For instance, you might use pieces of driftwood in your work and can usually find half a dozen usable

pieces per hour. If you are paying yourself $3 an hour, then these pieces of driftwood are actually costing 50¢ each. In addition, you have to consider the time and travel expense it cost to get to where you look.

Many artisans who use "found materials" make the expeditions to find these a family outing. If you are one of them, you may not want to estimate the cost of your "found material" so high because you are really mixing business with pleasure.

Figure 3 shows the materials list for an artisan who makes decorator pillows with bold appliqué designs. She can conveniently work on ten at a time, so she has made out her materials list based on ten pillows.

Materials
per ten pillows

Fabric	$8.25
Stuffing	5.00
Trim	1.00
Thread	.25
	————
	$14.50

Figure 3. First the artisan arrives at the total of her costs for materials.

As you can see, she uses fabric, stuffing, trimming, and thread. These costs are listed. To figure out the cost per pillow, she divides $14.50 by ten so that each pillow costs $1.45 in materials.

LABOR

While the cost of materials must be considered, the labor involved usually says a lot more about the selling price. If you are new at making items for sale, then you will naturally take longer than someone who has been at it for a long time. Therefore you are justified in putting a lower value on your time at first. As you become more proficient, your per-hour rate should naturally become higher.

The labor cost on items which you are making in quantity should be estimated only after you have started making them in quantity, and after you have the process set up efficiently. Decide on a good number to make at a time, and work on them on a production-type basis. When they are finished, clean up. How long did the process take? When you have the total of hours, you can divide it by the number of items made and you have the time necessary to make each item. The next question is how will you value this time?

In order to figure out the cost of the labor, you will have to set up an hourly wage for yourself. You can decide on a minimum which ·you would accept, but remember that you should actually be able to live on this minimum wage whether in reality you have to or not.

The decision as to what your time is worth is actually a very personal one. Your education and skill, as well as your experience and your reputation, figure in it, as do your age and previous jobs.Where you live has an effect on it, as well as the demand for your type of work. Your need for money will enter the equation, as will the enjoyment factor—if you really love to do what you are doing you may be willing to accept somewhat less payment. Finally, there is the ego factor—you want to feel your time and efforts are worth a good price.

The actual figure which you use is of course only a guess. You might say $1.50 an hour when you are just beginning. Later, you might earn $5 an hour and up—depending on your skill.

One way to estimate your labor is to consider it in terms of what you would pay a skilled person to replace you. Keep in mind the current minimum wage—you could never pay the worker below that and he certainly might expect a higher wage.

PROFIT

Some people define "profit" as the money left over after all the expenses have been deducted. If you are figuring out prices, when you have covered all your costs you should add an amount into the price to be sure you *do* have something left over.

Profit is important because it is a hedge against contingencies, and a protection against loss. Profit allows you to buy new equipment; it also gives you money to gamble on new marketing efforts which may pay off but could fail miserably.

If you do not add profit to your price, you will just break even, assuming you have figured out your costs correctly and employ someone to do the production work. If you are doing all the work yourself, then you will merely make the worker's wage.

Many artisans consider their profit the money which should be considered their wages, or hourly pay rate. However, above and beyond receiving the amount figured as labor, you should also be getting an additional amount for profit. Profit is actually the return for your creative and managerial abilities and for the amount you have invested in your project and the risk involved.

OVERHEAD

"Overhead" is the name given to all those hidden costs that are not directly part of the labor or materials necessary to make an item—all of those additional costs which you may not even think about in estimating the wholesale price of an item. Overhead should help to cover the uncertainties and the unexpected expenses, plus those extra expenses which you can predict all too well.

If you fail to take overhead into consideration, it can eat up your profits. One excellent cross-reference point by which to check up on your overhead costs is the deductible expenses on your income tax (see Chapter 5).

You can figure out your overhead costs in two ways. Either you can list all your overhead expenses on a monthly, weekly, or other basis. Then when you have a total, divide it by the number of items you produce within the time limit set.

Or you can figure out a shorthand method. One possibility here is to take a percentage of the labor or materials and add it in again as "overhead." You might, for example, find that your costs for overhead are running about a third of the cost for labor. Your shorthand method of costing then could be to add in again one-third of the labor cost.

No matter which method you use, you still should be aware of what is involved in overhead. First, overhead involves the cost of a place to work, including rent and utilities. If you are using your own home, you still should add in a cost for rent because you are actually using a certain percentage of your living space for your work and should therefore take a percentage of the cost as overhead. Later, as your business expands, you may want to rent a shop.

For utilities—including heat, light, gas, telephone, etc.—figure the same percentage as you took for the rent unless you can figure these costs exactly. Note that if your particular craft uses an excess of a particular utility, perhaps electricity, then you should take this into consideration when you are figuring out these costs.

If your work requires you to invest in expensive pieces of equipment, you might depreciate or take a certain percentage of the cost of these each year (as on your income tax—see Chapter 5). You may also have tools which must be replaced at certain intervals. If you have borrowed money to set up your business and to buy the initial equipment, then the interest cost is another overhead expense.

You will certainly need office supplies to carry on your business—envelopes, letterhead stationery, packing slips, pens, pencils, and so on. All of these are overhead, as well as the amount you pay for

postage. You will also have to pay for shipping supplies if your items are shipped.

There are a variety of other expenses, including perhaps payment for the services of an accountant or a lawyer. Look over your checkbook to locate such additional expenses.

One further overhead is the cost of your labor in doing all the secretarial work involved. You must seek sources of materials, place orders, pay bills. If you find yourself spending a long time with such chores, they could add significantly to the price of your products.

Designing time is another overhead cost, and one that is particularly difficult to assess in dollars and cents. In setting the cost for designing a specific item, much will depend on whether it is a one-of-a-kind item.

If you make one-of-a-kind pieces, you *must* charge for the designing time to arrive at a fair price, because all the designing time must be assigned to this one piece. It is this designing time necessary to create a unique item which makes the item much higher in price than one which is made on a production basis.

Actually, designing time involves three different times: first, the years it took to develop your talent; secondly, "think time," the time you took to create the concept of this unique piece. It might have come in a flash but the preparation for that flash of insight took time. Both of these are intangible and almost impossible to translate into the cost of the item.

Finally, there are the hours spent testing and trying in order to arrive at the unique item you produced. These hours are usually countable and you must take them into consideration when setting the price for a one-of-a-kind piece.

When you are creating an item to be produced in quantity you can spread the cost of the designing time over the number of items you will make. A successful design will pay for its designing time very quickly and may also pay for some of the time you spend with a variety of unsuccessful attempts. For items made on a production basis the initial designing time, plus the time to seek out the necessary materials if they are not at hand, can be spread over the entire number to be made. If you design an item and keep making it indefinitely, then the designing costs per item become nil.

Figure 4 shows the overhead costs for the artisan who makes the decorator pillows whose materials are listed in Figure 3. For working on her pillows, and storing materials and completed pillows, she uses two rooms of her five-room $275-a-month apartment. She figures $110 for rent then. She adds $20 for utilities which is two-fifths of her utility bills. She uses her car to deliver her work and pick up new materials, so she

estimates transportation at $30 (based on 15¢ a mile). She adds in the costs for office supplies and postage ($20), packing supplies ($15), as well as insurance ($15), and an additional $30 for miscellaneous expenses. Adding up these costs on a monthly basis her overhead cost is $240. On a daily basis her overhead would be over $10 if she works five days a week.

Overhead—Monthly

Rent	$110.00
Utilities	20.00
Transportation	30.00
Office supplies and postage	20.00
Packaging supplies	15.00
Insurance	15.00
Designing and secretarial time	30.00

$240.00 or $60 per week

Figure 4. Another important consideration is overhead costs.

You may find your actual overhead costs much higher or lower than those shown. Keep good records and figure your overhead costs so that you will be aware of them as part of the cost of producing your items.

Once you have figured out your materials, labor, and overhead, you are ready to set your wholesale price. Figure 5 shows the wholesale price for the decorator pillows. According to Figure 3, the materials cost $14.50. During an eight-hour day the artisan can make ten pillows. At $3 an hour the labor cost is $24. Taking her overhead costs from Figure 4, she adds $10. She also adds a profit of $1.50 so that the total cost for ten pillows would be $50. The price per pillow wholesale then would be $5 and the retail price $10.

Producing Cost—Ten Decorator Pillows

Materials	$14.50
Labor (8 hours @ $3/hr.)	24.00
Overhead	10.00
Profit	1.50

$50.00

Figure 5. If the artisan produces ten pillows a day, then the wholesale price should be $5 each.

SELLING COSTS

Once you arrive at a wholesale price, you can double it to arrive at your retail price. If you are selling through shops or galleries they will most likely double your wholesale price if they are buying outright. Note that this is called 100 percent mark-up, that is, the seller is adding 100 percent of the wholesale price to get the retail price. Or, to put it another way, your wholesale price is giving him a 50 percent discount on the retail price. In effect, he gets half and you get half of what the customer pays for the item. This is the traditional mark-up on items in the gift trade or business; hopefully, you can do better. If you are selling on consignment (see Chapter 8), the mark-up certainly should be less.

When you are selling the items yourself, you will get the selling half of the price to cover your costs. Selling may be much more expensive than you originally imagined. Once you decide to sell your work yourself, you have become a salesperson in addition to being an artisan. Depending on how you decide to sell your work, you might find that you are spending as much time or more on selling your items as you are in making them. Actually this is quite normal and to be expected, especially at first. You should soon become more knowledgeable about selling and get your selling costs in line with what your retail price allows.

To figure out how you are doing, you must pay yourself an hourly wage as a salesperson. After all, you are losing these hours from production. You must also add all of your expenses to the wage. If you go to shows, you might figure out how much you will need to make in sales to make them worth your time as a salesperson. Another consideration is that if you are working through an agent (see Chapter 8), you will probably be paying this person on commission, that is, a percentage of what he or she sells. This commission is often 20 percent of the wholesale (or 10% of the retail price). Note that this percentage must be figured as part of the wholesale price; in other words, it comes out of your half, not the store's half of the price.

COMPARATIVE PRICING

There are two basic ways of arriving at a price. The first one (already discussed) requires you to analyze all of the costs which go into producing the item and, from these costs, determine the price.

The second method works from the other direction. First, figure out what price you think you can get for your item (what will customers be willing to pay? what prices are other artisans asking?); then, once you have established a competitive price, figure out if this price will cover your costs.

Note that even if you use the second pricing method, you will still need the first so that you are aware of the costs involved and are not selling below these costs, in reality losing money on every item you sell.

If you are a new artisan, try out your estimated prices on yourself. Ask yourself if *you* would buy this particular item at this price. Use your own critical shopping sense and think about the price in relationship to the quality, workmanship, utility, and design. Of course it is difficult to be totally objective because you know the amount of work that went into the item and the quality of the materials. But if you did not know this, do you think you would be likely to buy it?

One of your best guides to pricing is what the competition is charging for the same or a similar product. Investigate what other people making a similar product are asking for theirs. Go comparison shopping to galleries, shops, and shows. If it is a one-day or short-term sale, you might come back later and see what products have sold.

What you are aiming for is a price that is low enough to meet the competition while still being high enough so that you can show a profit. Determining this price for any single item can be a challenge. The type of art or craft you are involved in is important. Some fields, like leather and pottery, are more competitive than others. On the other hand your craft may be unique or virtually so, in which case you may not have any products to compare yours to. Competition will not be important but the price a customer is willing to pay to own your product will be. You must price according to what the traffic will bear, that is, according to customer demand. The majority of people are price-conscious and will hesitate to buy even a unique prestige piece if they think the price is too high.

The customer does not worry about the costs of the materials, labor, overhead, etc., but only what price he is willing to pay in order to own an item. He or she usually is unaware of your pricing problems and can only estimate an item's worth by how much he likes it and how he imagines it will look in his home. There are of course many people who do appreciate crafts and do have some idea of the time, materials, and skill needed to produce. These people are usually much more willing to pay the price because they appreciate what you have made.

In certain geographic areas you can charge more for an item and get your price. If the show is held or the shop located in a wealthier town, customers are likely to pay higher prices without complaint.

If you are having trouble in pricing your items, the person you are likely to be discussing this with is the manager of the shop or gallery to which you are selling. He may be very glad to give you advice on what price to ask for your products. Watch out, however. If you asked three

different shop managers, you would probably get three different prices for a specific item. Remember, too, that this advice is coming from a prejudiced source. If the manager is buying outright, he wants to get pieces for as little as he can in order to increase his own profits. He will mark up your products more than 100 percent if he feels they will sell for a higher price. He habitually tries to get items as cheaply as possible and of course if you underprice your work it is to his advantage. While the manager will almost never tell you that your items are underpriced, he usually will volunteer the information if he thinks your prices are too high. If price is the reason he is not buying he will frankly tell you this, so that if he does not mention it your prices are probably not too high.

In considering a product you should realize that many handcrafted items are simply not saleable at a reasonable profit. The main ingredient of a handcrafted item is the labor that goes into it. Some items take much more time than you could possibly charge for. For example, a handmade sweater takes many hours to produce. The sweater is certainly superior to the mass-produced ones available in stores, but not superior enough in either usefulness or appearance to warrant the extremely high price a knitter would have to charge to make any reasonable hourly wage producing it.

This does not mean that no knitted item could be sold at a profit but rather that a knitter should look for items that are particularly attractive and are not available from other sources. Also the knitting time should be as short as possible—thicker yarn and larger needles can sometimes help here.

REDUCING COSTS

If you cannot get the price you know you must for a specific item in order to adequately cover all costs, then you have a choice. You can either reduce the costs or discontinue the item.

There are a variety of ways you can cut costs. The first move is to try to design your items from the beginning with costing in mind. If you are making items on a production basis, try cutting down the time it takes to produce each item. If you can work faster and more efficiently, then you are cutting the labor cost per item. You may have to redesign and simplify the construction of a piece in order to produce it more rapidly. Can you do this without affecting its quality?

Another way to cut costs generally is to cut down the cost of your materials. If you can invest the money and buy in larger quantities, you will save money. Try to get to know your suppliers; you may obtain some good money-saving advice from them.

Use materials carefully, getting the most you can out of each. Buy less

expensive materials if your product would not suffer. Ironically enough, you might also consider buying more expensive materials. The price of your item could be increased much more than the increase in the cost of the materials. If all else stays the same, then you have increased your profit per item.

Think of other costs you can cut if necessary. You may be able to cut down on shipping or insurance costs when you are mailing. Also try to use less expensive cartons or other mailing supplies. Some items give you a better profit than others. If you can balance them, then you can continue to make the items which you enjoy making even though your profit on them is minimal. The higher profit items made on a regular basis are sometimes called "bread-and-butter" items because you can make and sell them easily and they give you a good profit. You may not be too happy constantly producing these items, but they will fill in between the sales of the more expensive items which you prefer to work on.

When you are cutting costs there are some areas which you should *not* cut. You should not compromise the quality of your work in the interest of making more money. In the long run this is a losing proposition. Your reputation, as well as your self-respect, will suffer. After all, you went into business for yourself so that you could do things the way you felt was the right way—compromising with quality is certainly not the best way to conduct a business. If you have others working for you, you should check their work carefully for quality control. Do not take on so much work to be done by a certain time that, with the pressure on you, the quality of your work suffers. And never cut costs where safety is concerned.

EXPERIMENTING

Never feel that once you have put a price on an item it must remain that price forever, no matter how many you produce. The costs of your materials and tools will fluctuate—so must your prices to keep up with inflation and other factors which affect prices.

Perhaps you are producing one-of-a-kind items. If you are young and inexperienced, your prices will be lower but they can gradually increase with your reputation, experience, and sales.

If you work on a production basis and have a line of items, then you should constantly reconsider your prices and items. If an item seems overpriced to the buying public and you cannot cut costs in producing it, drop it.

At the beginning it is probably better to ask too much than too little for your work as it is much harder to raise prices than to lower them. No

one objects to a price reduction, but if you sell regularly through certain shops or galleries, the manager may be very upset when you try to raise your prices.

If you attend a variety of shows you can experiment with prices. Where a product is selling well, try raising the price slightly: if something sells for $7, increase the price to $8.50 and see how that affects sales.

When a product is not selling well, try lowering the price to see if that is the problem. If something is selling well and you want to see if it would sell fantastically well at a lower price, then try it at this lower price. However, where you would not substantially increase your total profits by dropping the price, there is no need to change it. You might be able to, for instance, triple your sales but not increase your profits on a particular item by dropping its price. Here you must consider what is your goal. If you are anxious to generate more sales to give yourself much more work, then the price drop could be justified. Most likely your goal is profits not sales, so that it is the profits you will be watching rather than the total number of sales.

THE PSYCHOLOGY OF PRICING

You will have been watching your customers' buying habits, and after a while may come to some conclusions about why they buy, and how they decide whether a price is reasonable or not.

Art and crafts are bought with disposable income—money which is not necessary for the essentials of living. This will definitely affect the attitude of your customers. When money is tight or scarce in general, this luxury buying of art and crafts will be one of the first things to feel the pinch.

Art and crafts are in style as decorator touches for homes and apartments, so that your products may be appealing to your customers as status symbols; if so, their prestige value, not their intrinsic value, is important. Other customers may buy because they appreciate art or fine craft work. Neither group will be anxious to buy if the price seems too high to them—but what is too high?

Many buyers have a preconceived idea of how much an item should cost. Usually their estimates are low because they do not appreciate the time which went into making the product nor have any idea of how retail goods must be priced to cover the cost of producing and selling.

Although their estimates are usually low, sometimes the customers think an item should cost more than costs would indicate. It is possible to lose sales to underpricing as well as overpricing. A customer quite often has a set notion of what a certain item should cost. If your prices fall

below this estimate, the customer wonders what is wrong with your products and does not buy them. If in fact they could be much less expensive, you should still charge the amount a customer feels the item should cost. Do not feel guilty if it is too high when you make the specific item quickly and get a higher profit on it, just accept it and let it make up for the loss you suffer on other items.

In planning a product, consider what price range it comes under. Small items or those in the souvenir range cost under $2. These usually sell very quickly but it is hard to make a handcrafted product that will sell this inexpensively.

The next range, from $3 to $10 roughly, is the gift range price. For purchases in this range the customer usually considers somewhat longer before buying as opposed to the impulse buying of items under $2. It is, however, the most steady range for the artisan and he will probably do best with products here.

In the over-$10 range, sales will be slower except in affluent areas. But one sale in this range can make up for quite a few transactions involving inexpensive items. If your art or craft allows, try to make items in each range so that your products will appeal to many different buyers.

When you are deciding on an exact price, use rounded numbers because these imply quality. If the item is marked "$8.00," the .00 implies quality; $7.98 is too reminiscent of discount department store pricing.

CHANGING YOUR MARKET

If you are having trouble selling your products at the prices you feel you must get in order to show a profit, then one possible solution is to upgrade the market you are using. If you need a higher priced market, look for shops or galleries which generally serve a wealthier clientele.

Generally this is the progression in markets. People expect the lowest prices at shows and fairs. When they go to a boutique in a private home, they still expect fairly low prices. Slightly higher might be sales from your own studio. In the middle might be department stores. Customers will pay higher prices at "shops" and the highest at a "gallery." Of course the specific show or shop makes a big difference. The degree of professionalism with which it is run, the type of merchandise it presents, and the type of clientele it serves, all affect the prices which can be charged. In trying to upgrade your market keep in mind that at higher prices per item you will most likely sell far fewer items.

PRICE TAGS

Once you decide on a price, let the world know. When you are working

directly with the customer at your own boutique, or at a show, everything you put out for sale should be priced. For small items in a container you can put up a little sign that tells how much each one costs. All other items should have a tag or sign on them indicating price.

Putting the price tag on each item makes it easier for people to choose what they want to buy. If they have to constantly ask prices they will quickly get discouraged and leave. Most people are timid about asking and prefer to read the price themselves and decide in private.

BARTERING

One last thought might be added to this chapter on pricing. Long before money was printed people used the barter system to exchange their goods. And this fine system of exchange is now coming back into vogue, especially among artisans.

Probably the person who would appreciate your work the most is another artisan. If you appreciate his work and would like to have something he made, the situation is ripe for bartering. Sometimes even suppliers might be willing to barter with you.

Chapter Three

Publicity

"Promotion" means anything you do consciously or unconsciously to get attention from the buying public for your name and your products.

It is vital to you as an artisan. As Ruth Wilson, a water colorist from Bridgewater, New Jersey, puts it: "You as an artist or craftsperson should be promotionally minded, because if you don't promote yourself no one will. You must constantly learn to think creatively and spot good opportunities. Be aware of the mileage you can get from a display or an article or whatever.

"What you want to do is to learn to see opportunities and then act on these. When people see your name over and over again it will become familiar and they will be more apt to buy from you. You may not sell much at first and may have to go to shows with the idea of exposing your work and your name. Once your name becomes familiar you will start selling."

Promotion comes in two main forms: publicity, which is free (relatively), and advertising, which is expensive. As someone with a product to sell, you should be aware of the various forms of publicity and advertising and how they can help you to get your products into the hands of buyers.

This chapter discusses publicity chiefly because as a single artisan you will probably do little advertising unless you sell your work by mail order. (The chapter on mail order will discuss advertising as it applies to this method of sales.)

You can get publicity in a variety of media, each of which has its own advantages and disadvantages. Some will be more suited to your purposes than others, and to make a wise selection you should know something about each choice. Become aware of your local opportunities and use them as you need them.

You are the best promoter for your own products because you produce them. The arts and crafts business is essentially a personal one and the special personal touch is important. Word-of-mouth advertising by satisfied customers is the most effective promotion. In selling what you make, remember that maintaining personal contacts is vital. Even something as small as a thank-you note to someone who has helped you can foster better relations and encourage the person to recommend you when the opportunity presents itself.

BUSINESS CARDS

One inexpensive form of promotion which no artisan can afford to be without is a business card. This is the one form of promotion which everyone should use. While there is a small cost involved, the card should pay for itself many times over. According to Bob Geagan, head of the Business Card Division of Vermont Business Forms Company, "The business card is perhaps the lowest cost and most easily distributed form of advertising for the artisan. He who goes to a show and doesn't have cards is really losing out!" Think of your business card as your introduction to potential customers and their link back to you.

Your business card should contain certain vital information—your name and the name of your business, your address with zip code, and your phone number with area code. You can add to this basic information a phrase or even a sentence or two describing your business or products. For additional interest you could use a simple drawing or outline or perhaps a photograph, your logo, or design or symbol.

Your business cards can be printed very inexpensively by a professional printer; or you may want to print them yourself with a silkscreen or other method. It is certainly worth putting in a few extra dollars and some effort to get a business card that is distinctive and attractive, and conveys the image you want it to.

Use your business cards constantly. Have them available on your display at shows (most show directors allow this practice). Tie or paste a card onto each item you sell. If you are selling at a show you might put your customer's purchase into a bag and then staple it shut with a card under the staple. When the customer holds the bag so others can see it, he is a walking advertisement for your products.

As soon as you meet a new fair director or buyer, immediately offer him one of your business cards. When writing to someone with whom you have not corresponded before, slip in your card.

In designing your business card, be creative; aim for simplicity and attractive design. You can do the whole card in your own writing or printing, making up the sample exactly as you wish the printer to reproduce it. Or, if you like, you can have the printer use the type style you choose for your wording. He will have a variety of type styles from which you can pick out a distinctive one that suits your personality.

For under $15 you can get 1,000 business cards. Order them from a local printer or use a mail order source such as the Vermont Business Forms Company (Business Card Division, Rd. 2, Montpelier, Vermont 05602).

Your card can be printed with black or colored ink, sometimes with

Figure 6. Lois Stromberg, who makes delightful applehead figures, has an appropriate apple on her business card.

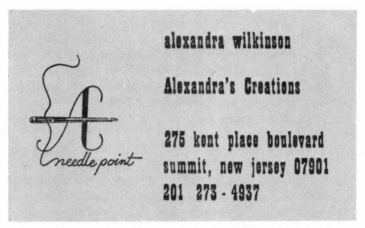

Figure 7. This is the business card of Alexandra Wilkinson, who designs original needlepoint canvases.

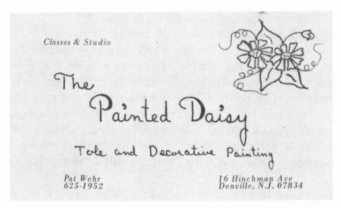

Figure 8. Pat Wehr, who does tole painting, uses her own handwriting on her business card.

SCRIMSHAW

Handcrafted by
DON THOMAS

52 Colonial Road
Sudbury, Mass. 01776 443-2826

SCRIMSHAW

Figure 9. This folded sheet doubles as a business card and a tag to put on his work for Don Thomas.

Scrimshaw is a true American folk art which dates back to the whaling days over 150 years ago. Idle hours at sea were spent etching or carving discarded whale teeth and bits of ivory.

Once abandoned in this country, this almost forgotten art has been revived and perpetuated in fine and unique jewelry and etched whale teeth.

Figure 10. The inside of Don Thomas's business card tells the story of scrimshaw, his craft.

Figure 11. Rip Bodman, who does silkscreen work, prints his own business cards.

"raised print" (rub your hand over this and you can feel the print). At additional cost most printers offer a number of extras, including more than one color of ink or several different type styles. You can have the cards made from colored paper rather than white or use a photograph rather than a line drawing.

Color will make your business card more attractive. Order colored paper or colored ink if you like. The business card in Figure 6 belonging to Lois Stromberg, who makes delightful applehead figures, is done very appropriately in apple colors with red on a cream-colored paper.

Your own line drawings can say something about your business. Figure 7 is the business card of Alexandra Wilkinson, who creates original needlepoint canvases. Her initial, with a needle and the word "needlepoint," identifies her business.

Or you can do some of the lettering in your own handwriting for a more personal touch, as in Figure 8. The traditional size of the business card is approximately 2 by 3½ inches but there is no reason why you must use this size. You could make your card double the regular size and have it a folder as in Figure 9. Figure 10 shows the inside of Don Thomas's card, which tells a little about scrimshaw, his craft. Figure 11 shows the business card made by Rip Bodman, whose business is silkscreen and whose style is shown clearly by his card. Look over these sample cards carefully and perhaps they will inspire you to create your own original card.

YOUR RESUME

Remember that you are publicizing yourself as well as your products—what makes them unique is that they were made individually by you. You may feel uncomfortable at first seeking publicity for yourself, but in building up a reputation you are creating a better market for your products.

You are an interesting person. You create, you sell what you create, and you are knowledgeable about your art or craft. Many people would like to read about what you do in their newspapers or hear you talk about it on a local radio or TV station.

In preparation for this publicity, write a brief resume or autobiography. On a single sheet give the pertinent facts about yourself, including your hobbies and previous work. Explain how you learned your art or craft, and include your education or training and your experience. Mention any awards or other recognition you have received.

Say a little about your business and how you happened to get started. What events led up to making your products and deciding to sell them? Get all the facts together and then pick out the most interesting.

Have several people read over what you have written and ask for suggestions. When you are pleased with it, type a good copy. If you are likely to use many copies, have a printer make them for you. This is an inexpensive process. If you will use only a few, you can copy it on a copy machine.

Use your resume as an introduction to shop or gallery owners. If you want to be in a show, send your resume when writing for an application. You can use it to introduce yourself to editors and broadcasters, and give copies to interested customers too.

Figure 12 is an example of a resume. Read it over to get some idea of the type of information you might include in your own resume.

PHOTOGRAPHS

If you have a good camera yourself or a friend who is interested in photography, you have access to an excellent promotional tool. If you have no other way of getting good photographs, it is worthwhile paying someone to do them for you.

Photographs have a great many different uses, some of which will be described here. Plan your photographs if possible so that you can use them in a variety of ways to get maximum benefit for the dollars invested.

If you are an artisan who makes one-of-a-kind gallery items, a camera can be absolutely vital to you. To have a complete record of your work, take a color slide of each piece. Number the photographs or slides consecutively to keep them in order and see your progress and development by reviewing them.

These photographs will be very helpful if you have them available when a customer is discussing his order for a one-of-a-kind commissioned piece. Fenn Vogt, whose resume is on page 44, uses photography this way. As soon as each piece is completed it is photographed for a permanent portfolio display which is helpful to customers ordering special subjects. The customer can examine photographs of over five hundred pieces Mr. Vogt has done in the past and choose sculptures which resemble the one he has in mind. The commissioned item will not duplicate any of those recorded, but they can serve as the basis for a discussion of what the commissioned piece will look like.

You will need two types of photographs: 8 by 10 inch or 5 by 7 inch black-and-white glossy prints, and color slides (35 mm or larger). Most newspapers and many magazines use only black-and-white photographs. These can accompany your press releases, which will be discussed in the next section of this chapter.

If you participate in a show, the show director might ask for photo-

About the Artist

Fenn Vogt is a retired Industrial Engineer. Upon retirement in 1968 he undertook the creation of series of wall sculptures in sheet copper and brass to decorate his den.

Friends and acquaintances saw them and began giving him orders. Since that beginning his unique creativity and craftsmanship have become well known in New Jersey and elsewhere.

Most of his work is mounted against old weathered barn wood, and the copper work is given an aged green patina which he does chemically.

In particular demand are his marine subjects, nostalgic Americana of all sorts, and humorous personalized caricatures of professional people in action.

His craftsmanship has been self taught and his creations are unique in conception and execution. Each work is a signed original, numbered, and one of a kind.

In the short time Fenn Vogt has been a craftsman he has exhibited in 16 shows and has a "best in metal sculpture" award.

Currently his work can be seen at the Oldwick Design Shop (Oldwick), the Cache (Fanwood), the Art Glass and Crafts Studio (Turntable Junction, Flemington), and the Figurehead (Bayhead). His studio is also open to visitors at 1088-B Argyll Circle, Lakewood, N.J. (In Leisure Village East, just off Garden State Parkway Exit 88)

The artist is an active member of the First Mountain Crafters, Inc. of N.J.

Figure 12. Fenn Vogt has this resume available for anyone interested in his work.

An artisan at work with tools and blowtorch

graphs of you and/or your products to use with his press releases or in a feature story for a local newspaper or magazine.

You will also use photographs in making up your own catalog or brochure. Even if you are planning a one-page flier, you will find that photographs can make it more attractive and show better what you are selling. If yours is a mail order business, you will totally rely on photographs to show your products to prospective customers. In entering juried shows, you will be asked for a specific number of slides of your work so that the judges can look at them before deciding which applicants to accept. You will need some very clear and complimentary slides of your work for this purpose.

THE PRESS RELEASE

The press release is the conventional way of giving out information in written form to newspapers and magazines; it can also be used to send information to radio and TV stations. The press release is usually a single sheet of paper, although it can be longer.

Keep your release brief and to the point. Use words economically. State the facts clearly, without obscuring them with advertising jargon or exaggerated claims. If the editor used a release with such claims in it, then it would be tantamount to his endorsing the claims. The release should only announce and describe. Remember what you are writing is supposed to be news. Try to use a new angle or a fresh approach to make the story appealing.

Write the release just as you would like to see it in print. Do not try to get in every detail or the important facts may be obscured and the effect become dull and repetitious. The lead—the first sentence—is very important because it has to grab the reader's attention. The opening paragraph should give all the major points immediately and contain all the vital information—the who, when, where, and how.

The editor may choose to insert the information in a calendar of events, and if you have the most important information first he can locate the vital details immediately. Arrange the information in descending order of importance, placing the most important and intriguing information first, the less important information next, and finally the least vital facts in the last paragraphs. If the editor cuts your release, he will usually do it from the bottom up using the more important information in the first few paragraphs.

Write as simply and clearly as possible. Read over what you have written aloud to yourself to be sure that it is clear. Then have someone else read it over. Ask your reader if anything is unclear and if so,

American Crafts Exposition/ P.O. Box 274 Farmington, Ct. O6OO7/ USA PLANET EARTH

NEWS RELEASE

FOR IMMEDIATE RELEASE Contact: Rudy Kowalczyk
 Director

CONNECTICUT'S "CHRISTMAS CRAFTS EXPO" - THIRD ANNUAL - DECEMBER 5, 6, & 7, 1975

The third annual Christmas Crafts Expo-75 is MOVING. This year the show will be
held at the NEW HARTFORD CIVIC CENTER in Hartford, Connecticut with easy access
off Rt. 84.

The Christmas Crafts Expo will be unique as it will be the largest indoor
craft show to be held in Connecticut. Over 150 craftsmen will exhibit along with
over 50 booths devoted to International foods and other unique merchants. The
show will feature craftsmen from all over the United States and will have a unique
mix of old traditional crafts and some new craft medias. The transformation of
some products often thought of as unfunctional into pratical items will surprise
the visitor to the show. A food booth and a beer fest booth will highlight the
show.

Craftsmen that will participate have been selected based on the originality
of their product, its uniqueness and their presentation. Selection procedures are
high so as to offer to the public some of the best craftsmen from each craft field.

The move to the new Hartford Civic Center is only natural due to the needed
features this building has to offer. The large well lighted exhibit hall, the
much needed parking areas at reasonable costs, and the central location will attract
both quality craftsmen and their buying public. The show will run Friday, Saturday
and Sunday. The Friday hours will allow the working force of Hartford and vicinity
to shop the show (Friday hours 12-10PM). Saturday the show will be open from 10AM
to 10PM and Sunday from 12 to 6PM.

Children will be admitted free with adult admission to the show-$2.00.
Students and senior citizens will be admitted for ½ price and presentation of
the discount tickets distributed will also allow a ½ price admission.

For further details write American Crafts Expositions, P.O. Box 274-XC,
Farmington, Connecticut 06032 USA-PLANET EARTH.

COME TO THE CRAFTS MARKETPLACE -THE THIRD ANNUAL CHRISTMAS CRAFTS EXPO.

Figure 13. Rudy Kowalczyk wrote this press release to announce his Christmas
Crafts Show.

rewrite, adding the necessary information or correcting the existing copy.

Since editors may print the release exactly as you have written it, be sure that it is polished and well written. Make it as neat and correct as you can. Proofread the final copy carefully. No editor wants to take the time to correct grammatical or spelling errors before using your release. If you provide well-written, factual, and interesting releases, editors may be willing to use your material.

Leaving margins of 1½ inches, type your release double spaced on 8½ by 11 inch plain typing paper, or your own letterhead, or on special paper which has "News Release" printed across the top.

At the top type: "For immediate release," or "For release after..." and give a specific date. At the bottom of the release, add: "For further information contact," and give your name, address, and phone number. If the editor decides on the basis of what you have written that he wants more information, perhaps to write a feature story, he can reach you.

Figure 13 shows the press release sent out by Rudy Kowalczyk, director of the Christmas Crafts Exposition held in Hartford, Connecticut. Notice that the vital information is contained in the first few lines where the facts to get you there are given. Then follows the type of information that is interesting but not vital, though it might convince you to attend. The release finishes by telling you where to write for further information.

If possible, include with your release a photograph which is pertinent to what you have said. This is optional, but if you are talking about a new product, for example, the picture could show exactly what you are describing. Also the photo will add interest to the copy and get you more space in the magazine or newspaper.

You can send an 8 by 10 inch black-and-white glossy print, but a 5 by 7 is quite acceptable to most publications and just as effective. The smaller size will save money both for the print itself and in mailing it. Be sure to back the photograph with cardboard so that it arrives safely.

Direct the release to the appropriate editor at the newspaper listed on the "masthead." This section, which gives vital information about the newspaper, usually appears on the editorial page. If you are unsure about which editor to choose, select one. If it is the wrong one he or she will pass it on to the correct person. Always send the release to a specific editor. If you cannot find a name, send it to the "Editor for the Arts" or "Home Page Editor," etc.

For newspapers it is advisable to send your material in a week or more ahead of when you would like it published. For magazines you must send your release months in advance.

When you start sending out press releases and contacting newspapers, radio stations, and so on, keep all of the pertinent information about them organized. Use file cards and head each with the complete name, address, and phone number. Keep a record of who your contact person is, when you made contacts, and the results.

In considering what newspapers to submit your releases to, make a list of all the daily and weekly newspapers in your area, as well as any "Shoppers" or other local print medium. Be aware of the fact that the one that covers the smallest geographic area and has the smallest circulation is most likely to use your material; the largest, in which you would get the widest exposure, is the least likely. The smaller paper probably has a small, overworked staff and is glad to receive well-written and interesting releases which it can use verbatim. The larger paper will receive many more releases and also probably has a much larger editorial staff to do the writing. The same is true for a magazine—the larger its circulation, the less likely it is to use your material. Look over some issues to see if and how the editor uses press releases. Note that if you are a regular advertiser the chances are much better that the editor will use your release.

Usually multiple copies of the same press release are made and sent to a mailing list of newspapers and magazines. The editors who receive the release reject it or use it in whole or in part just as it is written or alter it slightly to fit their purpose.

You will find out rather soon which ones are likely to use your releases and which are not. You may develop your own editorial contacts, getting to know some editors personally and developing a good working relationship with them.

Newspapers and magazines which cover the same territory on the same basis may be disturbed by the fact that their competition has printed exactly the same story or photograph. Therefore, for competing publications it is a good idea to send different releases and be sure to send different photographs.

FEATURE STORIES

Every newspaper prints a certain amount of timely news stories; the remainder is filled with a variety of "feature stories," interesting stories which could appear any time. Often these come to the newspaper by way of a press release. The editor may have found a particular release of interest and followed up on it asking for more information.

You might be able to get a local newspaper to print a story about you. Editors must fill up the space devoted to features and you might make a

good one. Sometimes releases will serve as an introduction, but if an editor does not approach you, there is no reason why you cannot seek him out.

To reach an editor, write a *brief* letter describing yourself and giving your idea for a feature story. Enclose a copy of your resume and a recent press release if pertinent. (You should also enclose a self-addressed stamped envelope.)

If you get no reply after at least two weeks, you could write a second letter. If the newspaper or magazine is a local one, you could say in your first letter that you will call at a specific time or at the editor's convenience. Be sure to call when you said you would to follow through.

It is best to approach one newspaper at a time. Editors do not like to see the same feature repeated immediately or scooped by their competition. You should guarantee without being asked some degree of exclusivity to the editor; once a story is done by one newspaper, wait a while before approaching another.

If you can supply an approach, a central idea for the story, or a theme which is especially timely or exciting, then the editor may very well be interested. In looking for an angle, ask yourself what it is about you or your work that would be of most interest to someone who knows nothing about it. What questions do customers ask you about your work? Does it fit in with a current fad? What about its historical importance? Is what you do somehow related to what the colonial forefathers did? Do you use clay from the same local pits that early settlers discovered and began using?

When you cannot think of a specific angle to suggest to the editor, you might tell your story briefly and ask him or her what angle he feels would be of greatest interest.

If you are successful in your first attempt at approaching an editor, consider yourself very lucky. If you are not successful, keep trying. An editor may promise to file your material in his "active" file until he gets a chance to use it. If so, continue to send press releases as appropriate in order to keep his information up to date, and of course to remind him that it is there.

If the editor decides he would like a story on you, you will have to supply further information. He may send a reporter to interview you and write the story, or he may say that he will consider a feature story submitted by you about yourself. Usually you will get no guarantee of acceptance—merely the guarantee that he will look at your story.

If you are writing the story yourself, you should first get down the main facts you wish to present, perhaps in outline form. Then you can

proceed to write the story, keeping your language simple and your presentation brief and logical.

In a feature story human interest dominates. Unlike a press release, this can be as lengthy as the subject matter allows. If you have a chance to choose which products the story will feature, choose your best sellers. Maybe the editor will prefer something more radical or outstanding or different; you will have to go along with what he prefers.

If you do not feel that you are capable of doing a good job of writing the article, consider paying a free-lance writer to do the story for you. The editor will be grateful if your writer does a professional job since it will save editing and rewriting time. To accompany your story, the photographs mentioned earlier will be invaluable.

In addition to the satisfaction of having a feature story about you printed, keep in mind that you want to use this free publicity to sell your products. If the story helps your image or that of your products, it can help sales. When it describes your products and lets potential customers know where they can purchase them, it can be very effective. If your products are sold in local shops or galleries, be sure to say exactly where they can be bought. However, before you give the name and address of a particular shop or gallery, be careful to get the permission of the buyer or manager of the store; he will be very glad you asked, even if he cannot give permission.

Timing can be important. The article should mention products now available or an event to happen soon. If there is no place the reader can send to or go to buy your product, the opportunity is lost. Such opportunities do not come along as frequently as you like, so use them wisely. But bear in mind that this timing, though important, is something which you cannot control. The editor decides when he will use a story and may delay for weeks or months while you wonder what went wrong.

When you are seeking publicity you can make no demands. You can only supply what the editor requests and hope he will use it. Often exactly what is used is beyond the control of the editor with whom you are dealing. Many decisions are made in putting together a magazine or newspaper and some material is necessarily eliminated. Do not be discouraged if you are not successful immediately. Well-placed publicity can be so valuable that it is more than worth the trouble of obtaining it.

SPECIAL DEPARTMENTS

Another way to get publicity is to look for special departments and sections of magazines which show the work of artisans. Some magazines

print the photographs and give credit to the artisan who made the item, and some will pay a fee to the artisan for using his work.

One magazine that reproduces photographs of reader's work is *Sunshine Artists,* which uses photographs throughout the magazine as well as on the front cover. They have a page called "Le Gallerie," which shows paintings and drawings, and another page called "Caravan of Crafts" shows the work of outstanding craftsmen. Any requests for information from galleries or shops are passed on to the artisan in question.

Another magazine which prints photographs of one-of-a-kind artistic handcrafted items is the *Artisan's Gallery.* This magazine asks readers to submit black-and-white photographs of their outstanding work. From those photographs submitted, a jury of editors chooses those to be reproduced.

Some general craft magazines also reproduce photographs of readers' work. *Creative Crafts,* an excellent general how-to craft magazine, has photographs of readers' miniatures, eggs, and dolls, from time to time. *Stitch and Sew* has a section called "Readers' Handiwork," and *Popular Handicraft and Hobbies* a column called "Handicraft Highlights." In these sections photographs of handcrafted items are reproduced with several paragraphs of descriptive text. If the craftsperson is willing to sell such items, this is indicated in the text. Some artisans state that a price list is available on request so that interested readers can send for it.

WHICH PUBLICATIONS?

When you are looking for publications that might be interested in using your press releases or a story about you, your business, or your product, you will find that there are many possibilities. The first step is to look over several copies of the magazines or newspapers you might think might be most interested. If they carry feature stories about artisans like yourself (or look as if they could), they might be a good possibility.

Begin by checking the newspapers and magazines you yourself read. Then look on local newsstands and in the library. You may be surprised by how many publications serve your area. The more local the publication, the better the chance it will use your story. In addition to magazines that specifically focus on art and crafts, there are a great number of magazines which have occasional articles on artists and craftspeople. In this category look especially at regional, state, and city-oriented publications, as these often have feature articles on local artists and craftspeople and may be interested in you as a local celebrity. Do not overlook the magazine section or Sunday supplement that comes with your local newspaper.

Regional publications which emphasize local color might be interested in you if your art or craft has a long tradition connected with the area. An excellent source of information on regional magazines is the *Writer's Market,* which is published annually by *Writer's Digest* (Cincinnati, Ohio 45242). Many libraries have this on their reference shelf.

If you live in New England, take a look at *Yankee Magazine.* It has a special column called "Small Business & Crafts," which covers small art and craft businesses like your own. You can write the story yourself or find someone who likes to write to do it for you—it need only be three or four paragraphs long. Be sure to end it with your name and address so that interested readers can contact you. Send with it some black-and-white photographs or color slides to Damon Ripley, c/o *Yankee Magazine,* Main St., Dublin, New Hampshire 03444.

If you live in the Ozarks, you should be reading the *Ozarks Mountaineer.* This has a regular column called "Ozark Arts and Crafts" which frequently features specific artisans. The magazine often has articles on art and crafts of the Ozarks, and also covers specific festivals and shows occurring in the area. If you do something that might be of interest to this readership, write to the editor, Mr. Clay Anderson, in care of the magazine (Branson, Mo. 65616).

Some general art and craft magazines carry articles on artisans telling about their work, often with emphasis on the methods. For example, *Creative Crafts,* which concentrates on how-to articles, might include in an article information about the artisan who did the work under discussion. Often there are photographs of the artisan at work as well as of completed items. Magazines on a specific art or craft frequently feature artisans. (A listing of art and craft magazines appears in Resource Section E.)

Magazines which emphasize marketing like *The Working Craftsman* might be interested in an article on your successful marketing efforts. Other types of magazines to check into are the historical and antique magazines; *Early American Life* often features early crafts and the contemporary artisans who practice them.

There are also a large number of other publications which you may be almost unaware of, even if you have copies in your own home. Some are company publications. If you or someone in your family works for Western Electric, you probably receive *WE* magazine, which is published for employees. Look it over and note the articles about employees and their families who do special art and craft work. There are many other unexpected magazines which you may not know exist until you begin to hunt for them. Look for these unusual magazines in the *N. W. Ayer Guide to Publications and Periodicals* or in the *Writer's Market.* (Most

likely your local library has a copy of one of these in the reference section.)

USING PRINTED PUBLICITY

Once you have been able to get a newspaper or magazine to print a story about you or your business, make this publicity really work for you by having copies made of the articles and distributing them to anyone who might be interested. This is called "remerchandising" the publicity; it is a very common practice and an excellent idea.

Cut out a copy of the article neatly, plus the name of the paper and the date of the publication as printed in the issue from which you are cutting, and have copies made. If you will not be using too many copies make them yourself on a copy machine; in volume it is cheaper to have a printer make them. A printer who does offset or photocopy printing can make as many copies of the article as you want. Don't forget that the more copies you have made, the cheaper they are per copy.

If you have had several articles printed you can have them done on one sheet. Glue them carefully to a background so that they are arranged attractively. The printer can then copy them, reducing them if necessary but still keeping the type legible.

Use the copies whenever you can. Every time you send out a payment or a bill you can include one. Send them out with your new price list or an announcement of a new product. Make a special mailing to customers on your list who have bought from you in the past.

Publicity clippings are more valuable than advertising. Anyone can buy space, but to have a story or photo in a magazine or newspaper the editor must have felt your work worth the space. Also you will tend to get more of a response from readers from a publicity story than from an advertisement in the same publication. Often the two are combined quite effectively: the feature tells about you and what you do, and the ad gives sales details.

RADIO AND TV

While the main focus of your attempts to get free publicity may be newspapers and magazines, do not overlook other media like the radio and TV. Tune in your local radio and TV stations and analyze the type of programs being presented. What possibilities do they offer? When you listen to an interview program, ask yourself whether it would be a good one for you to appear on. If so, note down the name of the interviewer and write a letter directly to him or her.

Begin your letter by saying that you listened to his program and

thought that he might like to interview you on a future one. If you have a specific theme or subject to suggest, you can discuss this very briefly. Enclose a copy of your resume. If you have had stories about yourself in newspapers or magazines, enclose copies. After reading over the material you send, the interviewer will have a good idea whether you would be a good subject for his program.

If he runs a daily or even weekly interview program, he should be on the lookout for good prospects—interesting people his audience would enjoy listening to. After reading over what you have to say, he can probably tell right away whether you would be a good subject.

Don't be nervous about going on an interview program. If it is a radio program, you will find yourself wondering, Am I really on the radio? You will sit in a rather unimpressive studio alone with the interviewer, a table between you, and a microphone in front of each. Through a glass panel you will see a technician giving signals to the interviewer as to when to begin, when to identify the station, and when to break for commercials.

If the broadcaster is good at his business he will put you at ease right away. Most likely he will ask you to be in the studio at least fifteen minutes before the program begins if it is to be live and informal. He will discuss briefly with you what points you might cover.

Some programs are more formally structured, but most interview programs are done impromptu. The interviewer may have a list of questions in front of him or just a few notes scratched out on his pad. If you have been able to supply some material in print beforehand, he will have read it over carefully looking for likely subjects to discuss.

Once the interview starts, you will relax and talk to him as if you were having a discussion with a friend. If he does a good job in drawing you out, you will have an interesting discussion and the time will fly by so fast you will hardly believe it when the interview is over.

Being interviewed on a TV program is admittedly a more harrowing experience. With the camera and hot lights trained on you, it is hard to forget that you are being filmed. But again, if the interviewer is skilled, you should get involved in the discussion and forget yourself.

After the interview be sure to write a brief note thanking the interviewer for having you on the program. Perhaps in a few months or a year or so you might want to contact him again. If you have a new angle or subject, or a different approach, the interviewer might well want to have you on the program again.

After you have been on one radio station you can of course be on others. But it is a good idea to wait a month or more before scheduling

another interview at a station in the same broadcast area. Each interviewer is trying to give his listeners new, interesting, and different material. He will not appreciate it if a competitive station has the same material at nearly the same time.

OTHER POSSIBILITIES

Opportunities for publicity abound. You will find many if you just start looking for them. When you are shopping or doing other errands, stopping at the library or bank, be aware of the publicity other people are getting through displays, posters, fliers, etc. Read over your local newspaper looking specifically for publicity about other artisans.

Once you develop a critical eye for spotting publicity possibilities, you are on your way to obtaining them for yourself. Depending on how far you are willing to travel, you will find numerous opportunities for gaining publicity through displays and lectures.

DISPLAYS

There are many public places in which you can arrange a display. Seize every good opportunity to have your work exhibited. Libraries in your area may be anxious to feature your work, especially if the librarian feels that it would have an informative or educational aspect. Some of the books from the library's collection about your art or craft could be added to the display of your items.

To schedule a display, ask to speak to the head librarian. Explain to him or her what you have to display and when your items would be available. Usually the library has a display case and a schedule of exhibits. Before leaving the library, look over the display area so you can bring whatever best fits into the available space.

In addition to libraries, there are museums, banks, real estate offices, hotels, theaters, and other business establishments, all of which may be willing to have displays. Become aware of what is being shown in these public places and ask about space that might be available.

Read the local newspaper carefully. If you learn that another local artisan has his work on display at a local bank, go to the exhibit and see if yours might not be similarly displayed. If so, ask to speak to the person in charge of arranging the display and suggest this to him. Hotels or motels sometimes have an arrangement whereby local artists and craftsmen can show their work. If no local hotel or motel in your area does this, try suggesting it to the management of one. The hotel profits by having its walls attractively decorated. Also displays draw people into the hotel, especially if there is a different set of works each month, making the lobby an attractive and interesting place to visit.

Ruth Wilson, the water colorist mentioned earlier, says that corporations sometimes allow displays in their cafeterias or hallways. Employees or visitors may see your work and contact you. Another good location Ruth suggests is hospitals—particularly in the administrative area. "Real estate offices are especially good," she says, "because people who are visiting there are buying a new home and may find a piece of your work just what they need to decorate it.

"Theaters are another possibility and a very good one," she claims. "People who go to plays are usually interested in creative and artistic work of all types. Cinemas are also a good possibility if they have an appropriate lobby. Keep your eyes opened for other possibilities. Look for windows downtown where you might exhibit, where your work would not conflict with the products or services offered by the business but instead would add to the appearance of the establishment."

Each item in your display may be marked with a price or a "Not for Sale" sign, unless you prefer to have a price list available to anyone looking at the exhibit. Each item then would be numbered and the prices given on the list. So that interested people can contact you directly, you might hang up a discreet sign: "For information call..." with your name and phone number. Otherwise you can leave business cards which passers-by pick up. Be as professional in your approach as possible, and ask the manager if one of these arrangements would be possible.

One word of caution as far as displays are concerned: be sure your work is covered by insurance. Ask the manager of the hotel, restaurant, bank, or whatever, where your work is to be shown whether his insurance will cover it. If not, be sure you have the insurance yourself.

Speak with a local agent about insurance. Ruth Wilson says you should try to get the insurance for $100 or under per year. In emphasizing the need for such insurance, she mentioned a painter she knows who had $3,000 worth of paintings on exhibit at a local restaurant. It burned down and neither the painter nor the restaurant had insurance on the paintings so they were a total loss.

LECTURING

Local groups are always looking for speakers. If you can present an interesting program showing some of the items you sell, many groups will be more than happy to have you come. Often a group is willing to pay a speaker for a well-prepared talk or demonstration if it is informative—not just a showing of the artisan's products.

You might be able to work up several different programs using what you make and sell. Find a subject or title which lends itself to your business. For instance, you could talk on "How to Decorate Your Home

with Paintings'' (or Handcrafts, etc.). Or you could talk about being in business for yourself, giving humorous incidents and interesting details.

To illustrate your talk, take along your products. Try to arrange it so that you will be allowed to sell these and to distribute literature after your lecture.

Speaking to a group can be done free or you can charge a fee. If you are primarily trying to sell something or bring people to your shop or gallery, you may have to do your lecturing free. However, if your lecture is mainly informative and the free publicity is a side-line, then you are quite justified in charging a fee. Women's groups and garden clubs usually have a budget for lecturers; so, quite often, do church- or synagogue-related groups.

Local libraries frequently arrange small lectures and demonstrations, and with some merchandise and an informative talk, you will probably be welcomed. Usually they do not pay, although some libraries have a special fund for lectures and demonstrations.

If you do charge you will get fewer jobs of course because some groups like girl scouts, 4H, and senior citizens may have no budget to pay lecturers. You must weigh the benefits with the time you have available. If the group cannot pay, but the publicity and possible sales might warrant your going to lecture, then you would do well to take on the task.

Chapter Four

Legal Aspects

When you decide to start selling your products, you have decided to go into business. While you may find the business and legal worlds very frightening, nonetheless you have entered them and must now learn to cope with their requirements.

At the very beginning, you should realize that you are not alone if you feel confused by what is necessary as far as sales tax, income tax, insurance, copyrights, etc., are concerned; there is professional help available. You may not need this help immediately but when the time comes do not hesitate to seek it. Of course, such help usually costs money. It can nevertheless be more than worthwhile if it helps you when you are in trouble, or better yet keeps you out of trouble to begin with.

This chapter will alert you to some of the legal questions and the next will discuss financial requirements in general. At some point you will need more specific assistance, and here it makes good business sense to seek the help of an expert. The fee you pay for his or her professional services will be more than worth the saving you realize in time, effort, and worry.

Also, mistakes can cost you much more than the fees you would pay to one of these professionals to keep you out of trouble. As Peter Weaver, in his book *You, Inc.,* says:

> Some people who want to go into business for themselves claim they can't afford to buy consulting services from lawyers, accountants and other professionals. I say you can't afford *not* to pay for good professional consulting advice. I suppose you could afford to "go it alone" if you're independently wealthy. You'll get an education out of your own mistakes but it will be costly.*

YOUR LEGAL STRUCTURE

One of your first decisions is the legal structure of your business. Perhaps you were not even aware that your business had a legal structure. If this is the case, then most likely you have what is called a single proprietorship. There are two other common possibilities, a partnership and a corporation.

*Peter Weaver, *You, Inc.* (Garden City, N.Y.: Doubleday, 1973), p. 210.

Each of these legal structures has its benefits and problems; if you know something about them all you can judge which is best for you. Even if you intend to consult a lawyer about the best business structure for you, if you have a little background on the subject you will be better able to ask pertinent questions.

The single proprietorship is of course the easiest business structure to set up, and it has many advantages for someone just starting out in business. It needs no government approval and requires no legal work. You merely open your door to business and make your business income part of your personal income for tax purposes. There are usually a few requirements to fulfill. You should get a license to collect sales tax if it is collected in your state, and also check if you need any other licenses to operate a business in your area. The sole proprietorship has disadvantages—the main one being liability. You are legally responsible for everything and can be sued personally for business debts for whatever you buy or contract to do. If you are sued for business debts you can lose your savings, home, car, stocks, etc., because under the single proprietorship your business and private affairs are treated as one.

With a small crafts or art business, the likelihood of your being sued is minimal; therefore you will probably remain a single proprietorship. Be sure to take the proper precautions, including insurance and the correct labeling of your product which must include how to use or wash it, and any precautions that are necessary.

As a sole proprietor you will operate your business under your own name. If you want to do business under a name other than your own, then you must register this name with the county clerk's office. Even if you are going to use your own name with a word after it (David H. Wilson Associates, for example), it must still be registered. Of course, you can also register a name that has nothing to do with your own, for example, the "One-Eyed Cockatoo." Note that you must not use the word "Incorporated" or "Corporation" in your name if you are not incorporated.

Registering the name of your business is a simple, inexpensive procedure, which you can do on your own without the help of a lawyer. Call the county clerk's office (look in the phone book under the name of your county) for details.

The clerk makes a search in the county records to be sure that the name you have selected is unique in your county. There may be other businesses in other parts of the country with the same name, but that does not matter. Of course if you try to register as "General Motors" or "IBM," you are not likely to succeed.

Once you have registered the business name, the clerk will give you a certificate for that name. You can then go to the bank and open up an account in the name.

PARTNERSHIP

The partnership is the easiest structure for two or more people to use if they want to go into business together. The partners may sign a partnership agreement; but a written document, while advisable, is not necessary, as an oral agreement can be equally effective. Actually, a partnership can be implied in the actions of two or more people even if no oral or written agreement was made.

A partnership does not mean everyone's contribution must be equal. You can set it up any way you want, and have each person contribute as much time, work, or money, as desired; each can receive profits in whatever manner you wish to distribute them.

But one thing in a partnership that is equal is liability. Even if the partners do not divide the profits equally, they are all responsible for any debts of the partnership. If one or more of the partners cannot pay his share of a claim against the business, the total assets of any other partner can be attached.

Therefore you are fully responsible businesswise for everything your partners do. When partnerships work, they can be an excellent way to carry on business; if they do not work out, it can be as messy as a divorce.

An alternative to the general partnership is the limited partnership, which is more complicated to set up. A written contract must be filed with the proper state official. The contract can limit the liability of one or more of the partners to the amount they invest, but at least one person must be a general partner and therefore generally liable.

As far as taxes are concerned in a partnership, each one is taxed separately on his income or share of the profits from the partnership.

The name of your business with one or more partners can be simply the names of the partners (for example, "O'Keefe and Creedon") or a completely different name. In either case it must be registered with the county clerk as explained above for a sole proprietorship.

THE CORPORATION

The corporation, the third common type of business structure, is more complicated in time and money than the others because it requires filing fees and is usually set up by a lawyer. A corporation has a variety of advantages, the most obvious being that once your business is incorporated you can no longer be sued personally for business debts. In addi-

tion, the assets of the corporation are beyond the reach of the creditors of any individual who is part of it.

A corporation is an artificial person, an entity separate from the individual(s) creating it; it is this artificial person that is totally liable for the contracts and debts of the business. If someone sues, or the business fails, only what is owned by the corporation can be used to pay off creditors. The personal wealth of the people who set up and run the corporation cannot be touched. As long as business is done in the name of the corporation, only it can be held liable.

Since your business is likely to remain fairly small, if you wish to incorporate look into the requirements for having yours considered a "Sub-Chapter S" corporation. In this case while the business is actually incorporated, and the personal assets of the manager safe, the business is treated as an individual for tax purposes. One aspect of the Sub-Chapter S you should be aware of is Section 1244, which may be of great interest to you if you are setting up this type of corporation. This allows you to insert into the minutes of the first meeting specific language which states that if the business loses money and fails, you can deduct the money you lost from your regular income. If this is not inserted, and the corporation loses money, you can lose your initial investment but cannot claim any tax loss.

Forming a corporation is not in fact a complicated process for a lawyer, and the cost is usually about $300-$500. If the lawyer asks for more, shop around for one who will charge less. The paperwork and legal responsibilities in running a corporation are such that working with an accountant and a lawyer may be virtually unavoidable.

The corporation is subject to many state rules and must conform to a variety of requirements. It must have a minimum number of stockholders and is required to send in reports on stockholders' meetings. It must have a certain number of directors with specific powers. If you are running the corporation yourself, you will likely have family members as stockholders and directors, and your meetings can take place over the kitchen table.

The corporation offers certain tax advantages which an accountant can help you to use. Furthermore, the corporation is virtually immortal, and not limited to the availability of the proprietor or partners. The administration is quite adaptable, so your business can be sold and still go on with the same name, servicing the same customers.

Another advantage of a corporation is that you as part of the corporation will be eligible for Workman's Compensation. Since disability income protection insurance is expensive and difficult to get privately,

this can be an important benefit. In almost every state (New Hampshire is the exception), incorporation is necessary for eligibility for Workman's Compensation.

One of the main reasons many businesses decide to incorporate is to attract additional capital. The corporation is in the best position to attract capital because it can sell securities or stock and attract a wide range of investors. Most art and craft businesses do not grow to need such funding, but if they should, the provision for funding is there.

When you start out you can operate well as a single proprietorship. If you pay your bills promptly and do not take on any large debts, you should be fine. Many businesses start as single proprietorships because this is the simplest approach and the most advantageous arrangement when you are in a fairly low income bracket. However, as your business expands you might want to consider incorporation.

LAWYERS

When you are just starting to sell a few of your items, you will not need the help of a lawyer; as your business expands to the point where you are hiring employees, though, you may need professional advice. When you do need such a person, if you have a competent and sympathetic lawyer at hand you will find his services more than worth what they cost.

Your lawyer can advise you of your legal obligations and will hopefully spend a great deal more time keeping you out of trouble than helping you defend yourself or sue anyone else. One of his main functions is to interpret the law; he will know what your obligations are as a business person in your particular area, and what governmental regulations (federal, state, and local) pertain to your business. He will know about zoning and whether you need permits for the type of selling you intend to do. Your municipality may demand that you have a vendor's permit if you are selling directly to the public. The city or town may also have a business tax. The state may have a sales tax, and of course the federal government has rules for you to follow.

Your lawyer will also assist you by explaining contracts, leases, and other agreements before you sign them. He will help you to prepare contracts of your own if necessary and will check them carefully. He should read over a lease from your landlord, for example, and discuss it with you so that you fully understand what you are agreeing to before you sign. If you do get sued by anyone, he will defend you; and if you want to sue someone else, he can represent you.

If you are not acquainted with a lawyer and feel you want to consult one, ask fellow artisans to recommend one. Your banker and accountant

are also good sources for recommendations. In arranging for your first visit, be sure to ask what the consultation fee will be and how much time you will be given for that fee.

VOLUNTEER LAWYERS

But what if you need the services of a lawyer and simply cannot afford them? If you live near one of the groups of volunteer lawyers for the arts, you are in luck (these are listed in Resources Section A). When you have a problem, just call the one nearest to you. If you do not live close to any, contact the nearest one and ask for advice.

The lawyers in these volunteer groups have given many hours of their time to help artisans and craftspeople, both those who make one-of-a-kind gallery items and those who work on a production basis. One such group is the Volunteer Lawyers for the Arts (VLA), a New York-based non-profit tax-exempt organization, which was founded by three attorneys in 1969 to deal with arts-related problems. The lawyers who provide all the legal help are volunteers, but the VLA has a small paid staff and pays operating costs with funding from the New York State Council on the Arts, the National Endowment for the Arts, foundations, and individual contributions.

The VLA functions as a sort of "Legal Aid" for artisans of all kinds, providing direct legal representation both to individual performing and visual artists and craftspeople, and to groups. It also provides a wide range of other helpful services of nationwide interest which help artisans indirectly.

If an artisan or group of artisans comes to the VLA for help, the first requirement is that the legal problem must be closely related to his or its artistic pursuits. The VLA asks the individual or group to put the request in writing, including information on income, background, and the specific problem for which help is needed. The VLA determines eligibility, then refers the case to one of the volunteer lawyers on its list. Now the ordinary client-lawyer relationship is established, although no legal fee is ever collected.

To qualify for free assistance the artisan must be unable to afford adequate legal services. The standard of neediness might be extended up to the artisan who is earning as much as $8,000 a year. Non-profit groups are also eligible for free assistance.

The volunteer lawyer works directly with the individual or group and the VLA staff monitors the progress. The lawyers handle a wide range of matters, including incorporation, drawing up contracts, negotiating leases for studios, theaters, and halls, securing tax exemptions, copyright

application, and general counseling on copyright, tax, labor, immigration and other arts-related problems. Often a lawyer starts by helping a new organization and stays with it as it grows.

In addition to direct legal representation, the VLA provides a variety of other services, mainly educational. In the course of helping a variety of groups and individuals, the volunteer lawyers found that many of the problems they were encountering could have been avoided if the individual had understood his rights or the implications of his conduct in advance. The VLA has now been trying to get this information across to artisans generally.

The VLA sponsors seminars on arts-related law for audiences of artists and administrators of art groups. It also arranges to have volunteer lawyers address audiences of artisans on given topics upon request. It has been assembling a central research facility where practicing attorneys can come to do research. Above all, it has worked to make lawyers in general more aware of the type of problems encountered by artisans and art groups, and to help them by providing the information necessary to deal with these problems.

The VLA has served as a model project, counseling groups in other cities to set up similar organizations so that legal help for artisans will be available all over the country, and legal information can be collected and disseminated on a nationwide basis. It also has a legislative research and consultation service, which helps both individuals and groups to review the relevant existing legislation if they wish to draft bills for legislative consideration. The VLA has gotten volunteer lawyers together to draft model contracts. It has a newsletter to keep volunteer lawyers and others up to date on arts-related legal and tax questions, to disseminate information about books and publications on related questions, and to give information about events and activities of interest.

Finally, the VLA works on publications to help artisans avoid legal pitfalls. It has already published—in cooperation with the Art Committee of the Association of the Bar of the City of New York and the Associated Council of the Arts—a book called *The Visual Artist and the Law,* put together by a group of VLA lawyers, which provides basic information about the rights of the artist. New publications on tax, accounting, and insurance are to follow.

In preparing this chapter, I interviewed volunteer lawyer Harry Devlin of Pettit, Higgins and Devlin, a law firm in Westfield, New Jersey. Mr. Devlin has been very active in the field of the artist and the law. He says that the services of the volunteer lawyers will be free to you if you cannot pay, but if you can pay then you will be charged on a favored basis, that

is, you will pay a much lower rate than the lawyer usually charges. He very kindly donated his time so we that could talk about the artisan and the law.*

Mr. Devlin has some general advice for you: "If you want to go into the business of selling your work, you must realize that you are going into *business.* You will face all of the accounting and taxes faced by the businessman. You must learn to act as a businessman and conduct your transactions in a businesslike manner." He adds, "This does not mean that you have to become callous, but rather that you must come to terms with the realities of the business world."

I asked Mr. Devlin one question artisans often put to me: How does local zoning affect their business? You may be wondering, if you work in your home and it is a residential area, whether you are breaking any local ordinances. As long as you are zoned for business, there is no problem.

If not, Mr. Devlin says that the crux of the matter is whether you are creating a nuisance in the neighborhood. With a kiln or other large piece of equipment you may need a permit. If you have noisy equipment and use it on a regular basis you may be creating a nuisance and may not be allowed to work in your home. But as long as you have a quiet business and disturb no one, in most areas you will not have any problem.

I asked Mr. Devlin what was the most common problem artisans brought to him. He said that it was collecting money owed to them, because often craftsmen and artists are trusting people, and leave their merchandise on the promise that it will be paid for. When it isn't, what do they do? If the amount is small, they may write it off as a bad debt; if it is large, they cannot afford to do so. To avoid this situation, Mr. Devlin suggests you keep the possibility in mind and work on a cash on delivery arrangement as much as possible. You may lose a few accounts this way, but most likely these would be the ones from whom you would have trouble collecting anyway.

He adds, "You must realize in dealing with shop owners that you are dealing with people who want to buy as cheaply as possible and sell as expensively as possible. As friendly and as nice as the retailer may seem, it is better not to work on trust but instead to conduct your sales in a businesslike manner, filling out all of the necessary forms although they may seem like a nuisance."

If you think you have a case against an individual or a company but do not have the money to hire a lawyer, you can seek the help of a local volunteer lawyers group. If you have no local group, consider looking for a

*When this chapter was completed, he also checked it for accuracy.

lawyer to work "on contingency." This means that you pay him no fee whatsoever unless you win your case. If you do, then you pay him a certain percentage (maybe 25% or more) of the amount you have won in damages, whatever percentage you both agreed on beforehand. And if you lose, the only fee you might have to pay is the court fee—which is not too high (for example, a state supreme court fee might be $60).

In looking for a lawyer to handle your case "on contingency," Harry Devlin suggests that you shop around. If one lawyer refuses, ask another. What you hope to find is a lawyer who is interested in the type of case you present. Of course, if you are trying to sue for a very small amount your chances of finding a lawyer are slim. In that case you can go to court without a lawyer.

SMALL CLAIMS COURT

If you have a reason to sue someone but the amount is not large enough to tempt any lawyer to take your case "on contingency," you do have an alternative that many people are unaware of: the small claims court.

Small claims courts were set up early in this century to allow the individual on his own to get justice as quickly, fairly, and cheaply as possible. The amount you can sue for is limited usually to $1,000 or lower, although in some states the limit is higher. No lawyer is involved; only the plaintiff, who is making the complaint, the defendent against whom the claim is made, and the judge, who listens to each side and decides on the matter. As a plaintiff, the cost to you is very small. If you have a good case, you have a fair chance of collecting your money.

First, you must translate your claim into cash. If a shop has refused to pay you for items which it took on consignment and you know the value of those items, you can sue for this sum. However, if for example a company has stolen your original design, you must assign a reasonable value to this design.

Before you go to court you must give the defendent every opportunity to settle with you. First, you should try telephoning; when you do so, be sure to note down the time and date of your call. If this does not work, write a letter stating the case and what settlement you want from the defendent. Be sure to make several carbon copies of this letter and send the original by certified mail with a return receipt requested (this is easy to do—just ask the clerk at the post office).

If your first letter does no good, write a second explaining that you intend to sue. If you still get no response, go to the county court house to the clerk of the small claims court. Give him all the information, includ-

ing why you are suing and the amount you are asking. You will pay a small fee (probably less than $5) to cover the summons, which is often delivered personally by the sheriff. You will also get a docket number to identify your case and a date for the trial.

Come to the trial prepared with all the documentation of your efforts at settling the case out of court. Be as brief and clear as possible. Perhaps the defendant will propose a settlement before you come to the actual trial, in which case you may settle without coming to court. If he offers a settlement and you refuse, be prepared to explain your refusal to the judge.

After listening to both sides, the judge may either make a decision immediately or reserve judgment (then the decision will be sent to you in the mail). If you win your case, you still may have trouble collecting the judgment. If letters and phone calls do not work, you may have to return to the clerk and have a "writ of execution" issued, which gives the sheriff the right to attach property or garnishee wages. Each state has different procedures, but this is generally how a small claims court works. If you do have a problem, try to let the court work for you.

PROTECTING YOUR CREATIONS

There are three basic forms of legal protection which you can get for what you have created: trademarks, patents, and copyrights. It is important to distinguish between them so that you know what benefits each offers and which you need in a specific case.

Each one is designed to protect a different type of creation, the procedures for obtaining each are different, and the cost involved varies. While you may at some time or other be interested in obtaining a trademark which protects a name or a symbol, or a patent which protects an invention, there is a much greater chance that you will be involved with copyrights.

Copyrights are most often thought of only in relation to printed work in books and magazines, but they can be obtained for a variety of other work. Ideas are no one's property; it is their expression in words or diagrams that can be copyrighted.

If you are a production craftsman who spends many hours designing new items for your line, you might consider getting a copyright to protect your new designs. In contrast, if you produce one-of-a-kind items, consider that these could be photographed and reproduced on stationery. Maybe you would like to copyright a new piece to protect your work.

The cost of registering a copyright is much less than that for obtaining a trademark or a patent. Copyrights differ significantly from trademarks

and patents, and it is important to realize and appreciate these differences.

When you get a patent or a trademark, these are searched out, that is, your creation is compared with all pertinent ones on file. Therefore when yours is granted, it is an assurance that it is unique. No such search is made for a copyright. When you copyright your creation, you are merely getting a formal registered notation of the date on which you disclosed, published, or made public your work.

A copyright is filed with the Copyright Office which is part of the Library of Congress in Washington. It is effective for twenty-eight years and can be renewed for an additional twenty-eight years. Registering a copyright is an easy, inexpensive process. You do not need a lawyer as in the case of a patent or trademark. Write to the Copyright Office for the form, fill it out, and send it off with two copies or photographs of the work to be copyrighted.

The purpose of a copyright is to protect composers, authors, and artisans from any unauthorized use or copying of all or a substantial part of their literary or artistic work. Limited copying is allowed by the rule that allows for "fair use" of copyrighted works—as in the case of a book reviewer who quotes a few sentences from a book he is reviewing. This principle mainly applies to written works; but it can apply to art or craft work—for example, when a reproduction of a painting is used in a review of an artist's work.

It is only the artistic content of the copyrighted work that is protected. Anyone can use the same source material and give his artistic impression of it. Without violating a pre-existing copyright, anyone can paint or photograph the same scene, such as the New York Skyline, for example. In the same way, anyone can use the same underlying theme already used in a copyrighted work and not infringe on it. Thus anyone can write on the subject of selling what you make, and not infringe on my copyright.

Titles of works are not normally protected by copyright (for some, obtaining a trademark is appropriate). In addition, functional items with no artistic value cannot be copyrighted. Their operation might be patented, however.

In order to get a copyright, you must classify your work into one of the thirteen classes of copyrightable works. When you request the form, it is by the letter code of the classification. Some of these overlap so that in certain instances you may have a choice as to which class or category your work would fit. If you should select the wrong classification, this does not affect the protection of the copyright secured.

The categories are: A—published book, B—periodical, C—lecture,

D—dramatic composition, E—musical composition, F—map, G—work of art or a model of design for a work of art, H—reproduction of a work of art, I—scientific or technical drawing or model, J—photograph, K—print, and L or M—motion picture.

Some of these categories are divided into subclasses. Basically you will be interested in class G, which covers paintings, drawings, sculptures, and other items usually classified as fine arts, as well as works of artistic craftsmanship such as designs for tapestries, textile fabrics, jewelry, glassware, ceramics, figurines, lace, etc. In this latter group the copyright does not protect the utilitarian aspects of the article, only the features that can be identified as a work of art.

The first step in copyrighting your work is to state on the actual work that it is copyrighted. The law stipulates that you can without permission of the Copyright Office put this notice on your work. In fact, if a work is published or republished without the necessary notice of copyright, the copyright protection is lost permanently and cannot be regained.*

The notice of copyright on the work is absolutely essential to the act of copyrighting your work. If it is printed matter, it *must* have the copyright notice printed as part of it. On a book, for example, the notice must appear on the title page or the page immediately following it. The act of publishing the work with this notice actually secures the copyright.

For a work of art, the copyright notice must be made permanently fixed to the item upon "publication." "Publication" consists of placing the work on sale, selling it, or making public distribution of it. What this means is making one or more copies of the work available to the general public without restrictions or limitations as to the use that can be made of it.

The form of the notice is exactly spelled out by copyright law and must be strictly adhered to if the copyright is to be valid. It consists of three parts: (1) the word "copyright," which can be abbreviated "Copr." or symbolized by ©; (2) the name of the owner or owners of the copyright; and (3) the year of publication of the work. The notice might read: © Matthew Holz 1976.

These three elements are essential to secure the copyright and they must appear together. They must also be legible and permanently fixed to the copy. They are not acceptable if they are too small, concealed, or appear on tags or wrappers than can be taken off the item.

The notice of copyright is more important than the actual registration of the copyright with the Copyright Office because the artist's right arises

*Associated Councils of the Arts, *The Visual Artist and the Law* (N.Y.: Praeger, Revised Edition, 1974), p. 8.

out of the proper notice on his work of art. However, to enforce the right obtained by the copyright notice it should be registered.

To register the copyright, the artisan must file an "Application for Registration of a Claim to Copyright" with the Copyright Office, and pay a minimal fee of $6. The necessary form can be obtained free from the Copyright Office by requesting it by letter (Copyright Office, The Library of Congress, Washington, D.C. 20559).

Form G, the application for "a work of art or a model or design for a work of art," is shown in Figure 14. As you can see, this form is very easy to complete because each question is explained right on it. You can complete it yourself without professional help.

Along with your completed form, two copies of the work must be sent with the application. In the case of printed matter, this is easy and inexpensive. When the work is expensive, heavy, large, or fragile, photographs are sent instead of actual copies. Note that you should never send your only copies of a work as these will *not* be returned. You will receive back only a stamped copy of your application.

Now that you know how to obtain a copyright to protect your own creation, what about what other people have copyrighted? You will know by the copyright line on their work that it is copyrighted. But you may be asking, does anybody really prosecute those who violate copyrights or are they really just used as a deterrent to discourage copying?

I talked to Mr. Clemshaw of Baker, Hostetler and Patterson—a Cleveland law firm that represents United Features Syndicate, Inc. (UFS), which is the owner of all copyrights and trademarks for the "Peanuts" comic strip by Charles Schulz. He says that until fairly recently his firm would give artists and craftsmen warnings that they would be prosecuted if they used copyrighted material without a license.

"For years the system of warning was used but it just was not effective," he explains. "Evidently artists and craftsmen and others who knew such actions were illegal thought that if they were caught, then all they would get was a warning. Since warnings were not stopping the illegal activity, now we are prosecuting cases and securing settlements of from $50 to $5,000 for copyright infringement. We have made settlements for our client both out of court and in court. We are making it hurt so that it is grossly unprofitable to pirate copyrighted designs."

His firm has sued individuals and companies in the name of UFS for infringing on its copyrights. The amount of settlement is usually related to the amount of profit the person infringing made in sales of the items in question. However, the settlement is not bound to this amount and may even be higher than the sales in question.

Mr. Clemshaw tells of several housewives in Maryland who were

Page 1 **Application**
for **Registration of a Claim to Copyright**
in a work of art or a model
or design for a work of art

FORM G	
REGISTRATION NO.	CLASS
DO NOT WRITE HERE	**G**
GF GFO GP GU	

Instructions: Make sure that all applicable spaces have been completed before you submit the form. The application must be **SIGNED** at line 11. For published works the application should not be submitted until after the date of publication given in line 6(a), and should state the facts which existed on that date. For further information, see page 4.

Pages 1 and 2 should be typewritten or printed with pen and ink. Pages 3 and 4 should contain exactly the same information as pages 1 and 2, but may be carbon copies.

Mail all pages of the application to the Register of Copyrights, Library of Congress, Washington, D.C. 20559, together with:

(a) If unpublished, a photograph or other identifying reproduction of the work and the registration fee of $6.

(b) If published, two copies of the best edition of the work (or if appropriate, photographs—see line 4) and the registration fee of $6.

Make your remittance payable to the Register of Copyrights.

1. Copyright Claimant(s) and Address(es): Give the name(s) and address(es) of the copyright owner(s). For published works the name(s) should ordinarily be the same as in the notice of copyright on the copies deposited. If initials are used in the notice, the name should be the same as appears elsewhere on the copies.

Name *Matthew Crump*

Address ...*22 Linden Place, Manchester, N.H. 03104*

Name

Address

2. Title: *"Country Boy"*
(Give the title of the work as it appears on the copies; a descriptive title may be used where the work is entirely pictorial or sculptural)

3. Nature of Work: *Stained glass ornament*
(Characterize the general type of artistic work involved, as, for example, painting, drawing, sculpture, etc.)

➤➤ **NOTE:** Leave line 4 blank unless the work has been **PUBLISHED** and photographs deposited in lieu of copies. ◄◄

4. Optional Deposit: (See information on page 4.)

Basis for claiming option (Check and fill in **ONE** of the following):

☐ Monetary value (retail value per copy) ☐ Weight (in pounds)
☐ Size (give dimensions) ☒ Fragility (give details) *glass easily broken*

5. Author (i.e., Artist): Citizenship and domicile information must be given. Where a work is made for hire, the employer is the author. The citizenship of organizations formed under U.S. Federal or State law should be stated as U.S.A. If the copyright claim is based on new matter (see line 7) give information about the author of new matter.

Name*Matthew Crump* Citizenship *U.S.*
(Give legal name followed by pseudonym if latter appears on the copies) (Name of country)

Domiciled in U.S.A. Yes *X* No Address *22 Linden Place, Manchester, N.H. 03104*

➤➤ **NOTE:** Leave all spaces of line 6 blank unless your work has been **PUBLISHED**. ◄◄

6. (a) Date of Publication: Give the complete date when copies of this particular work were first placed on sale, sold, or publicly distributed. The date when copies were made or printed should not be confused with the date of publication. NOTE: The full date (month, day, and year) must be given.

4 / 6 / 76
(Month) (Day) (Year)

(b) Place of Publication: Give the name of the country in which this particular work was first published.

(c) Manufacture Outside United States by Lithographic or Photoengraving Process: If the copies of this work were manufactured outside the United States by lithographic or photoengraving process, give the name of the country of manufacture.

United States

➤➤ **NOTE:** Leave all spaces of line 7 blank unless the instructions below apply to your work. ◄◄

7. Previous Registration or Publication: If a claim to copyright in any substantial part of this work was previously registered in the U.S. Copyright Office in unpublished form, or if a substantial part of the work was previously published anywhere, give requested information.

Was work previously registered? Yes No Date of registration Registration number
Was work previously published? Yes No Date of publication Registration number
Is there any substantial **NEW MATTER** in this version? Yes No If your answer is "Yes," give a brief general statement of the nature of the **NEW MATTER** in this version. (New matter may consist of compilation, abridgment, editorial revision, and the like, as well as additional artistic or graphic material.)

EXAMINER

Complete all applicable spaces on next page

Figure 14 (front and back of copyright application). To register your copyright send to the Register of Copyrights for Form G, fill it out, and mail it with the copyright fee of $6 and two copies of your work or two photographs of it.

8. If registration fee is to be charged to a deposit account established in the Copyright Office, give name of account:

--

9. Name and address of person or organization to whom correspondence or refund, if any, should be sent:

Name *Matthew Crump* Address *22 Linden Place, Manchester, NH 03104*

10. Send certificate to:

(Type or print name and address)

Name _____

Address _____
 (Number and street)

(City) (State) (ZIP code)

11. Certification:

(Application not acceptable unless signed)

I CERTIFY that the statements made by me in this application are correct to the best of my knowledge.

▶ _____*Matthew Crump*_____
 (Signature of copyright claimant or duly authorized agent)

Application Forms

Copies of the following forms will be supplied by the Copyright Office without charge upon request:

Class A Form A—Published book manufactured in the United States of America.

Class A or B Form A–B Foreign—Book or periodical manufactured outside the United States of America (except works subject to the ad interim provisions of the copyright law).
 Form A–B Ad Interim—Book or periodical in the English language manufactured and first published outside the United States of America.

Class B Form B—Periodical manufactured in the United States of America.
 Form BB—Contribution to a periodical manufactured in the United States of America.

Class C Form C—Lecture or similar production prepared for oral delivery.

Class D Form D—Dramatic or dramatico-musical composition.

Class E Form E—Musical composition the author of which is a citizen or domiciliary of the United States of America or which was first published in the United States of America.
 Form E Foreign—Musical composition the author of which is not a citizen or domiciliary of the United States of America and which was not first published in the United States of America.

Class F Form F—Map.

Class G Form G—Work of art or a model or design for a work of art.

Class H Form H—Reproduction of a work of art.

Class I Form I—Drawing or plastic work of a scientific or technical character.

Class J Form J—Photograph.

Class K Form K—Print or pictorial illustration.
 Form KK—Print or label used for an article of merchandise.

Class L or M Form L–M—Motion picture.

Class N Form N—Sound recording.

● Form R—Renewal copyright.

● Form U—Notice of use of musical composition on mechanical instruments.

FOR COPYRIGHT OFFICE USE ONLY		
Application received	Two copies received	Photographs or reproductions received
One copy or reproduction received		
Fee received		
Renewal		

making leaded-glass items in the figure of "Snoopy"' which is copy-righted by UFS. The women had not sold many of their items when they were caught. They hired a lawyer to defend them but lost the case. They had to pay damages of $50 as well as their own legal fees.

How are the offenders caught? Information comes in from all sources. Fans of the comic strip might write in if they see their favorite characters used illegally. Competitors of the artisan using the design might give in-formation. The law firm has arranged for paid advertisements in several ceramic and general hobby magazines warning about the illegal use of the cartoon characters, and cases have been brought to their attention through these advertisements which threaten penalties of $10 for each in-fringing item made, minimum damages of $250 for each character copied, and up to $1,000 in fines and a year in prison.

Artisans sometimes ask if it is acceptable to use a copyrighted design if the item using the copied design is made for one's own use or to give as a gift. While this use of copyrighted designs is much harder to police, it is actually illegal according to Mr. Clemshaw, because the definition of the law says that *any* copying of copyrighted material is illegal. Even if the copying is for a good cause (for a charity, for instance), it is still illegal.

Licensing of the copyrighted designs involves large amounts of money. Of course since the owner of the copyright is collecting from those who pay to use the designs, he will be anxious to stop anyone from doing it illegally. Any company that pays to use the design will be irate if a com-petitor uses the same designs without paying the large fees involved. This would be unfair competition.

Individual artisans would be unlikely to arrange a license because these are given only to major companies. The copyright holder wants to main-tain a good reputation and is concerned that his designs are used only on quality items. Shoddy goods with his designs would reflect badly on him. Therefore he licenses only to major companies and watches all uses of his designs. Licensing to small operators would not be worthwhile because the cost of negotiating with and policing all of these small operations would be too high.

The question of whether a specific design is a copy of the copyrighted one is a complicated legal matter. Mr. Clemshaw says: "Some people think that if they add one more spot say to Snoopy's back, then their design is not a copy. This simply is not so. Probably the best expla-nation is that if the design in question would be recognized by the general public as Snoopy then it would be considered a copy."

You do not have to call your design by the usual name in order to be copying. If it looks like the copyrighted design, for all legal purposes it is

a copy. Furthermore, if you use a design which someone else has copied (that is, you copy his copy) you are still liable for copying the original design.

You can recognize a copyrighted design by the copyright line giving the owner of the copyright and the date. Look for this on an item if you are in doubt. Be assured that most well-known characters are copyrighted. Walt Disney figures, Sesame Street characters, and many other types of designs are copyrighted. On the other hand, remember that other familiar stories and designs are general property which anyone can use. No one owns the copyright to the story of the three little pigs; you can use this theme in any way on any item you wish.

Financial Aspects

When you start your own business, there are a variety of free sources of information you can tap. Some of your fellow artisans may be able to answer your questions. If you do find an artisan who is quite competent in financial matters he may be willing to help, but you do not want to presume on his good will or take up too much of his time.

Another source of free advice is your banker. If you trade with a fairly small bank you may get to know your bank manager. When the time comes and you need a loan to expand your business, he can help you with this problem and also refer you to a good local lawyer and accountant.

The Small Business Administration (SBA) is run by the federal government specifically to help businesses like your own. It provides a variety of pamphlets with background information on starting a business, some of which you might find very helpful. The booklets are available from your local SBA office, which is listed in the phone book under "U.S. Government." (Some of the booklets are listed in Resource Section G in the back of this book.) Get a copy of the booklet *Small Business Administration Publications,* which lists hundreds of publications that are free or very inexpensive, and choose those on subjects of interest to you.

The SBA also offers loan money, but only to individuals whom the banks have refused. It is especially active in helping minority businesses. Further, it has organized the Senior Corps of Retired Executives (SCORE), which is a group of retired businessmen who help small businesses on a volunteer basis. This group is also a possible source of help.

Another source of information is the Bank of America, which publishes a series of booklets called the *Small Business Reporter.* Each one concentrates either on a specific type of small business or on some aspect of business operation for small businesses in general. These booklets are very well written and cost $1 each. Ask for further information at any branch of the Bank of America or write to Small Business Reporter, Bank of America, Dept. 3120, Box 37000, San Francisco, Calif. 94137.

INSURANCE
Another source of financial guidance is your insurance broker, who represents and sells for insurance companies. He can advise you on any additional insurance coverage you might need. Insurance is a complex

question and only some general ideas about it can be given here. For your specific needs both now and as your business grows, you would be well advised to speak to your agent. His advice is usually free, but the insurance you might purchase will certainly not be.

If you are working by yourself in your own home, you might talk to your agent about your homeowner's policy and consider carefully what coverage it offers you in case of fire, theft, flood, and so on. Tell him about large pieces of equipment you might need to have covered, as well as the value of raw materials and completed items you will be storing in your home. He can explain what additional coverage might be necessary; perhaps, with some minor changes, your present policy can be extended to cover the items in question.

If you are opening a boutique, as explained in Chapter 6, you may buy special temporary insurance. Check also about any additional coverage you might need when traveling to and participating in shows. Find out exactly what your automobile coverage includes. Special temporary insurance can be secured for certain situations but you may find this too costly; weigh the cost against the risk you feel you are taking, so that you can decide whether the insurance is warranted.

Should you have given up your regular employment and no one in the family has a job with group medical coverage, then you must look into the question of health insurance. Private health plans are often prohibitively expensive; group plans always less so. Several organizations for craftspeople and artists are working toward, or have already established, group plans which you might look into. They include the American Crafts Council, the New Hampshire League of Craftsmen, and the Foundation for the Community of Artists.

You should also investigate the disability income plans, which provide you with an income if you are disabled by accident or sickness. You may find it difficult to get such insurance at a reasonable rate if your business is unincorporated.

Another form of insurance you might be concerned with is "product insurance." Artisans in general do not have this, because it is mainly for items from which people could sustain injury or sickness, notably food. You might ask your insurance broker's opinion in view of what you make. He can tell you what you might pay for product insurance for your particular product and method of sale. He will explain the risks you are taking and you can weigh the cost against the possible worth of the insurance. If yours is a sole proprietorship or partnership, your risk is greater; generally with a corporation your private possessions cannot be touched by anyone trying to sue your company.

When your business grows, your need for insurance will grow with it.

If the project expands and you open a store or have employees working in your studio, you will need additional insurance. You will need owner's, landlord's, and tenant's liability insurance to cover an accident a customer might have while in your shop. In becoming an employer, your responsibilities grow and you will be required to have Workman's Compensation for your employees.

ACCOUNTANTS AND BUSINESS SERVICES

After you have tapped some of the sources of free help mentioned above and received some general information and advice, you may need more specific help with financial matters. Needless to say, the best and most reliable will be the help you pay for.

For bookkeeping and tax problems, you will need a competent accountant. This person has been specifically trained in all phases of business record keeping, especially tax law, and he or she keeps currently informed on all legislation regarding tax matters. Not only is he familiar with the legal procedures, forms, and other information; he also has had much experience dealing with finances. He may be able, after looking at your financial dealings, to point out the problems or where you might be going wrong.

He can help you to set up a bookkeeping system and instruct you on simple entry procedures. When it comes to tax time, your records then should be in order, ready for him to tabulate and enter onto the necessary forms.

Your accountant will know about those tax regulations that affect your business, and should explain them to you so that you understand. He may be able to tell you about additional legitimate deductions which you can claim, thereby perhaps saving more money than his fee.

If your business is small you may not need the aid of an accountant right away, but as it grows your financial obligations will multiply and you will need help in keeping them straight.

Perhaps the moment you most need the help of an accountant is when you are deciding whether or not to make your business a full-time operation. He should enable you to organize your finances and see them in perspective. He can then help you to figure out your minimum living and working expenses, and how you are to cover them until you begin to make enough money from your business. The decision is still yours, but he can help you face realistically what it will mean in terms of your lifestyle. Note, however, that accountants tend to be quite conservative; take this into consideration when weighing their advice. When you do need help in the form of a loan, your accountant can help you to get it by

preparing the necessary information which the loan officer at the bank will demand.

You can locate an accountant through the Yellow Pages, but a personal recommendation is usually better. Friends, especially those who have their own small businesses, can be excellent sources because you will do best if you can find an accountant who has been successful in helping others start a small business rather than one who deals mainly with big organizations. Such a person can give you the personal attention and sympathetic help you badly need. Choose an accountant with a small, unpretentious office and a small staff. An accountant with a large staff and expensive office will just not have the time to spend with small accounts. Be very careful in choosing your accountant (as I personally have learned through a negative experience with one). Do look around for someone with whom you will be comfortable; you will be baring your financial soul to him, and want to feel that you trust him personally and believe in his professional judgment as well.

To begin working with an accountant, you simply make an appointment with him; before you do so, however, it is quite legitimate to ask what the consultation fee will be. Usually he will charge an hourly rate to discuss your business with you, so have your questions and records ready. Before he handles any of your business, be sure that you understand what his fee will be.

An alternative to an accountant is a financial organization such as General Business Services, which operates a business and advisory service specifically for small businesses. This has hundreds of franchised offices around the country. Each is run by an individual businessman trained by GBS and ready to offer you, as a small businessman, the personal help you need. You can get the names of your local office in the Yellow Pages under "Business Services" or write to General Business Services, 7401 Wisconsin Ave., Washington, D.C., 20014. This organization also puts out informative booklets which you can obtain through your local representative.

In the case of both the accountant and a service such as GBS, much will depend on the particular individual you encounter. In preparing this chapter, I contacted Wayne Nelson, of Watchung, New Jersey, the local GBS representative. He answered the myriad of questions I had and very kindly checked over this section completely to be sure of its accuracy.*

*He then forwarded it to James McCarthy, vice-president of the Tax Services Group of GBS, who also checked it for accuracy.

INCOME TAX

Once you begin to earn money through your craft or art, you must report this income and possibly pay income tax on it. The likelihood is that you are conducting your business as a "sole proprietorship," as explained in the preceding chapter. This is the simplest form of business, wherein the income of the business is considered part of your personal income and must be reported on Schedule C. Your income may also have to be reported to your state if you have a state income tax. However, since each state is different no further explanation can be given here.

Tax forms for corporations are more complex than those for individuals and are beyond the scope of this chapter. If you have incorporated your business, you will probably have an accountant doing your tax work. The same holds true for a partnership which, while not as complex as a corporation, is still more complicated than a sole proprietorship. For more information about each, obtain from the Internal Revenue Service a copy of the *Tax Guide for Small Business,* Publication 334, which covers income, excise, and employment taxes for individuals, partnerships, and corporations.

As a sole proprietor you must report the income from your business on Schedule C, Form 1040, which is used for reporting "Profit or Loss from Business or Profession." You attach Schedule C to your regular Individual Income Tax Form 1040, and the income or loss from your business is added to or subtracted from your other income on Form 1040.

In addition to Schedule C, you may also have to fill out Schedule SE, which is used to compute your self-employment tax and also a declaration of estimated tax.

KEEPING RECORDS

While you will have to report the total of your sales or your gross income, you will not of course have to pay taxes on this full amount. Instead, you will be allowed to deduct a wide variety of expenses to arrive at your net earnings.

Keeping good records is extremely important—you will be very grateful that you have such records when it comes to actually filling out your income tax forms. Not only will your records be valuable to you at tax time, but also as a general guide to cutting your costs and increasing profits. If you have figures available on a weekly, monthly, quarterly, or even yearly basis you can measure your progress. The actual form your records take is not as important as the fact that they are complete, accurate, and permanent.

The IRS requires every taxpayer to maintain records that will enable him to prepare tax returns. It is actually to your advantage that the

records be complete because accurate records may lead to income tax savings. They will prevent you from leaving out or omitting deductible expenses which you may have forgotten if they were not properly recorded when incurred or paid; for instance, if you overlook a deductible item for $30, it could cost you $9 or more in extra tax dollars.

In addition to an accounting method for organizing your expenses, you are required to have proof to substantiate the claims you make for expenses. For small purchases you might have a petty cash fund. Keep the receipts for the items paid for from this account. When receipts are not available, keep a running account of the amounts in a small notebook with a brief notation on each amount.

For items other than those paid for with petty cash, pay by check. Once your business gets started, get a business checking account to keep your business separate from your personal checking account. You can then deposit all checks as well as the cash you receive in this account and of course make your payments by check. Your cancelled checks will act as the documentation of your business expenses. Your checkbook will give you a running account of your transactions for the year; this will be very handy for figuring out what you have earned and for substantiating expenses claimed on your income tax report.

To keep an account of your sales to shops, you will have copies of all of your invoices (this is explained in Chapter 8). For retail sales, use sales pads with duplicate copies—one for you and one for the customer. Between these two sets of forms you should have a complete record of your sales. If you spend your own money for a business expense, pay yourself back out of the business account.

How to organize your checks, deposits, and petty cash payments into an understandable form may be a problem once your business really picks up. You can set up your own notebook with spaces arranged for the necessary information on each transaction—a book from the library on accounting can help you to set up such a system.

If you wish to purchase a notebook already set up, one system you can use is the Dome Simplified Monthly (or weekly) Bookkeeping Record, which is available in stationery and office supply stores. Many artisans have found this book very helpful because it is both self-instructive and convenient.

As for keeping a record of your expenses, there are several accounting methods. The two best known are the "cash method" and the "accrual method." The "cash method" means that you show all items of taxable income actually received during the year, and those amounts actually paid during the year for deductible expenses.

The alternative, the "accrual method," means that you report the

income when you earn it, even if you do not receive it before the end of the year. Also you would report the deduction when it was incurred, even if you did not pay the bill during the tax year. If you keep special tax records you can use the "accrual method" but most individual taxpayers use the "cash method." Actually you can use whichever method of accounting you prefer, provided that the method you use properly reflects your income. If you have more than one business, you can use a different method for each.

Technically neither the "cash" nor the "accrual" method is entirely satisfactory for the small art or crafts business. The "accrual method" may be too complicated for your business, and does require a knowledge of accounting and tax law. The problem with the "cash method" is that it does not provide for inventory, since tax law requires that those who report inventory must accrue purchases and sales.

If your inventory, accounts receivable (amounts customers owe you), and accounts payable (amounts you owe suppliers) will be fairly similar and small from year to year, then you can elect to use the "cash method" and attempt to complete your own return, making no entry for these three items. If not, you should seek professional help in order to complete your return properly.

Some people are "keepers" and others are "throw-it-out-ers." If you are in the latter category, watch out with your tax records. The time limit for the IRS to investigate any of your returns is usually three years after the return has been filed, although for cases in which the taxpayer did not declare over 25 percent of his gross income or filed a false or fraudulent return this limit does not pertain. The three-year period is minimal; it is advisable to keep your records, perhaps six or seven years.

WHAT IS DEDUCTIBLE?
In order to be able to fill out your income tax you must know what is deductible and what is not. There are several government publications available on this subject. The most comprehensive is the *Tax Guide for Small Business,* Publication 334. Others include Publication 535—*Tax Information on Business Expenses*—and Publication 463—*Travel, Entertainment and Gift Expenses.*

According to the IRS, for an expense to be deductible it must be both "ordinary" and "necessary." "Ordinary" means that the expense is common and accepted in your particular line of business; "necessary" does not mean indispensable, but rather that the expense is helpful in maintaining and developing your business. For instance, if you pay an entry fee to sell at a show, this fee is an "ordinary" expense because it is

the usual procedure in your business. It is also "necessary" because it allows you to develop more business for your products.

Your expenses could be divided into two groups: (1) the costs involved in making the products; and (2) the costs involved in selling them. For both making and selling you will need to travel to look for and purchase supplies, deliver finished products, and so on. You will need a place to work as well as materials and equipment to make the items. In order to be able to continue in your art or craft, you may need to take courses or engage in other educational activities. You will also incur professional expenses such as membership dues in professional organizations, subscriptions to magazines and journals, as well as the cost of the books you should buy.

As far as the costs of selling are concerned, you may have many or few to claim, depending on how you go about selling your product. If you attend craft shows, the flat fee or percentage charged by the directors will be deductible.

Since you will have to maintain some sort of minimal "office" to take care of your records and do your corresponding and bill paying, office supplies (typing paper, envelopes, carbon paper, erasers, and so forth) as well as postage are all deductible. If you use forms for invoices, purchase orders, etc., these are also deductible.

If you pay agents a percentage to sell for you, their commissions are tax-deductible. When you hire a lawyer, accountant, or other professional person to help you, their fees are deductible. If you must pay for product liability or other types of insurance specifically for your business, these expenses too would be deductible.

When you have a phone installed just for your business, you can claim the total expense. If you use your home phone, you can claim all business calls outside your immediate area on which there is an additional charge. You can also claim part of the regular monthly service charge. Suppose you use the phone half of the time for business and half for personal use, then you can claim half of the service charge.

OVERHEAD

Should you rent a store, office, studio, or any area specifically to conduct your business, all of the rent you pay for this space is tax-deductible, as well as any costs you must pay for utilities and heating. If, however, you do not rent an area specifically for your business, but instead use part of your home or rented apartment, then a certain percentage of the expenses involved is tax-deductible and you must "allocate" your expenses, that is, figure out what percentage of the home is used for business

and what is not, and claim only that part actually used for business.

To determine this percentage, put the number of rooms devoted to your studio, storage, office, or display over your total number of rooms. Suppose you have a five-room house and you use one room, the spare bedroom, for your work, your percentage would be 20 or one-fifth. Another way to figure it out is by square feet. Determine the total area of your house and the number of square feet devoted to any phase of your business. Put the latter over the total area to arrive at the fraction of the house used for your business.

The next step involves listing all of your home expenses, including rent or mortgage, electricity, gas, heat, maintenance, insurance, etc., not claimed elsewhere on your return (for example, if you have already claimed interest on your mortgage and property tax among your itemized deductions, you cannot claim it again). Multiply the totals by your percentage of use and you have the amount of expenses which you can "allocate" to your business. Perhaps your expenses will total $975. If you use 20 percent of your home for the business, then you can claim $195 as a deduction for your working space or office.

MATERIALS AND EQUIPMENT

Everything you buy that becomes part of your product is deductible. This would include raw materials and any shipping charges you must pay on them, as well as any other materials necessary to your finished product. Your equipment and tools are deductible, as are all studio or workshop supplies you might use in the process of making the product.

If you buy large pieces of equipment such as a sewing machine or a car or truck which have a useful life of more than one year, you must "depreciate" them, which means claim part of the cost each year over a number of years—the expected life of the piece of equipment. A variety of methods of computing can be used to determine the yearly depreciation; the IRS will accept any reasonable one that is consistently applied. The three most popular methods are straight line, declining balance, and the sum of the years-digits. Straight line is the simplest and the only one I will try to explain. (For information on the other method, see the *Tax Guide for Small Business,* Publication 334.)

If you use the "straight line" method of depreciation, you claim the same amount of depreciation every year for the estimated life of the item. To figure out the annual depreciation, take the cost of the item minus the salvage value if you generally retire items while still quite useful. Divide the cost by the number of years you will use it. To determine the useful life of equipment, the IRS has set up tables to cover large categories. (For

example, cars are usually depreciated over three years and trucks over four years.) Once you decide on how many years you will depreciate the cost, you must depreciate it over this time period whether the item itself wears out much sooner or lasts much longer.

If in your experience the useful lives of certain items are longer or shorter than those specified by the IRS, use your estimate, as long as it is consistent with your retirement and replacement practices.

If a piece of equipment must be repaired, the cost of repairs (including labor and supplies) is deductible. Further, if you had to take out a loan to pay for a large piece of equipment, the interest on that loan is also deductible.

WAGES

You can deduct the amount you pay in salaries, wages, and other compensation. You may be paying members of your own family, or friends or neighbors to do certain tasks for you, or you may hire full-time employees. What you pay them is tax-deductible if the compensation meets certain requirements. First, the expense must be ordinary and necessary as explained above. Also it must be reasonable, that is, an amount that would generally be paid for like services by anyone in your position. And the compensation must be paid for services actually rendered; you cannot give your mother or your daughter a salary for work she never does.

The IRS says that "you may deduct salaries, wages, or other compensations paid to your relatives including a minor child, if the requirements listed above are met."*

In addition you are allowed to give bonuses if they are added compensation for services actually rendered, not gifts (you may deduct gifts but there is an annual limitation of $25 on these). Also deduct any fringe benefits you finance, including insurance, hospitalization, medical care, and so on.

When you make payments to sales representatives or to people who do special tasks for you (perhaps they perform part of the operation necessary to make a specific item you produce on a production basis), you are required to report the payments and may deduct them from your income.

Note that if you pay people to help you but they work on an independent basis rather than in your studio or shop, you can consider them "subcontractors," that is, they are self-employed like you, and

*See *Tax Information on Business Expenses,* Publication 535 (Washington, D.C.: Internal Revenue Service), p. 7.

must file Schedules C and SE as you do. This is much easier for you than undertaking the legal requirements of becoming an employer.

The form used to report what you pay your subcontractors is 1099 Miscellaneous, shown in Figure 15. A copy of this form must be sent out to each person stating his earnings and a copy of each must be filed with the IRS on or before February 28 with Form 1096. The purpose of the form is to advise the IRS that this person has been paid the specified amount of money. The copy of the form sent to the people involved informs them of the amount they received—the amount that is being reported to the IRS.

You can also deduct educational expenses if they meet certain requirements. If you can show that the education maintains or improves skills which are required in your business, then it is deductible. If however you are taking a seminar, course, or workshop to meet the minimum requirements of your occupation or to qualify for a new business or profession, these expenses would *not* be tax-deductible. Thus, suppose you do tole painting and wish to attend a week-long seminar which would improve your skill, then all of the expenses involved (including tuition, books, materials, travel, lodging) would be deductible. The IRS asks that a statement be attached to your return explaining the deduction and showing how the education related to your business.

TRAVEL EXPENSES

Once your business develops you may buy a car, truck, van, station wagon, camper, or other vehicle specifically for business use. However, at first you may be using your family car to do the driving for your busi-

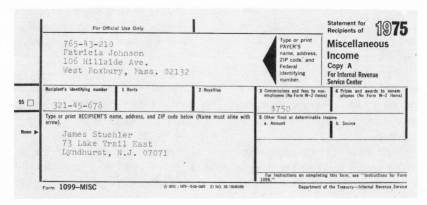

Figure 15. If you are reporting what you paid to subcontractors you will use a Form 1099 for each person and summarize these forms on Form 1096.

ness. Perhaps you drive to local stores to pick up supplies, and to the library to get books to give you information and inspiration for your creations. You may drive longer distances to attend classes or seminars, or visit craft fairs and festivals or outlets that specialize in supplies you need. Whether you do this driving in your family car or a vehicle purchased specifically for your business, you have a choice of methods to determine your deductible expense. You can either use the standard mileage rate or you can figure out all of your actual expenses. In the case of the vehicle used exclusively for business, all expenses would be deductible; in the case of the vehicle used partly for business and partly for personal reasons, only a percentage of the expenses would be deductible.

In order to figure out the total cost of the vehicle for the year, you must list all your expenses, including insurance, gas, repairs, tolls, license, and registration. You will also add in a figure for the cost of the vehicle itself. You will "depreciate" it as explained above for all large pieces of equipment: for example, if you paid $4,500 for the vehicle and expect to use it for three years, then the cost per year would be $1,500. Once you have added this depreciation to the other costs for running the vehicle, you have the deduction for it, if it is used exclusively for business.

In cases where it is used partly for business and partly for personal reasons, you must figure out the proportion of the mileage for each. Suppose you use the car about 25 percent of the time for your business, then you may take 25 percent of the total cost of the car for the year as a deduction.

But how will you know what percentage of the time you use the car for business? The only sure way is to keep a record of the mileage. You might have a pad of paper in your glove compartment on which you record the mileage for all your business trips.

You can use this mileage figure another way if you prefer not to keep a record of all car expenses. The second method involves multiplying your estimated mileage by the allowable per-mile rate. Currently the rate the IRS allows is 15¢ per mile for the first 15,000 miles and 10¢ per mile after that. You need only multiply your mileage by the allowed rate and you have your deduction.

Note that the method you choose can depend on the type of vehicle you own. For a small, inexpensive car which gets good gas mileage, you will probably do well with the allowable rate per mile. For a large car or other vehicle which uses a lot of gas and is expensive to purchase, you will do much better to itemize the costs.

In addition to travel by car you might go on some trips using a bus,

train, plane, or even a boat. Save your ticket stubs or use checks to pay
the bills. Whatever you spend for such transportation is tax-deductible.

If you take a business trip far from home and must stay overnight,
your motel or hotel expenses are deductible, as are the meals you must
buy and any tips you pay along the way. When you are taking the trip
partly for business and partly for personal reasons, you are expected to
claim only that percentage of the expenses for the business end of your
trip.

One warning is due here. The IRS has become stricter about travel
which combines business with pleasure, and is taking a closer look at
such deductions. Be prepared to prove the business angle of your trip.

THE FORMS

Now that you have some idea of the facts you must collect, we can
discuss how you must present these to the IRS. When you face the neces-
sary forms for the first time, you might feel that it is hopeless—you will
never be able to figure them out. However, if you have been able to do
your own income tax using the long form and itemizing deductions, you
will be able to do the necessary additional forms. The first time it takes
longer to figure out what goes where; but after you have done it once, it
will be much easier.

One source of information is the Internal Revenue itself. If you have a
local IRS office, you can call directly. If not, the Internal Revenue has set
up toll-free "800" numbers in each state so that you can call free. Do not
hesitate to call if you have a problem trying to figure out a form or a rule.
The person you reach at the IRS office will *not* ask who you are, but only
how he or she can help you. Have your questions ready and this person
will try to explain what you need to know.

There are a variety of informative booklets available from your local
IRS office (listed in the phone book under "Internal Revenue" and
under "U.S. Government—Internal Revenue"). You can order these
booklets and any additional forms you might need. Both the information
booklets and the forms are listed in the packet of federal income tax
forms which are sent out to you. In fact, the Internal Revenue has made
it easy for you to get the forms and booklets by giving a list and an order
blank for them right in the packet of forms you receive. Most of these
booklets are free and clearly written and can be quite helpful; they are
usually updated yearly but the order number remains the same.

Tax laws are subject to revision and change constantly, as are the offi-
cial forms on which income is reported. What follows is a general ac-
count of procedures up to date when this book went to press. For any
changes, read over the current forms and information booklets issued by

the government and/or check specific facts with your accountant or the Internal Revenue Office.

If you decide to take your tax forms to an accountant or a professional tax preparer, you will still need to know what basic information is required to fill out the forms. You must make available to this person the raw facts, which he will then incorporate into the proper spaces on your return. So read this section even though you intend to hire a professional to complete your tax forms.

SCHEDULE C

To report income from your business, use Schedule C, which is called "Profit (or Loss) from Business or Profession (Sole Proprietorship)." This form may change but should stay very much like the form reproduced in Figure 16. Look back and forth from this form to the explanation given here of each section.

People who own a business or practice a profession must complete and file this form. If you had more than one business, you must fill out one for each. If your husband or wife has a separate business you must complete a separate Schedule C for each business but, of course, if you both work on the same business you need only one form.

Fill in your name and social security number at the top as shown in Figure 16. The name of the artisan and all information is fictitious, but it will give you an idea of how to fill out the form. The first section, which has lettered questions, gives background information on your business. Item A asks for your principal business activity. Fill in the one business activity that accounted for the largest percentage of your gross income. For instance, Marcia Freund sells her stuffed animals and dolls mainly through shows, so she writes, "retail—soft goods." She also sells through a few craft shops but the majority of her work is sold at shows.

Item B asks for the name of your business and D asks for the address. Do not put your home address, unless you actually conduct your business from your home. The IRS wants a street address rather than a box number. Marcia calls her business "Marcia's Menagerie," and has her bank account for the business under this name.

You do not need an employer identification as called for in line C, unless you had to file an excise, alcohol, tobacco, firearms, or employment tax return. If you did, fill in your employer identification number in C and answer the questions concerning forms in F and G. Question E asks your method of accounting. Like Marcia, you probably will check "Cash," as explained in the preceding section under accounting methods.

Now on to the two main sections of the form. Line 1 asks for your

SCHEDULE C (Form 1040) Department of the Treasury Internal Revenue Service	**Profit or (Loss) From Business or Profession** (Sole Proprietorship) Partnerships, Joint Ventures, etc., Must File Form 1065. ► Attach to Form 1040. ► See Instructions for Schedule C (Form 1040).	19**75**

Name(s) as shown on Form 1040 ► *MARCIA FREUND* Social security number *123 45 678*

A Principal business activity (see Schedule C Instructions) ► *retail* ; product ► *Soft goods*

B Business name ► *MARCIA'S MENAGERIE* C Employer identification number ►

D Business address (number and street) ► *123 HOME ST.*

City, State and ZIP code ► *DEDHAM, MASS. 02026*

E Indicate method of accounting: (1) ☒ Cash (2) ☐ Accrual (3) ☐ Other ►

	Yes	No
F Were you required to file Form W–3 or Form 1096 for 1975? (see Schedule C Instructions)		X
If "Yes," where filed ►		
G Was an Employer's Quarterly Federal Tax Return, Form 941, filed for this business for any quarter in 1975?		X
H Method of inventory valuation ► *MARKET* ... Was there any substantial change in the manner of determining quantities, costs, or valuations between the opening and closing inventories? (If "Yes," attach explanation)		X

Income

1 Gross receipts or sales $ *2,262* Less: returns and allowances $ *10* Balance ►	1	*2252*
2 Less: Cost of goods sold and/or operations (Schedule C–1, line 8)	2	*870*
3 Gross profit	3	*1382*
4 Other income (attach schedule)	4	
5 **Total income** (add lines 3 and 4)	5	*1382*

Deductions

6 Depreciation (explain in Schedule C–3)	6	*55*	
7 Taxes on business and business property (explain in Schedule C–2)	7		
8 Rent on business property	8	*250*	⅓ of household expenses
9 Repairs (explain in Schedule C–2)	9		
10 Salaries and wages not included on line 3, Schedule C–1 (exclude any paid to yourself)	10		
11 Insurance	11		
12 Legal and professional fees	12	*35*	
13 Commissions	13		
14 Amortization (attach statement)	14		
15 (a) Pension and profit-sharing plans (see Schedule C Instructions)	15(a)		
(b) Employee benefit programs (see Schedule C Instructions)	(b)		
16 Interest on business indebtedness	16		
17 Bad debts arising from sales or services	17		
18 Depletion	18		

19 Other business expenses (specify):

(a) *office supplies and postage*	*110*	
(b) *automobile expenses*	*136*	
(c) *900 mi. @ .15 mi*		
(d) *travel expenses*	*32*	
(e) *bad check included in gross*	*20*	
(f)		
(g)		
(h)		
(i)		
(j)		
(k) Total other business expenses (add lines 19(a) through 19(j))	19(k)	*298*
20 **Total deductions** (add lines 6 through 19(k))	20	*638*

21 Net profit or (loss) (subtract line 20 from line 5). Enter here and on Form 1040, line 28. **ALSO** enter on Schedule SE, line 5(a)	21	*744*

SCHEDULE C–1.—Cost of Goods Sold and/or Operations (See Schedule C Instructions for Line 2)

1 Inventory at beginning of year (if different from last year's closing inventory, attach explanation)	1	
2 Purchases $ Less: cost of items withdrawn for personal use $ Balance ►	2	
3 Cost of labor (do not include salary paid to yourself) *Subcontractors-3.*	3	*446*
4 Materials and supplies	4	*424*
5 Other costs (attach schedule)	5	
6 Total of lines 1 through 5	6	*870*
7 Less: Inventory at end of year	7	
8 Cost of goods sold and/or operations. Enter here and on line 2 above	8	*870*

Figure 16. Here is a copy of Schedule C as Marcia Freund filled it out.

total sales and allows you to subtract any returns and allowances, that is, items that might have been sent back to you for which you refunded the purchase price. The total of Marcia's sales for the year was $2,262, less $10 worth of merchandise returned by one shop.

Line 2 asks for the cost of the goods you sold, including the materials, labor, etc., that went into making and selling these goods. This line directs you to Section C-1 below, in which you detail the various amounts that went into the total which you record on line 2.

In Section C-1, first, do not fill in the value of your inventory if you checked "Cash" on line E. Line 2 would be filled in if you were buying goods for resale, but like Marcia, you make all of your products so this line is blank. In line 3 you record what you paid your production employees or those who worked for you on a free-lance basis and are self-employed. Marcia paid her three women subcontractors a total of $446 figured on a piecework basis.

On line 4 you must record what you paid for materials and supplies which went into making your product. You can total this from your checks or from the paid bills which you have collected over the year. Marcia paid $424 for fabric, filling, thread, etc. If you have other costs, these can be given in line 5 and a separate sheet of paper attached explaining them.

On line 6 give the total of lines 1-5. Enter this total on lines 6 and 8 below and on line 2 in the "Income" section above. Marcia's result was $870 for the cost of the goods which she recorded in line 2 above.

The cost of goods which you have just figured out is now subtracted to give you in line 3 your "Gross Profit." Any other income is added in line 4, and line 5 gives your total income. Marcia subtracted her costs of $870 from her receipts of $2,252 to give her a total income of $1,382.

From that total income you are allowed to take a variety of deductions. These are actually overhead costs in your business. Line 6 takes care of the depreciations on your business equipment. You are allowed to subtract in full the cost of small pieces of equipment under "Materials and Supplies" but larger items, for example, those costing over $100, you must depreciate over the lifetime of the equipment. You are also allowed to depreciate furniture and fixtures, buildings, transportation equipment, and machinery.

In order to depreciate your equipment, you must list it in Schedule C-3, which is on the reverse side of Schedule C as shown in Figure 17. Note the headings across the top. For each piece of equipment give a description of it, or otherwise classify it in column a. In column a, list what you acquired and when you acquired it, in column g and column c what it

SCHEDULE C-2.—Explanation of Lines 7 and 9

Line No.	Explanation	Amount	Line No.	Explanation	Amount
		$			$

SCHEDULE C-3.—Depreciation (See Schedule C Instructions for Line 6) If you need more space, you may use Form 4562.

Note: If depreciation is computed by using the Class Life (ADR) System for assets placed in service after December 31, 1970, or the Guideline Class Life System for assets placed in service before January 1, 1971, you must file Form 4832 (Class Life (ADR) System) or Form 5006 (Guideline Class Life System). Except as otherwise expressly provided in income tax regulations sections 1.167(a)-11(b)(5)(vi) and 1.167(a)-12, the provisions of Revenue Procedures 62-21 and 65-13 are not applicable for taxable years ending after December 31, 1970. (See Publication 534.)

Check box if you made an election this taxable year to use ☐ Class Life (ADR) System and/or ☐ Guideline Class Life System.

a. Group and guideline class or description of property	b. Date acquired	c. Cost or other basis	d. Depreciation allowed or allowable in prior years	e. Method of computing depreciation	f. Life or rate	g. Depreciation for this year
1 Total additional first-year depreciation (do not include in items below) →						
2 Depreciation from Form 4832 (See Note above)						
3 Depreciation from Form 5006						
4 Other depreciation:						
Buildings						
Furniture and fixtures						
Transportation equipment						
Machinery and other equipment *sewing machine*	1/74	250	25	st. line	10	25
Other (specify) *electric typewriter*	1/75	300	—	st. line	10	30
5 Totals						55
6 Less amount of depreciation claimed in Schedule C-1, page 1						
7 Balance—Enter here and on page 1, line 6						55

SCHEDULE C-4.—Expense Account Information (See Schedule C Instructions for Schedule C-4)

Enter information with regard to yourself and your five highest paid employees. In determining the five highest paid employees, expense account allowances must be added to their salaries and wages. However, the information need not be submitted for any employee for whom the combined amount is less than $25,000, or for yourself if your expense account allowance plus line 21, page 1, is less than $25,000.

Name	Expense account	Salaries and Wages
Owner		
1		
2		
3		
4		
5		

Did you claim a deduction for expenses connected with:
(1) Entertainment facility (boat, resort, ranch, etc.)? ☐ Yes ☐ No (3) Employees' families at conventions or meetings? ☐ Yes ☐ No
(2) Living accommodations (except employees on business)? ☐ Yes ☐ No (4) Employee or family vacations not reported on Form W-2? ☐ Yes ☐ No

Figure 17. On the back of Schedule C, Marcia filled in information on each piece of equipment she is depreciating.

cost. Column d asks for the depreciation which you claimed in prior years. The first year this space would be blank; after that you would give the total of the depreciation claimed on that item to date.

Column e asks you for your method of computing depreciation. The easiest is "straight line," which means that once you decide the life of the equipment (fill this in in column f), you divide the cost equally among the years involved. If the life of the item is five years, then you would divide the price into five equal parts and claim one part each year.

Marcia has two pieces of equipment she is depreciating. She bought a sewing machine in January 1974, at a cost of $250. She estimates the life of the machine to be ten years and so in 1974 claimed a depreciation of $25 and then in 1975 claimed another $25 depreciation. She will continue to depreciate the machine until 1982. In January 1975 she bought an electric typewriter for $300 and will be depreciating this for ten years also. If the typewriter had been bought in July she would claim one-half of the amount for a full year. Her total for this year is $55 depreciation, $25 on the sewing machine and $30 on the electric typewriter. She transfers this total from line 7 in this schedule to line 6 on the other side of the page.

Lines 6-19 on the front side of Schedule C give a variety of possible deductions you might have, most of which are self-explanatory. Line 8 lists rent on business property. If like Marcia you do not rent a shop or store but do your work at home, you are allowed to deduct a certain percentage of your rent or home owner costs as explained in the preceding section.

Marcia and her husband own their own home. She listed all of the expenses for the home not claimed elsewhere on her tax return. The total for the year came to $1,250. Since she uses the spare bedroom exclusively for her business, she could take one-fifth of this total, or $250. In line 12 she listed $35 which she paid to a lawyer for consultation on her business.

In line 19 she listed her other business expenses, including office supplies and postage. She traveled to a variety of different shows and so put 900 miles on her car. She can claim 15¢ a mile for this travel. She also had $32 of other travel-related expenses. She received one bad check for $20 at one of the shows. Marcia then totaled her deductions on line 20, subtracted this amount from line 5, and came up with her total net profit of $744. This amount she listed in two places on Form 1040 or the basic form on line 28 and also on line 5a of Schedule SE.

If you end up with a profit or a plus figure on line 21, this amount of money will be added to your income from other sources. However, if you make a relatively small number of craft sales you may have a negative income, that is, your expenses may exceed your income. This will be es-

pecially true in the first few years that you are selling your work because you presumably made a large investment in equipment and materials, taking courses, buying manuals and books, and so on.

If you do lose money on your business, this loss will be deducted from your other income (salary, interest, rents, or whatever) in the process of completing your Form 1040. If you have a small part-time business you will have to beware that the IRS does not classify it as a hobby. Losses from hobbies are not deductible. In borderline situations, the rule reads:

> A taxpayer is presumed to be engaged in an activity for profit in the current year if, in two or more years out of 5 consecutive tax years ending with the current tax year, his gross income from the activity exceeded the deductions attributable to it.*

SCHEDULE SE

If you have a regular job, then your employer deducts F.I.C.A. (Social Security) as well as federal income tax from your wages. If you are self-employed, then you must pay this social security yourself using Schedule SE, so that when you retire you may collect Social Security in the same way as those who have held regular jobs. If you have a full-time job in addition to your business which deducts F.I.C.A. and from which the maximum deduction was made, then you do not need to fill out Schedule SE.

However, if you made no income as an employee or made less than the maximum, then you must file Schedule SE. Note that if your net self-employed income is less than $400 you will fill out Schedule SE but you will pay nothing. Even if you are retired and receive Social Security income, if you work part time as a self-employed person you must file Schedule SE.

At the top of Schedule SE, for a joint return, put the name of the spouse who had the self-employed income. If both husband and wife have self-employed income, each one must fill out Schedule SE and each one is subject to paying the self-employment tax.

If both husband and wife work in the same business, then all income from the business for income tax purposes is usually considered the husband's according to rules set out by the IRS. However, if the wife exercises substantially all the management and control of the operation, the income is considered hers.

Schedule SE, shown in Figure 18, has many blanks which you can dis-

*Internal Revenue Service, *Tax Information on Small Business Expenses* (Publication 535, Washington, D.C.), p. 4.

Computation of Social Security Self-Employment Tax

▶ Each self-employed person must file a Schedule SE. ▶ Attach to Form 1040.
▶ See Earned Income Credit Instructions on page 8 and Instructions for Schedule SE (Form 1040).

1975

- If you had wages, including tips, of $14,100 or more that were subject to social security or railroad retirement taxes, do not fill in this schedule unless you are eligible for the Earned Income Credit. See Instructions.
- If you had more than one business, combine profits and losses from all your businesses and farms on this Schedule SE.

Important.—The self-employment income reported below will be credited to your social security record and used in figuring social security benefits.

NAME OF SELF-EMPLOYED PERSON (AS SHOWN ON SOCIAL SECURITY CARD) *MARCIA FREUND*

Social security number of self-employed person ▶ *123 45 678*

Business activities subject to self-employment tax (grocery store, restaurant, farm, etc.) ▶ *making + selling soft goods*

- If you have only farm income complete Parts I and III. ● If you have only nonfarm income complete Parts II and III.
- If you have both farm and nonfarm income complete Parts I, II, and III.

Part I — Computation of Net Earnings from FARM Self-Employment

You may elect to compute your net farm earnings using the OPTIONAL METHOD, line 3, instead of using the Regular Method, line 2, if your gross profits are: (1) $2,400 or less, or (2) more than $2,400 and net profits are less than $1,600. However, lines 1 and 2 must be completed even if you elect to use the FARM OPTIONAL METHOD.

REGULAR METHOD

1 Net profit or (loss) from:
- (a) Schedule F, line 54 (cash method), or line 74 (accrual method) . .
- (b) Farm partnerships

2 Net earnings from farm self-employment (add lines 1(a) and (b))

FARM OPTIONAL METHOD

3 If gross profits from farming [1] are:
- (a) Not more than $2,400, enter two-thirds of the gross profits . .
- (b) More than $2,400 and the net farm profit is less than $1,600, enter $1,600 . .

[1] Gross profits from farming are the total gross profits from Schedule F, line 28 (cash method), or line 72 (accrual method), plus the distributive share of gross profits from farm partnerships (Schedule K-1 (Form 1065), line 14) as explained in instructions for Schedule F.

4 Enter here and on line 12(a), the amount on line 2, or line 3 if you elect the farm optional method . .

Part II — Computation of Net Earnings from NONFARM Self-Employment

REGULAR METHOD

5 Net profit or (loss) from:
- (a) Schedule C, line 21. (Enter combined amount if more than one business.) . . . — **744**
- (b) Partnerships, joint ventures, etc. (other than farming)
- (c) Service as a minister, member of a religious order, or a Christian Science practitioner. (Include rental value of parsonage or rental allowance furnished.) If you filed Form 4361, check here ▶ ☐ and enter zero on this line
- (d) Service with a foreign government or international organization
- (e) Other (See Form 1040 instructions for line 35.) Specify ▶

6 Total (add lines 5(a) through (e)) — **744**

7 Enter adjustments if any (attach statement)

8 Adjusted net earnings or (loss) from nonfarm self-employment (line 6, as adjusted by line 7) . . — **744**

If line 8 is $1,600 or more OR if you do not elect to use the Nonfarm Optional Method, omit lines 9 through 11 and enter amount from line 8 on line 12(b), Part III.

Note: You may use the nonfarm optional method (line 9 through line 11) only if line 8 is less than $1,600 and less than two-thirds of your gross nonfarm profits,[2] and you had actual net earnings from self-employment of $400 or more for at least 2 of the 3 following years: 1972, 1973, and 1974. The nonfarm optional method can only be used for 5 taxable years.

SE

NONFARM OPTIONAL METHOD

9 (a) Maximum amount reportable, under both optional methods combined (farm and nonfarm) **$1,600 00**
- (b) Enter amount from line 3. (If you did not elect to use the farm optional method, enter zero.) . .
- (c) Balance (subtract line 9(b) from line 9(a))

10 Enter two-thirds of gross nonfarm profits [2] or $1,600, whichever is smaller

11 Enter here and on line 12(b), the amount on line 9(c) or line 10, whichever is smaller

[2] Gross profits from nonfarm business are the total of the gross profits from Schedule C, line 3, plus the distributive share of gross profits from nonfarm partnerships (Schedule K-1 (Form 1065), line 14) as explained in instructions for Schedule SE. Also, include gross profits from services reported on lines 5(c), (d), and (e), as adjusted by line 7.

Part III — Computation of Social Security Self-Employment Tax

12 Net earnings or (loss): (a) From farming (from line 4)
- (b) From nonfarm (from line 8, or line 11 if you elect to use the Nonfarm Optional Method) . . . — **744**

13 Total net earnings or (loss) from self-employment reported on line 12. (If Line 13 is less than $400, you are not subject to self-employment tax. Do not fill in rest of schedule.)

14 The largest amount of combined wages and self-employment earnings subject to social security or railroad retirement taxes for 1975 is **$14,100 00**

15 (a) Total "FICA" wages and "RRTA" compensation —
- (b) Unreported tips subject to FICA tax from Form 4137, line 9 or to RRTA . . —
- (c) Total of lines 15(a) and (b) —

16 Balance (subtract line 15(c) from line 14) —

17 Self-employment income—line 13 or 16, whichever is smaller — **744**

18 Self-employment tax. (If line 17 is $14,100.00, enter $1,113.90; if less, multiply the amount on line 17 by .079.) Enter here and on Form 1040, line 59 **59**

☆U.S. GOVERNMENT PRINTING OFFICE: 1976—653-351

E.I. No.—36-2234445

Figure 18. Because she is self-employed Marcia must pay her own F.I.C.A. or Social Security Tax, figuring the amount due by filling in Form SE.

regard as you fill it out. Skip Part I. In Part II on line 5(a), fill in your total profit from your business as on Schedule C, line 21, and repeat this figure on lines 6, 8, and 12(b). Marcia has repeated her profit of $744 on these lines. If you have no wages from regular employment or tips, repeat the figure again on line 17 as Marcia had done.

Line 18 instructs you to insert $1,113.90, which is the maximum F.I.C.A. if your income was $14,100. If it was less, you multiply your income by .079, which Marcia has done and obtained the figure of $59.78 which she repeats on line 20 and transfers to Form 1040, line 55. She will then pay this amount in addition to her federal income tax. The money of course will be credited to her Social Security record.

Note that as a self-employed person you actually pay more F.I.C.A. than you would as an employed person: you pay 7.9 percent, while an employed person pays 5.85 percent. However, this 5.85 percent is matched dollar for dollar by the employer, so that a total of 11.7 percent is actually being paid on the wages of each employee. For further information on this form, ask for Publication 533, *Information on Self-Employment Tax,* from the local IRS Office.

ESTIMATED TAX

As a self-employed person your income is not subject to withholding; you do not have an employer who deducts a certain amount of money from your weekly check for federal income tax and F.I.C.A. and forwards it to the Internal Revenue Service. Instead you must do it yourself if you expect to make more than $500 from sources other than wages, and if your total estimated tax on self-employed income is $100 or more.

If you do have a regular job, to avoid the necessity of filing this declaration yourself and paying the required installments directly to the IRS, you can arrange with your employer to increase your withholding so that the balance due on your total income (wages plus self-employed income) will be less than $100.

Should you fail to pay the required amount on your estimated income and self-employment tax, then a penalty of 6 percent or more a year may be imposed. There are two common ways to avoid this penalty. First, find your total "paid-in" amount. This is your withholding (not including F.I.C.A.) plus your spouse's withholding if you are married filing jointly, plus your estimated payments. If your total "paid-in" amount is at least 80 percent of your total tax (including S.E. tax) for *this* year, you will not be penalized and need do nothing further. If your total "paid-in" amount is at least 100 percent of your total tax for *last* year,

and you paid your estimates on time, you will not be penalized if you attach a Form 2210 to your return. There are other methods of avoiding the Penalty for Underpayment of Estimated Tax listed on the reverse side of Form 2210.

To compute and forward your estimated tax you will use Form 1040-ES. The first year you will have to order this form from your local IRS office. Once you have filed such a form, it will arrive automatically in subsequent years printed with your name, address, and Social Security number.

This form consists of instructions, a worksheet, and four declaration vouchers. It is fairly easy to work with, although you may find it quite depressing to see what you are going to owe the government before you even earn the money. To arrive at an estimate of your taxes, fill out the worksheet provided with the vouchers. Keep this worksheet for your records, and mail in only the vouchers with payment.

In estimating your income, take into consideration your current circumstances and what you anticipate for the next year. Look at the worksheet in Figure 19. On line 1, enter the amount you think your adjusted gross income for the year might be. This is of course a guess—you cannot tell beforehand how your sales will go. If you are totally self-employed and do not have a regular job, then this adjusted gross income would be the final figure on Schedule C (line 21), that is, your net profit from your business. Look at this year's figure in estimating for next year.

From this adjusted net income, subtract your estimate of itemized deductions (from Schedule A, "Itemized Deductions") and your exemptions, to arrive at your estimated taxable income on line 5. Then on line 6, look up your tax using the proper tax rate schedule.

Figures have been filled in on the form for mythical craftsman Bruce Marshall. Last year his adjusted gross income was $8,400 but he expects to have perhaps $2,000-$4,000 more sales this year, so he makes a guess that this adjusted gross income will be $10,400. Last year he had $1,800 in itemized deductions, so he uses this figure for line 2 and subtracts it from line 1, to arrive at $8,600 on line 3.

Bruce is married and has two children; he therefore multiplies $750 (the amount allowed for each dependent) by four for $3,000 to insert on line 4. He subtracts this figure from $8,600 to arrive at $5,600 on line 5.

Now he looks up the tax rate schedules which accompany the estimated tax forms or can be found printed in the booklet of federal income tax forms. He uses Schedule Y because he is a married taxpayer. He finds that for this income of $5,600 he must pay $620 plus 19 percent of the

1975 Estimated Tax Worksheet (Keep for your records—Do not file)

Name *Bruce and Susan Marshall*

Social Security Number 098 76 543

1	Enter amount of Adjusted Gross Income expected in 1975 (See Instruction 2)	10,400.
	TAX TABLE USERS OMIT LINES 2, 3, 4, AND 5. FIND TAX IN TAX TABLES 1–12 IN 1974 INSTRUCTIONS FOR FORM 1040 OR FORM 1040A AND ENTER ON LINE 6	
2	If you expect to itemize deductions, enter estimated total of those deductions. If you do not expect to itemize deductions, enter 15% of line 1 (limited to $2,000 ($1,000 if married filing separately))	1,800
3	Line 1 less line 2 .	8,600
4	Exemptions ($750 for each, including additional exemptions for age and blindness)	3,000
5	Line 3 less line 4. This is your estimated taxable income	5,600
6	Tax (Compute tax on the amount on line 5 by using appropriate Tax Rate Schedule X, Y, or Z on page 4, or tax on the amount on line 1 from 1974 Tax Tables 1–12 (See "Caution" in Instruction 2)) . . .	924
7	Credits: retirement income, foreign tax, investment, political contributions, and work incentive (WIN) . .	—
8	Line 6 less line 7 .	924.
9	Tax from recomputing a prior year investment credit (See Form 4255) and work incentive (WIN) credit . .	
10	Estimate of 1975 self-employment income $................; if $14,100 or more, enter $1,113.90; if less, multiply the amount by .079. If joint declaration and both have self-employment income, make separate computations .	822
11	Add lines 8, 9, and 10 .	1746
12	Estimated income tax withheld and to be withheld during 1975 plus credit for Federal tax on gasoline, special fuels, and lubricating oil (See Form 4136) .	—
13	Estimated tax (line 11 less line 12). Enter here and in Block A on declaration–voucher. If $100 or more, file the declaration–voucher; if less, no declaration is required	1746.
14	Computation of installments:	436.50

14 Computation of installments:

If declaration is due to be filed on:	April 15, 1975, enter ¼ June 15, 1975, enter ⅓ September 15, 1975, enter ½ January 15, 1976, enter amount	of line 13 here and on line 1 of original and subsequent declaration–vouchers

Note: *If your estimated tax should change during the year, you may use the amended computation below to determine the amended amounts to enter on your declaration–voucher.*

Amended Computation		Record of Estimated Tax Payments				
(Use if your estimated tax substantially changes after you file your first declaration–voucher.) 1 Amended estimated tax. Enter here and in Block A on declaration–voucher 2 Less:		Voucher number	Date (a)	Amount (b)	1974 overpayment credit applied to installment (c)	Total amount paid and credited from Jan. 1 through the installment date shown. Add (b) and (c) (d)
(a) Amount of last year's overpayment elected for credit to 1975 estimated tax and applied to date .	4/75	1	4/75	406.50	30	436.5
(b) Payments made on 1975 declaration .	6/75	2	6/75	406.50	30	436.5
(c) Total of lines 2(a) and 2(b) . .	9/75	3	9/75	406.50	30	436.5
3 Unpaid balance (line 1 less line 2(c)) . .	11/76	4	1/76	406.50	30	436.5
4 Amount to be paid (line 3 divided by number of remaining installments). Enter here and on line 1 of declaration–voucher . . .		Total ▶		1626.—	120.00	1746.—

Detach here

Figure 19. To figure out the tax you must pay in advance, you can fill out the estimated tax worksheet.

excess over $4,000. Multiplying that out ($1,600 x .19) he arrives at $304 to add to $620 totaling $924 which he fills in on line 6. Having nothing to fill in on line 7 he repeats this figure on line 8. Now he wishes he were finished—but alas that figure is only his estimated federal income tax. Now he must figure his self-employment tax or F.I.C.A.

Line 10 asks for your estimated self-employment income, which again is the figure from Schedule C, line 21. the same as filled in on line 1 above. This figure is multiplied by .079 to give your estimated F.I.C.A. or self-employment tax.

Bruce repeats his estimated adjusted gross income of $10,400 as on line 1 and multiplies this figure by .079 to arrive at $822, which he fills in on line 10.

Now you have the two amounts you must pay. By adding together your estimated income tax from line 8 and your estimated self-employment tax from line 10, you have the total in line 11. If you have a regular job, fill in the amount your employer will withhold on line 12. If you have nothing to fill in on line 12, repeat the figure from line 11 on line 13, and then in block A on your first declaration voucher. Bruce adds his estimated federal income tax of $924 from line 8 and his estimated self-employment tax of $822 from line 10 to arrive at $1,746, which is the estimated tax total.

In figuring out your installments, note first that if your estimated combined tax (federal and self-employment) is less than $100, you are not required to file the vouchers and prepay. However, if your tax is more than $100, you will divide it into four installments and send in these payments with the vouchers provided.

The first declaration voucher, as in Figure 20, is due on or before April 15; the remaining forms are due on or before June 15, September 15, and January 15. It is a "pay-as-you-go" system, arranged so that you pay most of what you will owe in income tax and F.I.C.A. during the year as you earn it. When you file your return the following April 15, you will pay the balance of what you owe for that year or get credit toward the next year's payment.

To arrive at your individual payments, take the estimated tax from line 13 and divide it into four equal parts as instructed on line 14 and enter this amount on that line. Bruce owes $1,746 according to line 13, so he divides this figure by four to arrive at four equal payments of $436.50 which he fills in on line 14.

Figure 20. You will send in a completed voucher with each prepayment of tax.

If you have overpayment credit from your last return, you can credit it to your estimated tax payments. On the worksheet, fill in the "Record of Estimated Tax Payments." Put the dates of your payments in column a, and the quarterly payments in column d as noted in line 13.

In column c, fill in your overpayment. This overpayment may be partially or fully applied to any installment. If it exceeds the first installment, you can complete the voucher and send no money. File the remaining vouchers only when the amount of unused credit is less than the amount of the installment due. Or you may prefer to divide the credit into four equal parts so that each payment is reduced. Finally, fill in column b with the correct amounts so that b and c will equal d.

Bruce transfers the quarterly payment of $436.50 from line 13 to column d. He has $120 credit from last year's return, so he credits each payment $30 so that he will pay four equal payments of $406.50 to arrive at a pre-payment of $1,746—his estimated tax.

Once you have filled in the figures on your worksheet, they need only be transferred to the vouchers. The vouchers themselves are very easy to fill out. On Voucher 1, fill in your total estimated tax for the year in the block marked A; and in block B fill in any overpayment or credit from last year's return. Transfer your figures from your record of estimated payments, checking to see that line 2 subtracted from line 1 yields line 3. Make out a check for the amount on line 3.

After filling in his name, address, and Social Security number, Bruce filled in section A of his estimated tax of $1,746 from line 13 of his worksheet. He filled in 12/75 as the end of the tax year and in B he wrote $120, which was the overpayment from his last return.

On line 1 he filled in $436.50 from line 1(d) of his Record of Estimated Tax Payments. On line 2 he recorded $30 as the amount of unused overpayment, and on line 3 he recorded $406.50 as the amount of this payment, which is $436.50—the full payment minus his credit of $30. He attached a check for $406.50 and sent it with this voucher to the IRS.

The first voucher which you have just filled in is due on or before April 15. For Voucher 2, which is due June 15, fill in lines 1-3. Fill in the amount in A only if you have changed or amended the amount of your total estimated tax, that is, if something has happened to convince you that your estimate is too high or low and you wish to change it. Do the same for the third voucher, due on September 15, and the fourth, which is due on January 15. If you plan to file your completed income tax forms by January 31, you do not need to file the fourth voucher but instead pay the actual last segment when you file.

RETIREMENT PLANS

Suppose, as a self-employed person, you are making more than enough money to live on, you might want to start putting some of it away for retirement. You can do that using the Keogh Plan, which allows you to have it tax-sheltered, that is, you pay no income tax on it until you are retired and are using it. At that time, presumably, you will be in a lower income bracket and will have to pay a lesser percentage for income tax.

Note however that you cannot just put money in the bank and call it your retirement plan if you want to get the tax-shelter benefit. The rules governing the process are very precisely outlined in the Keogh Plan (also called HR-10). The limit of the amount you are able to salt away each year is 15 percent of your net profit or $7,500, whichever is smaller. You may deduct all self-employed income (not merely 15%) up to a limit of $750. Perhaps you have a full-time job and your art or craft is only a sideline. If you earn $900 self-employed, you can salt away all but $150 of this income; you are not bound by the 15 percent maximum. The money you are putting into the retirement plan is deducted from your income, using Schedule K, before your tax is calculated.

If you decide you would like to take advantage of the tax shelter, then you must find an approved plan in which to put your money. The easiest is to invest in U.S. Government Retirement Bonds, which are already approved by the IRS and designed for this purpose. They pay an interest of 5 percent and can be bought in denominations of $50, $100, $500, and $1,000. To participate, just fill out Form 4578 from the IRS office and you are enrolled.

There are other plans available also. Many banks, loan associations, mutual funds, and insurance companies have set up their own IRS-approved plans, which have a higher rate of interest than do the bonds but usually charge a handling fee. Talk to the person in charge of the plan at the institution you choose.

If you are young and not making too much money, then most likely you will not be interested in the Keogh Plan. It can be advantageous to you if your income is high enough, but the poor rate of interest on your investment can offset some of the tax advantages. Never go into such a plan if you might need the money to live on. Once you have committed yourself, you are not supposed to withdraw the money invested until you are at least fifty-nine and a half. If you do so before this, there is a stiff penalty.

For further information on all this, see Publication 560, *Retirement Plans for Self-Employed Individuals,* and Publication 566, *Questions*

and Answers on Retirement Plans for the Self-Employed, which are free on request from your local IRS office.

DEPENDENT CARE

If you have children under fifteen or a disabled spouse or other dependent and must have them cared for so that you can work on your art or craft, you may be able to claim the cost of such care as a deduction on your income tax. Expenses for household services might also be deductible.

In order to qualify for these deductions you must be "gainfully employed," which means you must be employed by others, employed in your own business, or actively searching for gainful employment. Unpaid volunteer work or work for a nominal salary does not qualify you for the deduction. Further, you must be employed "substantially full time." The IRS defines this as "three-quarters or more of the normal or customary work week or the equivalent during the month." If we define the normal work week as forty hours, then you should be working at least thirty hours a week. If you set up a regular five-day-a-week schedule, you could work six hours a day including a one-hour meal break. (Or you might work only three days but ten hours each day, or work seven days a week between four and five hours each day.) However you arrange it, the total should be at least thirty hours a week.

If you are "substantially employed," what exactly can you claim? You can claim the cost of baby-sitting or child care, perhaps in a day care center or nursery school. If you send your child to private school (first grade up), this *cannot* be claimed. But if you send the children to summer camp this can be claimed, as well as the cost of the transportation to and from the camp.

You can claim this child care for a dependent child under fifteen; in addition, you can also claim the care of a disabled dependent, for instance, if your wife or husband or aged parent requires constant care.

There are limits to the amount you can claim. If you have one child you can claim up to $200 a month, and for two children $300 a month; for more than two children the limit is $400 a month.

In addition to dependent care, you can also claim housecleaning and maid service, whether you have a part-time worker whom you pay to come and clean or hire a cleaning service. This amount must be combined with child care costs and the total is then subject to the $400-a-month limit.

There are a few other stipulations which you must follow. You cannot be making any of the payments for child care or housecleaning to mem-

bers of your own family; and your income must be within certain limits to be able to get the full tax-deduction benefit. If husband's and wife's adjusted gross income together comes to under $18,000, you can deduct to the limit explained above. For incomes over this figure the deduction claimed is reduced by one-half of the amount over $18,000.

To claim deductions for dependent care or home services, you must list your claims month by month on Form 2441; the total from this form is subtracted from your gross income. For further information, see Publication 503, *Child Care and Disabled Dependent Care,* free from your local IRS office.

SALES TAX

You must charge sales tax on all the taxable items you sell directly to the public if the state in which you are selling has such a tax. Each state is different, and even within states there is sometimes a difference from county to county.

The collection of sales tax is based on the fact that you are "doing business." This is a vague term but its interpretation depends on common sense. Suppose you conducted a one-time-only garage sale, then you are not in business but are making a "casual" sale, defined by the State of New Jersey, Department of Taxation, booklet *Sales and Use Tax Act* as: "An isolated or occasional sale of an item of tangible personal property by a person who is not regularly engaged in the business of making sales at retail where such property was obtained by the person making the sale through purchase or otherwise for his own use in this state."* But your sales are not casual if you as an artisan are in business for yourself; should you regularly attend shows or otherwise regularly sell your products to the public, you ought to be collecting sales tax.

Since sales tax revenues are very important to state budgets, tax officials are anxious to collect all of the justified sales tax. The penalty for the willful failure to file a return or for filing a fraudulent return varies from state to state, but typically it might be a fine of up to $500, imprisonment for up to six months, or both.

To get started collecting sales tax, write for information and forms to your state sales tax office (in care of the state office buildings in the capital city of your state). The forms you must fill out are not that complicated and you can do them yourself if you do not have the help of an accountant.

When you write to the sales tax office you will be assigned a sales tax

Sales and Use Tax (Trenton, N.J.: State of New Jersey, Dept. of Taxation), p. 8.

number, which identifies you as authorized collector of sales tax money. In writing for your sales tax number, you can inquire whether you need any licenses or permits other than the one to collect sales tax. If you describe your business, explaining your business structure (sole proprietorship, partnership, or corporation), the type of business you will engage in (retail or wholesale), and the type of merchandise you will handle, then the state office can send all the forms, information, and instructions necessary.

When you apply for your permit or license you will be given complete information on how to collect the tax (which items are taxable, and which are not, etc.), how to file your reports, and how to turn in the tax collected.

In New Jersey, for example, you would be filing quarterly reports. If the tax liability for the quarter is $100 or more, you must file a monthly remittance statement and send in the money monthly. Even if no sales are made in a quarter, the quarterly report must be sent in.

In collecting the tax, you work from a chart which the sales tax office furnishes. On your sales slips you list this amount separately and label it as sales tax. This tax is of course added to your regular selling price—unless you choose to include the tax in the price and label the price as including tax. In organizing your records it is probably best to make an extra column for the sales tax you collect and not list this with the rest of your sales.

You will find that having a sales tax number is to your advantage in some ways. True, it is a bother to collect the money and make the reports, but with this number you can save yourself money. Any materials you buy for use in making your products can be purchased without paying sales tax—you are buying them for resale so that your purchase is not taxable. You must give your supplier a sales tax exemption certificate with your sales tax number. He writes this number on your bill and does not charge sales tax.

Usually you do not have to supply a certificate each time you make a purchase, only the first time; after that the company has your number on file. You cannot of course claim tax exemption on tools, equipment, office supplies, etc., which you use or consume, but only on those materials which actually become part of your product and are passed on to the customer.

In addition to not having to pay tax on materials to be used in your product, a much more important benefit is that your sales tax number entitles you to buy materials at wholesale prices. This can mean a great saving to you.

Of course, if you are selling through stores, they collect the tax. However, you must write down the tax number of each shop and the amount of items each shop has sold for you. When filing your quarterly sales tax report, you must list the full amount of your sales and then stipulate the taxable amount.

In shipping your product out of state, you do not have to pay a sales tax to either state. But if you go to another state yourself—perhaps to sell at a show—you may be required to obtain a temporary sales tax number and turn in the tax collected according to the instructions you are given. The show director may be handling sales tax; find out the details from him.

Your Own Boutique

When you begin to create handcrafted products, you may start by selling them to friends and relatives on an informal basis, showing them your newest creations as you meet.

Soon you may want to have the selling arrangement more formal, even though you are still selling to people you know from your home. Try running a "boutique." The term as it is used in this book means an arts and crafts sale held in a private home; it is somewhat akin to a garage sale, but the quality of the merchandise and the method of display is very different. Whereas a garage sale is like a bargain basement, the boutique is more like a tastefully arranged shop or gallery.

Run your boutique on any scale you wish, either alone or with friends. Sell your own items exclusively or take items on consignment from other artisans. Hold your sale one afternoon, a whole week, or even longer. There are many possibilities—experiment to find the best for you and for your area.

ADVANTAGES AND DISADVANTAGES

There are many advantages to running a boutique. If you work to build it up, it is an event which can grow, each year becoming more successful than the previous one. You can make a fair sum of money in a short time provided that your boutique is well run and popular. More and more people are discovering this and boutiques are growing in popularity in many states. Once a person in an area starts the trend, soon he or she will have many imitators.

One advantage to the boutique is that as far as your own work is concerned, you maintain complete control over how your items are displayed. The whole retail price for your items goes to you and need not be shared with a middleman. If you sell items made by other artisans, you can charge a percentage. What remains of this percentage after you have deducted expenses adds to your earnings.

Running a boutique is an enjoyable experience. You will meet many interesting people—not only the artisans showing their items but also the customers who are interested in them. Although a boutique requires a lot of physical work, preparing for it, running it, and cleaning up afterwards, it is an enjoyable experience and one which you will want to repeat (but probably no more than once a year).

You must be a certain type of person to run a boutique—certainly not retiring or shy. Since you have to provide your own customers, it is helpful if you know a good many people to invite and do not mind inviting them. For those of you who are active in one or more clubs, or in a church or synagogue, the membership list will be an excellent source of names for people to invite. The more people you know the better, because with such people the chances for sales are greater than from strangers. When buying gifts they can tell the recipient about the friend who created the item, thus making it a more personal and meaningful present.

THE PLANNING STAGE

Before you hold your boutique, do some "market research," if possible by attending several boutiques and observing what is being sold and how it is displayed. While this chapter can give you many general hints, it is very important for you to see what is being done in your area. If you cannot locate any boutiques, you will have to experiment to find what works best locally.

The more boutiques you attend, the better you will be at planning your own. Get ideas on what items are popular locally and what customers are buying. Experience the boutique from the customer's perspective, deciding what you like and dislike, and make your plans accordingly. It is very important to see what prices are being asked for merchandise similar to that you expect to sell; observe whether the items sell well at these prices.

If possible, talk to the person running the boutique. If he or she is willing to help, you may get some extremely valuable advice, for instance, on the most effective form of advertising to reach prospective customers in your area. Perhaps this person would be interested in having his or her items in your boutique, and vice versa.

Plan to have items in a wide price range. If children are likely to come with their parents, try to have some inexpensive items that might interest them. It goes without saying the more items you have, the more you are likely to sell. When there is a lot to see, people linger longer and will be tempted to buy more.

In planning your boutique at least a month in advance, you will have to pick dates on which you hope the weather will be good. In some parts of the country weather is no problem, but in other areas you are taking a chance in the winter; the heat plus vacations make the summer less popular—therefore boutiques are most popular during the spring and fall. In addition to considering the season in picking the date, try to avoid conflicts with any local events that your prospective customers might be attending.

Probably the most popular time of the year is the pre-Christmas season. However, do not choose a date too close to Christmas or people will have already bought their gifts or will be too busy to come to a leisurely boutique. November is the prime month for boutiques; early December may also be good if the weather is likely to cooperate. Spring months have the advantage that customers may have stuck close to home during the winter and like to get out when the weather becomes milder. Also they may be looking for graduation or wedding gifts or items for Mother's Day and Father's Day. Most likely your boutique will be planned for indoors so that it can operate rain or shine.

You will have to guess how many days your boutique should run. The first year, do not run it for more than a few days. The best are usually later in the week and the weekend. Friday, Saturday, and Sunday are good choices. How many days you decide on depends on how much merchandise you have and the number of people you expect to attend. After a few years, when your guest list is built up, you can run it longer, perhaps a week, or any length of time you find is appropriate. In adding any additional day, consider whether it will add significantly to your sales—or will that day only spread them out unnecessarily?

As far as setting the hours is concerned, you will probably open at 9:00 or 9:30 *a.m.* and may stay open one or more evenings until 9:00 *p.m.* if enough customers want to come at night. Plan your hours according to the shopping habits of your area.

GUEST ARTISANS

If you are involved in a wide range of arts and crafts and produce many handcrafted items of different types, you will not need to ask other artisans to bring items to be sold at your boutique. But if you are involved in only one or a few, you might ask fellow artisans to join your endeavor. Having the work of other artisans to display will make your boutique more interesting, and the more different types of things you have on display, the more you are likely to sell.

Even if you do several different types of work, you can still supplement your work with that of other artisans. Those of you who do weaving and embroidery could look for a painter, or someone who works with leather or wood, or artisans who do decoupage or stained glass. Such a variety of items will make for a much more interesting boutique. As long as you have not accepted items that directly compete with your own, the additions should enhance the sale of your own products and generate many more sales than would have been made in a boutique centering on only one or two crafts. Another advantage to having guest artisans is that

they can reciprocate by running a boutique at a different time and you can be a guest artisan there.

Unless the guest artisan spends time helping you with setting up and selling, you should take a percentage of his or her total sales. Decide this in advance and make the arrangement clear to each one who participates. You will probably take 10, 15, or 20 percent, depending on your own costs. (If you plan to do much newspaper or radio advertising, for instance, or are investing in display materials, you will have to ask a higher percentage.) You do want the artisans to set their prices low enough so the items will sell, and they can do this if you only take a small percentage. Further, you want them to feel that it is worthwhile participating in your boutique even though they must come to your home at least twice—once to deliver their work and once to pick up unsold items. In addition they must tag each item and give you a list of what they are bringing. If the percentage you take is small, then the trips and the other work involved are worthwhile.

Guest artisans will bring you more customers. Since their items are also on sale, they will probably be constantly telling people they meet about the boutique and encouraging them to go. This "word-of-mouth" advertising is probably the most effective you can get.

How will you find artisans to participate? Most likely you know some artisans and they know others. Once the word is passed that you are having a boutique, artisans tend to call and come to you to ask whether they may join in. If you attend craft shows, you will have an opportunity to meet others and see what they do. When you like their work, tell them about your boutique and take their names and addresses so that you can contact them at the appropriate time. You may find it hard after a while to include all those who want to participate. Some must be refused, either because you do not have the room, or because you have too much of that type of item already, or because you do not feel that their work is up to the standard you want to maintain. In giving your reason for not accepting the work of a particular artisan, it is best to be honest but as kind as possible.

In order to avoid problems, be sure that each of your guest artisans knows what you expect of her or him. When a large number are participating, consider writing down all the information and having copies made. If someone you know has access to a ditto or mimeograph machine this is the cheapest way to duplicate, or use a copy machine; or you can ask a local printer who does small jobs for a price quote.

Explain to each artisan that you will not be responsible if items are damaged or stolen, and that you have the right to accept and display

whatever items you choose as well as to display them as you wish. This should avoid complaints from anyone that his or her items are not being prominently displayed.

Be sure that the artisans know when to deliver the items and when they must pick them up. They must also be certain of the exact dates and times when the boutique will be opened so that they can send customers to you.

Ask each artisan to label every item submitted with its price. If you want all of the labels to be uniform, you should supply them. Indicate if you want the artisan to put a code on the price tag, perhaps his initials, so that you can check when in doubt who made a specific item.

You will also need from each artisan a listing of the items he delivers. If possible check the list as each box is unpacked. Keep the lists of items in a folder or punch holes in the papers and put them in a looseleaf notebook. Have each artisan put his name, address, and phone number on the inventory sheet in case you must contact him during the boutique to check a price or to ask for more of a specific item that has sold out fast. Keep the sheets in alphabetical order by the artisan's last name so that you can find a specific sheet quickly. At the end of the sale, use the lists to mark off unsold items and to tally the amount of sales for each artisan.

As far as the legal implications of your sale are concerned, you will have to find out about any local or state rules that apply to what you are doing. In most areas your boutique would be considered akin to a garage sale and there would be no problem—as long as you do not cause any uproar which would bother the neighbors and could be reported as a disturbance. It is best to let the neighbors know in advance what you are planning and invite them to attend the boutique and even participate if they would like to make items to sell.

People who live in a state which has a sales tax should check on this obligation before the sale. If it is a one-time-only, small sale, a sales tax may not be required; however, if your boutique is large or held regularly, you should go through the process of collecting the tax so that what you are doing is legal. Usually this reporting is fairly simple. (For further information, see the section on sales tax at the end of Chapter 5).

When you are running a large boutique and accepting thousands of dollars' worth of merchandise, you should consider taking out extra insurance on your home. Having the items for sale there in your home of course means that the risks are greater and so the cost of the insurance will be greater. Consult the insurance agent through whom you have owner's or apartment dweller's policy for further information and specific rates.

PUBLICITY

Letting people know about your boutique so that they can attend is vital. There are many different ways you can do this, but the most effective is word-of-mouth. Talk about your boutique to everyone you meet. Ask them to tell their friends and neighbors about it. Describe some of the exciting items you will be selling. If you are very enthusiastic, you will fire up those listening to you.

Beyond word-of-mouth, you can take one of two courses: you can confine yourself to extending personal invitations, or you can also advertise publicly. Which you choose to do will depend on personal preference, but in either case the personal invitation will probably be your most effective method of advertising. Once you have run one or more boutiques you may find that you can totally rely on this method and not need to use any other.

The first year your mailing list may be a problem. However, in subsequent years you will make use over and over of the work you did the first year in developing a list of people to invite.

In starting out, first list all the people you know who might be interested in attending your boutique. Ask friends and neighbors for more names and addresses. If you have any membership lists of clubs you belong to, these are an excellent source of names; ask friends and relatives if they belong to women's clubs or garden clubs. These clubs lists would supply an excellent source of prospects for your mailing list.

Another source of names is craft fairs and shows. Ask customers who stop to look at your work to write down their names and addresses for your mailing list. You could personally extend the invitation by telephone to each person on your list, but this process is time-consuming. You would spend time talking to each explaining what you are doing, not to mention general conversation.

An excellent alternative to telephoning is sending out invitations. The first year you will most likely handwrite these unless you are planning a very large boutique; in subsequent years you might consider having a printer make up the invitations. Printing will cost money but the time you save will probably be more than worth it.

You can either use folded cards, to be sent in envelopes, or send postcards. The postage for these is less than for a letter as long as they *are* postcard size or smaller. Since the customer can read your message without even opening an envelope there is less chance that the postcard would get tossed away unread. To make your invitations more attractive and eye-catching, you could have the printer use colored paper and/or ink and add decorative line drawings. This is exactly what Lew Watters

did when he printed the invitations shown in Figure 21 for the boutique he and his wife were planning. Figure 22 shows the reverse side of the postcard.

After your first boutique, extending personal invitations will be much easier. If you used a guest book, you will have a list of people to whom you can send invitations. Of course you must be sure that everyone who attends signs the book; the guest book is therefore a very important part of your boutique and an investment in the future. If your boutique is to be an annual affair, the number of people attending can constantly grow if you work on developing your mailing list.

The book itself can be any type as long as it gives your customers a place to record their names and addresses. Stationery stores carry official guest books for social affairs. You could buy one of these or just use a school-type notebook. Draw lines to form columns in which your customers can enter their names and addresses. If you are using several forms of advertising in addition to personal invitations, include a column marked: "How did you find out about this boutique?" From this you will get valuable information on how effective each type of publicity has been.

If you do not have enough relatives, friends, and acquaintances to whom you can send personal invitations, especially the first year, consider opening your boutique to the public, as you would a garage sale. Depending on the area in which you live, it is most unlikely that you will have trouble. Not one person interviewed for this book who had a boutique ever had any problem.

A problem you are more likely to encounter is shoplifting, but since most of your items are inexpensive the danger is minimal. As a precaution keep items which are small but expensive, especially jewelry, in a glass case near the sales table if possible. Since you will not leave the cash box unwatched, the items located near it will be protected.

Of course it is impossible for you to watch every customer, but keep an eye on anyone acting suspiciously. If a customer is continually checking to see what you are doing, keep an eye on what he or she is doing. Try to have at least one person helping you at all times. Do not allow customers in other parts of your home not being used for the sale. Usually a closed door is all that is necessary.

You might not become aware of any loss until after it is too late. However, if you think you saw someone take an item, be sure to proceed cautiously and consider if recovering the item is worth taking the chance of accusing someone falsely. Try commenting generally on the item to the person, letting him or her know that you are aware he has it. Never

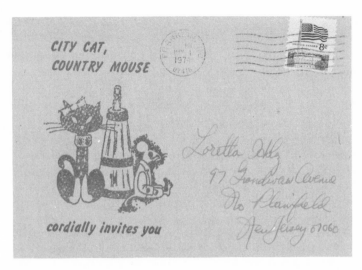

Figure 21. Lew and Bonnie Watters sent out postcard invitations to hundreds of people on their mailing list. The clever design on the address side makes you curious to turn the postcard over.

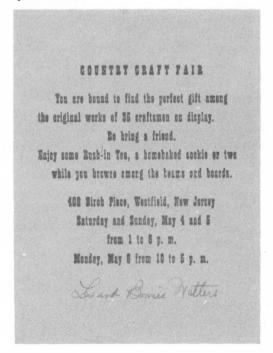

Figure 22. On the reverse side of the postcard, which Lew printed himself, is completed information about the boutique.

touch him. Threaten to call the police if you wish but do not physically detain him. If he drives away, get the license number.

Again let me emphasize that most likely you will have no trouble at all. If you take a few precautions, keep aware of what is happening, and work with another person at all times, any potential problems should be avoided.

Once you decide to open your boutique to the public, first take advantage of free forms of publicity available to you. One is to send a press release to local newspapers, as described in Chapter 3. If you can buy a small display ad in the same publication, your chance of having the release used is greater.

Chapter 3 described other methods of obtaining publicity. Read it over again and decide which approaches are best for your area and your particular boutique. If you have ever had a garage sale, you will be familiar with some forms of advertising; decide which are most appropriate for your project.

One useful form of free advertising involves the bulletin boards in public places. Many stores—especially supermarkets—have such bulletin boards, where you can post a free notice of your boutique. Go not only to your local supermarket but to as many others as you can within reasonable driving distance. Try to get notices onto bulletin boards in local companies where you, a relative, or a friend works. Do any of the civic, fraternal, or religious groups to which you belong have a bulletin board on which you could post a notice?

If you can make colorful and attractive cards (remember that on some bulletin boards you are limited to index-card size), people will notice your announcement. When your invitations are printed, maybe these could do double duty as announcements to hang on bulletin boards.

Consider advertising on your local radio station. Quick spot announcements can be extremely effective and not too expensive. If you have a local TV station or cable station these are also a possibility. And consider classified advertising in local newspapers. For weekly papers, advertise in the issue which will come out prior to the start of your boutique. For daily papers, have your ad appear a day or two before your boutique starts. Be sure to find out in advance the deadlines for classified ads for each of the newspapers in which you wish to advertise so that you deliver your information on time.

SET UP AND DISPLAY

Before you actually planned a boutique you must have given thought as to how you could use your home and the space available for display

areas. A living room, dining room, kitchen, and perhaps a hallway too can be quite sufficient. If you have a playroom or family room or a room fixed up in the cellar this can also be used.

In setting up be sure that it is obvious which areas of your home are meant to be sales areas. Hang up signs telling customers which way to go and not to go.

Decide first where you will have your sales table. This will depend on your general layout, but the ideal place is where you can welcome people as they come in and check out their items as they leave. The sales table should be equipped with a cash box with change. Be sure to get rolls of coins and dollar bills from the bank so that you have no problem giving change.

Before the boutique starts, decide whether you will accept personal checks. There is some risk in doing so but if the customers are a select group from your mailing list such risk is slight. If you refuse checks you might miss some good sales. Should you decide that you do not want to take the risk, put up a sign to the effect to warn customers.

At the check-out desk you will need sales pads on which to write up the sales. These can be bought at stationery supply stores or you can merely use small pads of paper. What is important is that you are able to list the prices on the items being purchased and add them up. If you have an adding machine or a pocket calculator or can borrow one, it will be of tremendous help, especially when you are exhausted and hardly able to add.

Be sure that every item for sale is marked with a price (see the section on price tags in Chapter 2). If you have guest craftspeople, the easiest way for you to handle this job is to have each one put prices on his or her own merchandise.

Under your sales table keep a supply of wrapping materials. Collect a supply of bags beforehand from your own store purchases, and have friends and neighbors contribute. If your boutique grows to be a large one you may have to buy them from a local supplier listed in the Yellow Pages.

How you arrange the items you have for sale is very important. People who come to your boutique know they are visiting a home, not a store, so they will not expect your displays to be professional; nevertheless they will appreciate it and be more apt to buy if the things are conveniently and attractively displayed.

Use your furniture to best advantage for the main part of your displays. Empty the bookcases and arrange merchandise in them. What you have to sell will dictate to a great extent the additional display mate-

An effective display of Christmas items

Glass window ornaments

Toys for sale in a home setting

rials needed. The artisans who are contributing to your boutique may have display equipment which they can let you borrow, or the items they deliver may already be arranged on display equipment. Encourage them to bring such equipment as it will make your job easier.

THE SALES DAYS

The actual sales days will be very hectic ones for you no matter how much planning and preparation you have done in advance. Of course the more time and effort you have put into preparing for the boutique, and the more thorough the preparations, the more smoothly it will go and probably the more successful it will be.

The first day may start with a knock on the door long before the hour you have stated as opening time. Once you have decided on an opening time, try not to allow customers in earlier. Explain to "early birds" that you are not quite ready, and ask them to wait until the scheduled time. You will certainly have many last-minute details to attend to; it is also fairer to all customers to abide by your stated hours.

The first few hours are likely to be the busiest of the whole sale, because customers feel that your very best items will be sold then. It is very important to be ready for this rush, so allow plenty of time to complete preparations. Everyone who is willing to help you should be present at the beginning; later you will not need so much help.

AFTER THE BOUTIQUE

As soon as the boutique is over, if you have put up signs outdoors you should remove them. This will avoid bringing people to your boutique after it is over and will help to keep your town tidier. Don't forget to remove the signs you put up on supermarket bulletin boards and elsewhere.

Bank the money in your cash box as soon as possible. If the boutique runs several days, you might plan to go to the bank several times during that period for safety's sake. Once the final sale has been made, tally up each artisan's sales and get payments ready. Probably the easiest way to pay is by check, especially if you have banked the cash.

As soon as possible, sit down with a pen and paper and write down what you did wrong and what right in staging your boutique. Consider what you would do differently next time and write down what you have learned by experience, while this is fresh in your mind. If you have any good ideas for advertising or new items, or for another type of display, write these all down before you forget them.

Note down too what types of item sold out quickly and how many of them sold, as well as what was left. Consider what price range sold best,

what things people asked for which you did not have, what they ignored. Put down any discoveries about the effect of various types of advertising.

Tuck this paper away so that you can bring it out when you begin to make plans for your next boutique. It may be extremely helpful, because you will be surprised what you have forgotten in the meantime.

POLLY'S BOUTIQUE

Boutiques are held all over the country in the homes of artisans. A very successful one is that held yearly before Christmas by Polly Reilly of Westfield, New Jersey. Polly has been running her boutique for seven years; it has become an annual event to which local artisans and customers look forward with equal pleasure.

Polly has an active crafts business of her own, making and selling hand-painted Christmas tree ornaments cut from balsa wood. Her original designs are whimsical and attractive and the workmanship is excellent. She makes these ornaments year round; her husband cuts them out, and a crew of twenty local people paint the large areas of color in their own homes. Polly does all the detailed painting herself and signs each ornament.

She produces over 12,000 of these ornaments annually and sells most of them through stores. However, when she started making the ornaments one of the first ways she sold them was through her own boutique. Over the years her sales through stores have boomed, but she has continued to run the boutique because it is so successful.

Customers look forward to being able to buy ornaments from her new line when they attend her boutique—on the first day she has sold as many as eight hundred. Approximately one hundred other artisans bring their handmade items to Polly's home for the boutique; over a thousand people attend the event and the number is constantly increasing as more and more people hear about it.

But it took Polly more than five years to build up the attendance to that figure. She started her boutique in 1968 and that year pooled her resources with four other women. In a four-day period they did $600 worth of business. They thought this was excellent. Now Polly does thousands of dollars' worth of business in a one-week period!

That first year the women advertised the boutique by taking several classified ads in local newspapers. They paid for spot announcements on the local radio for two days and were extremely pleased with the results. They also told everyone they knew about the boutique and asked them to pass the word along.

Now that her boutique has grown, Polly does not need to advertise.

Polly Reilly's Christmas ornaments

Instead, she has a mailing list and to each person on that list she sends a personal invitation giving all of the necessary information—including the dates and times and a map to guide them to her home. Originally she wrote all of the invitations by hand; only recently has she begun having a local press print them for her.

Every year she has a guest book and asks all of her customers to sign it. In fact she considers it so important that she puts up a sign on the door greeting people with the message: "Be sure to sign the guest book." And each year she sends invitations to everyone who attended the year before.

Sales do not even begin that first day; they have already started the week before as the artisans come to bring their wares, admire items already brought by other artisans, and promptly buy them. Finding artisans to participate in her boutique is no problem for Polly. In fact, just the opposite. She says that refusing artisans is the hardest job connected with the boutique. Polly is selective about the items she accepts and chooses only the best because she wants her boutique to be known for quality. She also wants to avoid overlapping—that is, too many people doing the same type of work.

She attends a few art and craft shows each year. These give her a chance to meet new artisans whom she can invite to participate in her boutique. This way each year she has exciting new items to display. The shows also allow her to add to her mailing list. She always has a guest book and a small notice inviting people to sign up for the mailing list for her boutique. In addition the shows allow her to meet the public directly and see how they react to her ornaments. She has to be selective about which shows she attends in order to avoid the customers who are looking for bargain-basement items.

The week before the boutique Polly spends setting up, though of course she has been planning for months in advance—indeed, she is making plans for next year's boutique before this year's event is over.

Some of the items arrive weeks before in the mail; most of the artisans bring their items the week before, along with a list of what they are delivering. Before any of the artisans arrive, Polly has stripped the family's possessions from the first floor of her home. She removes almost everything that is portable, leaving only large pieces of furniture and items that can be used for display.

She has a spacious first floor perfect for a boutique. There are many bookcases and sets of shelves excellent for display. She also uses her mantelpiece and even the window sills. She hangs things from the ceiling and walls, and on the drapes. She uses the porch as well as the stairway and the family room upstairs. Stained-glass ornaments decorate windows and strings of fluff-ball creatures dangle on door jambs. Even the top of the refrigerator is used for display. Handcrafted items are everywhere, so that it takes the casual browser quite a while to see the hundreds of items on display.

In running her boutique Polly has the enthusiastic support of her family. Her three children who are in grade school find the boutique exciting and they help with carrying in boxes, fetching hammers, and so on. They enjoy the break in family routine and somewhat irregular meals.

Polly's husband, a toxicologist by profession, is also an enthusiastic supporter. All year he helps by cutting out ornaments for Polly with his jigsaw, by keeping all the records of her business, and by sending in the necessary forms to the government. At the boutique he helps out with sales; afterwards there is a huge box of sales slips to check over and organize in order to make the sales tax report.

Polly sets up her sales table in the kitchen. She or a helper writes out a slip for each sale and there is a handy adding machine for totaling sales. At first she was able to save enough bags for wrapping but now she has to buy them specially.

All week more items are added to the boutique as pieces temporarily stored in the basement are brought up to replenish the supply. When an item sells out fast and Polly thinks the artisan has more, she will call to ask for a further delivery. Some items she has to replenish several times. Beforehand she cannot always tell which will sell especially well, although after all her experience with running boutiques she usually guesses pretty accurately whether her customers will buy a specific item.

After the sale is over, the artisans come to pick up any unsold items and a check in payment for pieces sold minus a 15 percent commission. With the boutique over and all of the items returned to the artisans, Polly is ready to collapse, but must hurry back to her studio to finish her pre-Christmas orders.

Selling Through Shows

Artisans have become the gypsies of the seventies as a growing number of them have made the show circuit the market for their products. Living in campers, they map out an itinerary with a different show virtually every week of the year as they move on constantly from one location to the next; and when they are not actually at shows, they are either making their products or traveling on to where the next show takes place.

The show circuit has been a good market not just for these full-time gypsies but also for a growing number of artisans who have made the shows an important part, though not all, of their marketing efforts because they have found shows to be an excellent way of selling what they make.

If you are just getting started, shows can be a very good takeoff point for you. If you are already selling your wares through other markets, you may still find it a good idea to participate in shows. While they require a large investment of time, if you are wise and lucky in choosing which to attend, you may find them quite profitable.

But what exactly is a show? Shows differ greatly among themselves. Basically, the term is applied to almost any occasion on which artisans gather to sell their wares. It can be called a fair, or a show, or a festival—and be anything from a few tables set up in a church hall to the gigantic shows held by the Southern Highland Handcraft Guild in which hundreds of artisans participate. While there are great differences among shows, the main purpose remains the same: to bring the artisan face-to-face with potential customers.

ADVANTAGES AND DISADVANTAGES

As with any other type of selling, there are pros and cons to attending shows. Whether you choose to go in for shows depends on what type of person you are, where you live, your family situation, your product, and other factors. An important consideration is whether your lifestyle will allow you to spend long periods of time away from your home and studio. If so, shows may be an excellent marketing method for you.

But first, what are the advantages and disadvantages of this method of sales? The primary advantage is profitability. At shows you are selling

directly to the consumer and therefore earning the selling half of your price. At a good show you are being paid well for your selling time—but at a poor show you are being paid miserably.

The second advantage in going to shows is that you will gain exposure for your products. If you are just starting out, this may be important to you; however, if you are a seasoned artisan, the value of such exposure may be negligible. "Exposure" means that the public has a chance to see what you do and you begin to make a name for yourself in your particular field. Often artisans are well known in their area for a certain specialty and customers seek them out when they want a specific item.

A third lure of shows is prize money. Of course only some shows offer prize money and usually the competition is keen. Certain shows that offer prizes also provide sales, yet there is a good chance the emphasis is on exhibit rather than sales; if so, you should be aware of this before deciding whether or not to participate.

A fourth important advantage of shows is that they can be an excellent source of contacts. Shop and gallery owners often attend shows looking for artisans to invite to submit work for their shops. Directors of other shows come looking for competent artisans to invite to their productions. A related advantage is that you can test your new products. If you have been developing some new items, you can put them out on your table and see how the public reacts to them. You may get some very interesting feedback, and from the comments and discussions could come up with modifications to the product which will make it more saleable.

You can also test your prices. You may not be sure that a particular product is going to prove worthwhile financially. Try selling it at the price you need in order to make a profit. If it sells well, try a slightly higher price at a different show to see how the change of price affects sales. And you can experiment with a variety of different display arrangements. A new piece of display equipment may turn out to help sales considerably.

If you usually work at home or in your shop, you will find that a trip to a show can provide an excellent change of pace. Contacts with fellow artisans can be very stimulating as far as your own production is concerned; you will make good friends and have a chance to socialize.

And shows can be just plain fun. Sometimes they are run like "fairs" with strolling musicians and puppeteers designed to attract the public—and hopefully put them in a buying mood.

But there are also many disadvantages, one of the biggest being that shows are very time-consuming. Remember that during both traveling and setting-up time you are *not* producing and are *not* actually selling.

Perhaps your sales will justify spending this time, perhaps not. You can decide this only after you have attended a number of shows and really know what you are doing.

Shows are definitely a gamble on your part. Whenever you go to sell at a show, there are many factors beyond your control. Sometimes you will lose the gamble. You may attend a show that is so poor you do not even cover costs. In contrast you may find a show in which you "sell out," hardly having anything left to pack up and take home with you. Most shows fall between these extremes and if you average out at fairly good sales, then each is worth the gamble.

Remember that the expense involved can be quite high, especially if the shows are far from your home base. In addition to the fee you must pay to the director, you will have a variety of personal and travel expenses.

Another disadvantage is that you are likely to sell your lower price items, if you have a wide range of prices. If you make only higher priced items, your sales record may be poor. At a show you are dependent on the impulse buying of the public. Customers in general tend to prefer to buy more expensive items from a store, which is there permanently and to which they can return. If they are putting quite a bit of money into an item, they may want to go home and think about it and then return to make the purchase.

Also people have more faith in the prices a shop or gallery charges—a psychological problem which is difficult to overcome. Somehow customers generally feel that artistic and handcrafted items must be worth what the shop is asking for them, without considering the 100 percent mark-up the shop has made. In contrast they may feel that the artisan is running a "fly-by-night" operation and may not be charging fair prices. To make your business look more stable, be sure to have business cards available and photos of your studio on display.

At a show you will be facing an audience that may or may not appreciate artistic and handcrafted items. If you have hesitated to enter your first show, perhaps you are afraid to go out to the marketplace to sell your products because you are concerned that the work may be rejected. Give it a try and steel yourself against rejection. Try to take disappointments in stride and go on to the next task.

TYPES OF SHOWS

A few years ago you would have gone begging looking for shows in which to participate; today the number of shows has proliferated at such a phenomenal rate that during some of the most popular weeks you may have a choice of several in which to participate within reasonable driving distance.

Because of this growing number of shows, you will be able to choose among the possibilities. But don't expect to be able to do this immediately. Depending on how many shows you attend, it may take quite a while before you have learned about all the shows held in your area and can pick those that are best for you. Even seasoned artisans make mistakes.

When you are aware of the variations between shows you will have a better idea of what to expect and what questions to ask about a specific show.

Shows can be classified in various ways. First the age of the show can be significant—is it a new one or has it been an annual affair for many years? The season in which the show is held is important; so is the type of merchandise to be sold—art only, crafts only, or a combination of both—or are these only a side-line to a county fair, an antiques show, flea market, or similar event? What is the means of entry—is the show open or juried? What method of sales is used—booth or consignment? Who are the directors—professionals or amateurs? And where is the show to be held—in a mall, on a street, in an open field, an auditorium, a church or school? Finally, is the show a "good" or "bad" one, and how do you differentiate?

One significant difference is that some shows are free to the public and others charge an admittance fee. A fee, if it is high, tends to discourage customers and does keep down the crowd. However, those that do come tend to be more affluent; and if there is an admittance charge, the people who pay it expect to be entertained, not merely to shop. If the fee is minimal this expectation is usually not significant. But the higher the fee which customers pay, the higher their expectations. Yet the artisans have also paid to be there. They have come to sell, not to entertain, and they may resent the fact that they are expected to perform. If the show is not well run this situation can cause much hard feeling.

LONGEVITY

Some shows have been so successful—at least from the point of view of their directors, if not also from the point of view of the artisans—that they have become annual, bi-annual, or even quarterly events. Other shows whether by choice or by necessity have been one-time affairs.

Some annual shows are just getting started. Of course the directors hope they will grow each year, so they start out optimistically by naming their show, say, "The Dedham Mall First *Annual* All Crafts Show." Others have been going on for years and years, witness titles like "The 25th Annual Laguna Gloria Fiesta." Long-running shows have an established clientele which only needs to be notified of the date; and they

usually gain new customers each year so that a momentum has been built up. Some artisans feel that the longer the show has been running, the more likely it is to be a buying show and the more likely it is to attract customers who will buy more expensive items.

Does this mean you should go only to the established shows? Not necessarily. Directors who are trying their best to build up the reputation of a show or are running one for the first time often spend much money on publicity and do draw a good crowd. They need you as a competent artisan to participate and you should encourage them by doing so, if you feel they are trying really hard. What often happens is that for the first few years directors go begging artisans to participate, but once the show has a good reputation too many apply and they may have trouble finding a fair way to choose. One good method here is to limit the number of participants in the same craft area. Often directors ask to see slides of the artisan's work or actual samples.

SEASON

Since a great number of artistic and handcrafted items are bought for gifts, the gift-buying pre-Christmas season is the busiest for shows. These pre-Christmas shows begin during October and continue through November and December. However, shows held in shopping centers and malls are few during December because the publicity directors of these areas feel that they do not need added attractions to draw people into the stores. Other Christmas shows take place as late as the weekend before Christmas.

During the pre-Christmas season you will probably have a number of shows to choose from; then right after Christmas and sometimes for weeks afterwards, shows are few and far between. In the colder areas January, February, and sometimes even March are the bleakest time of the year. Most artisans finish up any custom orders they had for post-Christmas delivery and replenish their stock since it was depleted before Christmas.

The next busiest time for shows in many areas is the summer, because of the popularity of the outdoor show. People consider going to such shows a vacation, and if the weather is good, there will probably be lots of families out for the day attending the show.

Spring is a popular time, especially for pre-Easter shows. May can be a good month because Mother's Day, Father's Day, graduations, and June brides all provide occasions for gift buying.

A specialized kind of art

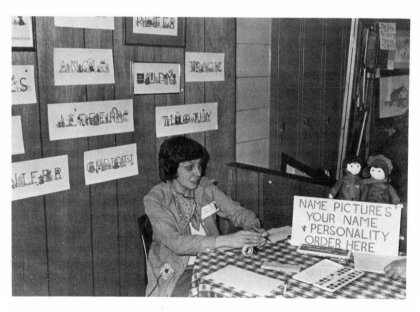

Art and crafts combined

WHAT IS BEING SOLD?

Some shows are strictly crafts, others strictly arts; a third type combines both arts and crafts.

Sometimes the show is run on a theme. The Renaissance Show has been popular—especially on the West Coast. Shows on the theme of early America were made popular by the Bi-Centennial celebration. In such shows the participants are asked to come dressed in the costume of the era being evoked. Crafts of that era are featured, although most arts or crafts may be accepted.

In addition to shows run specifically as arts and craft shows, there are a great many other public events in which arts and crafts can be included (some possibilities already mentioned include antique shows, flea markets, county and state fairs). Like art and craft shows, these markets vary greatly. Some could be profitable for artisans, but they are often disappointing. While there may be many customers at such an event, they are often not interested in quality artistic and handcrafted items but rather in antiques or bargain items. The arts and crafts may have just been tacked on at the end as an "afterthought" or a way to earn a few more booth fees for the directors. If the advertising for the show puts little emphasis on arts and crafts, the artisans are likely to be short-changed.

To make their shows more varied and interesting, some directors limit the number of participants in a specific craft medium. For instance, the Crafts Expo—an annual show held the first full weekend in June, by American Crafts Exposition—limits the number of craftsmen per craft to 5 percent of the total participating. This can be helpful to the artisan; if there are too many examples of one type of craft, everyone suffers.

JURIED SHOWS

Shows can be categorized as "open" or "juried" depending on how participants are selected. An "open" show is one in which any artisan can participate as long as he pays the fee, if required, and as long as there is room for him.

A "juried" show is one in which the work on display was in some manner evaluated before being exhibited. Each piece may have been judged and accepted individually, or representative pieces by the artisan may have been judged before he was accepted and allowed to participate.

Juried shows tend to have more expensive one-of-a-kind pieces. There are many different procedures for the jurying. Sometimes it is very formal, with the names of the judges and their qualifications announced beforehand along with a list of rules precisely spelled out. Sometimes the

jurying is quite informal; the director or committee simply asks to see a few pieces of your work before accepting it for the show.

The larger and more prestigious a show is, the more likely it is to be juried. Often the rules will ask you to send in three slides of your work; from the slides received, the judge or judges will determine who is to be allowed to enter.

At the other extreme is the show which has no rules of entry whatsoever, either stated or implied. In such shows you are likely to find pseudo-artisans selling imported or manufactured items—and sometimes pretending the items are their own work. You will also find very poor craftsmanship and design, as well as items made from kits.

Most show directors have their own standards for the type of work to be sold in their shows, in order to maintain the quality and reputation of their productions. It is usually a requirement that everything sold was actually made by the person doing the selling, or his partner if it is a two-man (-woman) operation. Others stipulate that the items must be the original design of the craftsperson. Many directors state specifically in their information fliers that they reserve the right to ask participants to remove objectionable work.

BOOTH VS. CONSIGNMENT
At most craft shows you must be there to set up your booth and make your own sales; but there are also shows which work on a consignment basis. There you do not have to be present during the show but are only required to deliver your work before the show starts and pick up unsold items when it is over.

The directors of the show may have a professional set up the displays or they may do it themselves; either way you do not have to worry about display. While you need not spend any time there, you may have paperwork to do beforehand. Usually you must carefully label each item you are submitting according to the instructions the directors of the show have given you, and give the directors a tally sheet listing all the items you are submitting. At the end of the show you should receive back a copy with a tally of your sales, together with the payment for these minus commission.

The consignment show may be run by a group of artisans or by a nonprofit group, often one that has nothing to do with art or crafts. It almost has to be run by a group with members as a volunteer sales staff, because quite a few people are needed to keep it running smoothly.

There are advantages and disadvantages to this type of show. Often the commission is higher. As the artisan you have no control over how

A variety of craft show booths

Displays at
consignment shows

items are displayed or even if they are displayed at all; there is a chance of losing items in the plethora of paperwork. Sometimes the emphasis in such a show is on display rather than selling. Among the advantages is the time you save by not having to remain at the show with your work. Usually these shows are juried, so the items tend to be of higher quality than at other shows. You may therefore be able to sell some of your higher priced pieces. All in all, a well-run consignment show can be very beneficial to you.

AMATEUR VS. PROFESSIONAL DIRECTORS

Shows can be categorized further by whether they are run by amateur or professional directors. Many shows are run by non-profit groups trying to make money for a charitable cause or for their club treasuries. A director for the show is usually elected from among the membership and this amateur director probably has a committee of people working for him or her to help run the show. All of course are working on a volunteer basis.

Such shows tend to be less organized than those put on by professionals, but not necessarily. While the amateur director usually is not as knowledgeable about the details of running a show, he is likely to be extremely enthusiastic and a hard worker who spends many hours in advance trying to make a good show.

Amateur directors put on such a wide variety of shows that it is difficult to comment on them generally. If they are run by groups of artisans, the directors are more likely to be considerate of participating fellow artisans and to cater to their needs.

In contrast to the volunteer, amateur show director is the professional, who earns all or part of his or her living by running shows. Such directors usually put on efficient shows because, with so much experience in the field, they know what problems can come up and are prepared to handle them. Furthermore, they have a following of dependable artisans who will participate and help them run a very professional show. This does not mean that every show put on by a professional director will be a success—far from it. But if a director consistently runs poor shows and is unconcerned about the welfare of the artisans who work with him, he is sure to lose his following. Word gets around; sooner or later the incompetent director will not be able to find enough artisans to participate in his shows.

Professional directors sometimes put on shows in public buildings. However, many directors have come to specialize in mall shows which are held at some of the thousands of enclosed malls or suburban shopping centers that have grown up all over the country. Malls allow the

shows because they believe they will bring in additional customers who will shop in their stores as well as look at the artisans' wares. Mall shows must be successful in attracting more foot traffic, or the malls just would not bother with them, claims Don Swann, an East Coast director who runs more than twenty shows a year, mostly in the Washington/Baltimore area. He says: "The Montgomery Mall in Bethesda, Maryland, made a survey the first time I put a show on there and found that the show raised foot traffic by 20 percent."

Advertising is vital to the success of the show, since it is meant to attract more people than would ordinarily be shopping at the mall. If customers are to come, they must be told the show is there. Usually both the mall and the show director supply advertising in newspapers, on the radio, sometimes even on TV.

The director works out all the necessary arrangements and rules with the mall management. The merchants do not want the artisans to be in competition with them, so for some shows certain types of crafts will be excluded. If the mall has a candle shop, for example, then the director will be told that no artisans selling candles can be allowed. Jewelry may be excluded as being in competition with the products offered by the stores.

Once the director has made all the necessary arrangements with the mall, he must recruit artisans. Sometimes show directors advertise their shows in such publications as *West Art, The Working Craftsman,* and *Sunshine Artists.* Many publications offer show directors free publicity for their events; they need only send in the necessary details. Artisans who see the shows listed in these publications can contact the director directly. (There is a list of such publications in Resource Section D.)

In addition, show directors keep a mailing list of artisans who have already participated in their shows or have stated a desire to do so. Periodically they send out announcements to all the names on this list describing the shows that have been planned. If you want to get on the mailing list of one or more directors in your area, write and ask to have your name added. Most will be more than willing to do this.

A listing of many professional show directors is given in Resource Section B at the back of this book. In writing to one of these directors to have your name put on his mailing list or to ask for an application for a specific show, be sure to tell him something about yourself. Explain the type of work you do. Do not just say "leathercraft" but explain that you make belts and purses and perhaps add a comment on how your products are outstanding or different from the work of other leathercraftsmen.

Tell the director what shows you have been in, especially juried ones, and what organizations you belong to, especially those with entrance re-

quirements. Include a resume if possible. If there have been articles in the newspaper about you, include copies—this type of information is very useful to the show director and it saves time if you submit it immediately.

WHAT IS A "GOOD" OR "BAD" SHOW?

Once you get started selling through shows you will learn from experience that certain shows are good and others poor. After several years you may be able to make a shrewd guess before the show about its likely success, although you will still make mistakes and attend shows you wish you had never heard about. At first, however, you will probably attend whichever ones you can in search of "good" shows.

But what is a "good" show? Is it the number of customers there? In fact, the exact number of customers who come is far less important than whether they are buying customers or looking customers; certain shows tend to attract more people who look but do not buy.

Probably the most important criterion is the amount of sales you make. Some shows are very profitable and the artisans attending have good sales. Of course, what constitutes "good sales" varies greatly from person to person, and from region to region. If you have few buying customers, you may sell nothing, but at a truly fantastic show your sales could reach several thousand.

The responsibility to provide this buying public belongs to the director, who must advertise adequately. If customers do not come, then no matter how attractive the show is, no matter how many artisans are involved, as far as its main purpose of generating sales is concerned, it has failed. Obviously the level of expectation for each artisan varies—an artisan may be very happy with a show even though sales were down if he made some good contacts.

The next criterion of a good show is quality work by competent artisans. Juried shows tend to have work of higher quality. Many show directors informally jury the work of artisans who participate and are constantly looking for new, well-qualified people to invite to their shows.

The third criterion of a good show is that it is well organized, as well as smoothly and equitably run. While artisans cannot control how a specific show is run, they can influence shows in the long run by participating in "good" ones and avoiding those that are poorly run or do not have enough publicity to attract a good buying public. If a show has a completely different group of artisans this year than participated last year, there is something wrong. Artisans want to come back to good shows. Customers seeing them again will often buy more than they did the previous year.

How can you tell in advance whether a show will be good or not? There are several methods you can use, but if these fail you will just have to take a chance. First, if you can find another artisan who has attended the show before, you can get a good idea of what it will be like. Shows do change from year to year but the directors are building on past successes (or failures).

A second way of predicting what a show will be like is to consider who is running it. If it is a professional director, study the type of shows this person has run in the past, using your own experience or talking to another artisan.

A third indication of a show's probable success can be found in the material about it sent to you. If it is coherent and gives you all the facts you need to know, if it spells out the rules that will apply to the show, then there is a good chance it will be well organized and smoothly run.

Shows can be poor for a variety of reasons, the most prevalent being lack of advertising. Other possible reasons might be that it was held at the wrong time of year, or the weather was against it, or it was the wrong spot for such a show. Exactly what went wrong will be discussed at length by the artisans who sit around waiting in vain for sales and discussing the problem.

Is there anything you can do if you feel a certain show or promoter is taking advantage of artisans and running poor shows? In addition to warning other artisans about participating, there are several publications that try to help. *Sunshine Artists* is written by people who are working artisans and was generated out of the feeling that everyone sits around and talks about the problem and no one does anything, the feeling that we as artisans are at the mercy of promoters, defenseless because "we need them more than they need us."

Sunshine Artists is subtitled "The Voice of the Nation's Artists/Craftsmen." It aims to help artisans by letting them know which shows were good and which should be avoided. It publishes monthly reports about shows all over the country, though the best coverage is of the South, and uses a rating system which tells artisans whether a show is improving or declining. It cannot of course cover all shows but tries to deal with a sampling, especially the largest ones. Basically it calls the promoters to task for what is wrong with shows, pointing out the ways to improve them. Space is allowed for replies to its at times very severe criticism.

Another publication, *Crafts Fair Guide,* covers the shows in northern California, using a comprehensive rating system depending on information from numerous artisans. Because it gives so much information on so

many shows, this is an invaluable guide for artisans in its area.

FINDING OUT ABOUT SHOWS

Shows, fairs, and festivals are growing in number every year. Finding out about them in advance is vital for the artisan who cannot wait until the publicity for the general public comes out—a week or so before the event. By that time all of the available booths are reserved, if the show is a good one.

One of the best sources of information on upcoming shows is fellow artisans. At most shows, there is a camaraderie among the participants and usually the talk does turn to forthcoming events. If you are willing to share your information with others they will most likely be willing to help you.

Magazines can be a good source of information on craft events. Check in the general arts and crafts magazines as well as those for your specialty. The addresses of a variety of arts and crafts magazines are listed in Resource Section E. Many of these list events; *Creative Crafts,* for instance, has a regular column entitled "Craft Events" which lists shows all over the country. The *Lapidary Journal,* a magazine for gem cutters, collectors, and jewelers, has an extensive "Calendar of Events."

When using any periodical for information about a show be aware that such information may be incorrect because of changes made after it was sent to press. The lead time, that is, the time between when the magazine was compiled and when it is actually published, is often months. So check in advance on all events—sometimes a show has been cancelled or there is a change in schedule.

A growing number of periodical publications aim to provide artisans with show information. Some are devoted entirely to show listing, others combine such listings with other editorial matter, while still others have the show listings merely as an added feature.

Since finding the shows and determining which to attend is so important to you, read carefully through Resource Section D of this book which is devoted to publications for selling artisans. Each publication is discussed briefly so that you will be able to choose those that best serve your needs.

FINANCIAL ARRANGEMENTS

Once you have learned about a show, one of your first questions will be: What will it cost to participate? Two different financial arrangements are used—fee and commission. The director decides in advance which he will use and informs all artisans who show an interest in participating in the show.

If you are paying a flat fee, you will pay that fee whether you sell $10 or $100 or $1,000 worth of merchandise. The directors generally will not even ask you how much you sold, although some do so in order to gauge how successful the show has been in producing sales.

The fees vary greatly. For a show held in a prestigious location—Madison Square Garden in New York, for instance—you may pay perhaps $500 for a booth. Some small local shows are free. Generally, though, the fees run from $10 to $50 on the average.

For some shows instead of paying a flat fee you will be asked for a commission—or a certain percentage of your sales, which of course cannot be paid until after the show is over. This percentage may be as low as 10 percent or as high as 30—again depending on where the show is held, who is running it, its past success at attracting customers, and so on.

In addition to the fee and the percentage type of selling, a third method combines both of these. Some directors charge a set fee plus a commission, that is, you pay a certain entrance fee before the show and at the end of the event you pay a percentage of sales. You might have to pay a $10 set-up fee plus 10 percent commission on sales. Sometimes directors make the initial fee deductible from the percentage paid as a commission; others charge the entrance fee in addition to commission.

Which method is better is debatable. Some directors say that if the director has to depend on a percentage of the sales for his own fee, then he will work harder to bring more people to the show so that more sales will be generated. Others feel that they do not need this incentive to produce good shows; they have an obligation to the artisans who participate to do the best they can in any case in promoting the show. And so the argument goes on.

What does the money paid to the show director cover as far as you are concerned? First and most importantly, it pays for the space you are allotted. As to which specific space, sometimes you have a choice but often the spaces are randomly assigned. They may just be parcelled out in the order in which the entry forms are received.

Occasionally all of the locations are about equal, but usually some spaces are far better located than others. The flow of traffic may be much heavier in certain parts of the show: if your booth is off to the side or tucked back in a corner, fewer customers may find you and your sales will be down. In contrast, your sales might be up if you are located near a refreshment stand, where people milling around drinking their Cokes or carrot juice might discover you. Once you have attended a show, you will know what space to request. Some show directors will accept requests for

specific spots from artisans who have worked with them before. If so, be sure you get your request in early.

If the show is to last several days, often the director arranges for a night watchman who will patrol the area. This allows you to leave display equipment and merchandise in place if you wish, so that you do not have to set up again each day.

The most important cost which your fee should cover is good publicity for the event. Show directors vary considerably in the amount of publicity they manage to obtain, and this is often a point of contention between directors and artisans; the former always feel that they have provided more than enough publicity, and the latter seldom think that it is enough.

Obviously for a show to be successful, publicity is a necessity. If the show is held where the people will be anyway, for instance, in a shopping mall or a downtown area, there is a certain guaranteed attendance if only of curiosity seekers. Artisans however want buying customers, and those who heard about the show and have made a special effort to come are usually buying customers.

If the show is held in a less traveled area, then the lack of publicity can spell sheer disaster; at such poorly attended shows artisans generally sit around complaining to each other and vowing never to come back again. Unless the directors can recruit a whole new group of artisans who have not gotten the word from the grapevine, they are not likely to have a show next year.

The amount of promotion that is feasible depends on how large the show is, who is running it, and so on. A fair percentage of the fees collected from the artisans should be spent on advertising. Many of the methods for gaining publicity discussed in Chapter 3 should be used by show directors; press releases to all the local newspapers, radio, and television stations are only a beginning. Directors should have handbills and posters made up and distributed. They should obtain as much free publicity as they can in the form of feature and news stories; they should also buy advertising space in local newspapers, and pay for spot announcements on local radio stations. And if the budget allows, they should pay for advertising on television.

In addition to telling the public about the show, directors should be sure that the artisans know all about it and the area in which it is located. They might send out information about local accommodations, restaurants, and camping grounds. Some directors make special arrangements with local motels where artisans can stay. If dormitory space in local colleges is available—which it often is during the summer

months—the directors might arrange for artisans to use it at minimal cost.

DISPLAY

If you intend to participate in shows on a regular basis, you will need to buy or construct some display equipment and add to it as necessary. Exactly what you make is up to you, but it should: (1) be adaptable to various situations; (2) fit in with your personality and the type of work you do; (3) be easy to assemble and disassemble; (4) show off your work to best advantage; and (5) allow you to keep an eye on your merchandise to protect against theft.

An eye-catching display is almost as important as the work itself because it is the general attractiveness of the display which makes people stop and look closer. If the bright fabric you bought to cover your table draws people's attention to the items on that table, it is worth the investment. And conversely, if the general appearance of a display is poor, messy, or shoddy, then customers may conclude that the work is so too, and pass you by without looking any closer.

June Richardson—a leathercraftswoman and one of the co-directors with her husband of J & R Productions—feels that display is vital. She says, "Stress to your readers that an essential factor in selling their products is how they present the product and themselves. This is an area where the best of artists and craftspeople fall apart. Too often beautiful work is set out on a card table and tablecloth or even just a blanket on the ground. This may have worked ten years ago when handcrafted products were in their boom period. Today, however, the card table routine doesn't work. *Professionalism* in all respects is now the key to selling one's products."

Each artisan's display should be different. Look at the photographs in this book, and study what the artisan has done to show off his or her work. Attend local craft shows and see what other artisans are doing. Examine the displays in local shops and galleries and consider how the ideas used there might be adapted for use at a show. But do not duplicate what others have done. Observe carefully what they have used and how they have used it, then use your own flair and imagination to adapt the ideas you have collected to your own needs and personality. If you attend a number of shows, you will find yourself modifying your display equipment as you get new ideas and have new work to display.

In planning your display, try to be as clever and original as you are in designing your items. Writing in *Craft/Midwest* (now *The Working Craftsman*), Bruce Towar says, "Ingenuity is perhaps the key word to

setting up your display. Whether an indoor or outdoor fair, cleverness can save you valuable time and enable you to operate more effectively in tending your customers."*

Versatility in your display is very important because if you attend a variety of shows you will have to adapt your display equipment to a great number of different situations. You might plan your display for a 10 by 10 foot area, which is the size generally used; but it should be flexible enough to fit into a larger or smaller space, or to conform to almost any given set of requirements. Most shows do have certain requirements for the height of the display.

Your equipment must also be adaptable enough to use inside as well as outside, on a grassy or paved area. Setting up outside will obviously present different problems from inside. You may want to build some sort of booth with a cover over it—perhaps you can buy a canopy or adapt a tent you already have. If you will be leaving your booth set up over night, plan your display so that some heavy plastic covering material fits over it to protect it from the elements.

Remember that whatever you buy or make should be as easy to carry as possible. Seek out lightweight, inexpensive materials. Remember too how often you may have to take down, carry, store, carry again, and set up these display pieces.

On the other hand you must be sure that the equipment is sturdy enough to withstand a crowd of customers and support the weight of the objects being displayed, plus lights if you use them, as well as any signs you wish to attach.

Try to design your basic pieces of display equipment so that they are easy to set up, with as few nuts and bolts as possible, and organize yourself so that you remember to bring all the parts and necessary tools every time. The display should also be quick to take down in case of a sudden rainstorm.

Finally, in planning your display keep in mind that it must fit easily into your vehicle, which should have enough room for display equipment knocked down and compactly arranged as well as for your products, carefully packed.

At first you will doubtless make do with the vehicle you have; a station wagon will probably be large enough. Later if you get very involved with attending shows, you may buy a van, used truck, trailer, or camper which you can equip especially for these jaunts.

*Bruce Towar, "Setting Up at the Fair," *Craft/Midwest,* Vol. 2, No. 3 (Spring 1973), p. 13.

Remember that you will be arriving at the show only an hour or two before it opens. In that time you must carry everything to your location, unpack, and have your display neat and ready to go and yourself well organized before opening. For some shows the first few hours are the busiest and you want to be ready for the onslaught of early customers.

Make each piece of equipment you bring as functional as possible to cut down on the number of items you must transport. Look for display props that will act as containers or display stands. For instance, you can use a big wicker basket to pack your items for transporting them; then use the basket as a display piece to hold some of your products.

Make use of ordinary, inexpensive materials in surprising ways. Pieces of wood and bricks can be useful—you can hide almost anything with a piece of fabric if you want some raised platforms. An ordinary stepladder can be painted attractively and used for display. Keep all your equipment in good condition, painting and repairing items when necessary, and your fabric coverings as clean and wrinkle-free as possible.

One of the most important considerations in preparing display equipment is that it is appropriate to your art or craft, and shows your work off to best advantage. Some arts and crafts can be effectively displayed in all kinds of ways. For others there do seem to be "best ways." Look closely at displays by artisans doing similar work. Then experiment with different types of displays to see which is the most effective for you.

According to Gordon Gattone, a show director and craftsman, the background you create for your work is crucial. He makes wire jewelry and has tried to display it in a number of ways. He says, "I have found only two ways to effectively display my work, either on velvet or on Plexiglas. Any other way I tried to display it simply did not work—it did not sell."

Gordon also says that lighting makes a big difference, especially for crafts like jewelry because it draws the customer's attention to certain items. Just the right lighting can make pieces even more attractive. At many shows it is difficult to find a convenient electrical outlet and get permission to use it, so artisans often carry battery-operated lights for their display.

One more consideration in preparing your display is security, which could be a real problem for you if your items are small and expensive. This is why those who make jewelry usually display it in a glass case that must be opened in order to reach the item inside.

To minimize your losses if you sell a variety of items, put the less expensive ones out front where customers can touch them and group the most expensive together so you can watch them better. Keep an eye on

A ladder used for display

customers—especially those who turn away when you look at them. But try to watch without seeming to do so, unless the person acts very suspiciously. Then watch intently so that he or she becomes discouraged waiting for you to look away.

If you think someone has pocketed one of your products you may comment on the item if he is still standing there, thereby letting him know you know. If this does not work, you can accuse him if you are absolutely positive. If not, proceed cautiously. If he walks away, perhaps someone can take over your booth while you follow and look for the director or a security guard who might ask the suspect to produce a sales receipt for the item in question. However, you will probably not get the chance to be your own detective because the likelihood is that you will not discover your loss until the end of the show when you check inventory.

DISPLAY UNITS

The most common display unit is the table. Some shows will provide you with a table and chairs if you wish, but most only give you a designated

A well-arranged, uncluttered table display

floor space or ground space—usually about 10 foot square. If you plan to use a table as the main part of your display equipment, buy the aluminum folding type which is light to carry and easy to assemble and take down. Get a good-quality one so that it will be as steady as possible. You will also need at least one chair. Folding aluminum chairs, sold for outdoor summer use, are fine. They are not very elegant but this hardly matters since you will be sitting a lot of the time and people will not notice it. Be sure you get a comfortable one as you may spend long hours in it.

Your table should have a covering, which should fall almost to the floor in front so that it hides whatever you store under it.

One way to make a table more interesting and attractive is to put platforms at various heights. Use anything sturdy to form the platforms and cover them with fabric. If you use the boxes in which your items were packed, they will be doing double duty for you. There are a variety of containers and other display props which can make a flat table more interesting and your individual items more visible.

Many other types of display units can of course be used, bookshelves being perhaps the best. If you have carpentry skill, you can do wonders with some wood and a few nails.

Some artisans make items which are meant to hang on the wall. Painters who paint pictures for hanging, weavers who make wall hangings, carvers who make wall plaques are among those who need some place to hang their work. These artisans have designed a variety of contraptions to stand there and hold up whatever is hung on them. Probably the most popular material for such units is pegboard, which is inexpensive and can be painted; with the proper hooks, items can be hung very easily and quickly at varying levels. Make the pegboard any size you can carry and fit into your vehicle. Pieces of wood are necessary to provide a solid base and a skeleton for the pegboard. Two or more tall sections of pegboard can be hinged together—these can be folded flat, but standing they help to support each other when set at an angle.

Another display device is one on which items can be hung. Potters who make hanging planters, leathercraftsmen who want to hang their belts or purses, and anyone who makes mobiles will need such a device. The ''A''-shaped form is probably the most popular and versatile. Think of it as an overgrown sawhorse but it can be just about any size. Shelves can be added to it for greater versatility.

When arranging items on your display equipment, group the less expensive ones together but give the more expensive items room so that they are sure to be seen. In setting out your pieces for sale, it is advisable

not to put out too many at a time—especially if they are similar to each other. Customers are willing to look at a limited number only and may be discouraged by too many. Keep a stock and put out more items as things are sold.

Try to put your items into a setting which will make their function obvious. If the piece is meant to be a vase, put some flowers in it; if it is a tea cosy, slip it over a teapot and put a few tea cups round it.

PACKING

In preparing to go to a show you must pack up and remember a myriad of items. A checklist is the best way to keep track of them all. There is something about writing down an item (even if you lose the list) which seems to help you to remember it. If you have a complete list, you will not be wondering as you finish packing, What have I forgotten?

When you have attended a good many shows, packing up becomes second nature to you, but still you might keep a running list so that you do not forget anything important. You have four types of items to remember: (1) merchandise, (2) display equipment, (3) sales equipment, and (4) personal items.

In preparing your merchandise, label each item with a price tag unless it will be with a group that has a sign on it. The price of each item should be visible. Once you establish a price for a piece at a specific show it is best not to bargain, even at the end of a show. Word will get around and everyone will try to bargain you down. But which price should you use? Should you charge the full retail price which a shop or gallery would ask? If you have established business selling through the shops in the area, then most likely you will keep the prices on your items the same as you would if they were selling in these shops. A shop owner stopping by and seeing your prices would feel you are underselling him if your show prices are less.

However, if you do not sell through local shops, you can set whatever prices you wish. Some artisans make it their policy to set somewhat lower prices at shows than would be charged for the same items in shops and galleries; but if the entry fee or percentage is high, they generally use the normal retail prices.

There is a difference of opinion on this matter of charging full retail price at shows. Those who charge less feel that customers come to shows hoping to pay less than the retail prices. If other artisans are charging less, they must do so also to keep their prices competitive.

Others say that you should stick to your retail prices regardless. If a buyer from a local store comes along and asks whether you would like to

Different levels are used to show dolls

Hanging items on
racks and pegboard

Pottery for sale, indoors and out

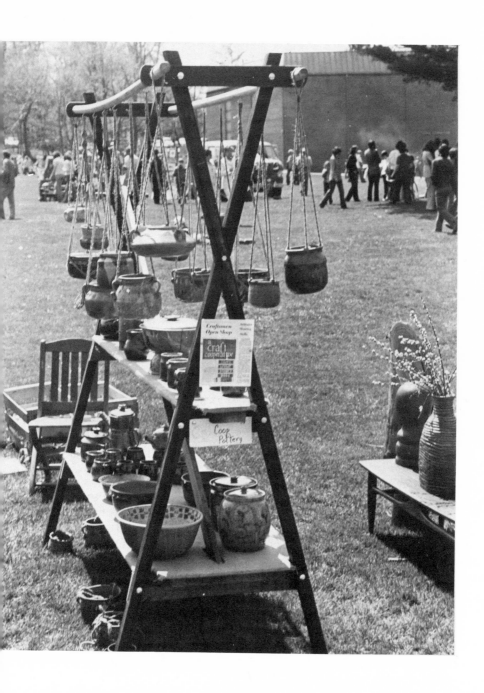

sell to his shop, he will expect your retail prices to be the full retail price, the one he will sell the items for.

When preparing your merchandise for the show, make a running inventory sheet or a list of the items you are bringing as you pack them (use single-letter notations and codes to make the list a quick and convenient one, because if it takes too much time it may not be worth the trouble). You can use this list to check off the items at the show as you sell them, or to check off the remaining items after the show. If your bookkeeping is correct, you should be able to account for each item either in your sales slips or in your inventory sheet. By using this method you can tell whether or not anything was stolen. Also it is a good way to tell which items are selling best.

In selecting which merchandise to bring to a particular show, base your judgment on the type of show and the caliber of customer you expect. For most shows, try to have merchandise in a wide price range if possible, with a concentration of items in the range you feel will sell best.

In addition to all the merchandise, you must also pack up your display equipment and the tools you will need to put it up. Try to anticipate any problems with the display and bring spares or tools for repair work. You may need cellophane tape or a staple gun. If you forget a vital item, precious set-up time can be wasted in trying to borrow or buy it.

In addition to merchandise and display equipment, you must bring your sales equipment. For most shows you will need your own change box, well stocked with small change and bills.

If you must collect sales tax (and most likely you will), then you should have a sales tax chart. Different states have different tax rates, as mentioned in Chapter 5, and in some states the rate differs from one county to the next. When you are going out of state, check into this beforehand, so that you will be ready to collect the correct sales tax.

At certain shows, especially those which are less professional, you may find that some artisans do not collect the tax. They are supposed to do so, and could get into trouble for not doing it—in some areas tax men have been known to frequent shows to check up on artisans. Some directors take the responsibility for sending in the sales tax but most leave this to you, and they may judge your "professionalism" by how you handle it.

Another piece of sales equipment you may bring is a sign and imprinter for a charge plan like Master Charge or Bank Americard. If you attend many shows, you may want to subscribe to one or both of these plans. Experienced artisans will tell you that they feel that having these plans available has upped their sales by 25 percent, especially if they have more

expensive items to sell. Many customers will come not intending to buy much. Suddenly they see something they like; but unfortunately they do not have the cash on them. If you accept a credit card they may buy; if you do not have such a plan available, you will have lost the sale. In the more professional shows, more artisans tend to subscribe to such plans. Of course not all artisans use charge plans—some feel they are "too commercial."

Should you wish to enroll in a credit plan, check with your bank to see if it offers one of the plans. If so, go to the bank officer in charge of it and he or she will help you with the enrollment. The procedure varies somewhat from bank to bank but is fairly easy. If your bank does not offer one of the plans, ask a local merchant who has a card on display which bank he uses. You will not have to pay a fee to enroll; however, you do pay to rent each card imprinter. In addition you pay from 3 to 5 percent service charge based on the volume of your business.

You will also need a sales pad with you for most shows. If the show director is charging a percentage he may give you a sales book to use, but usually you must provide your own (they are obtainable in local stationery stores). Usually such pads are made up with carbon paper built in so that you have copies of each sales slip—one for the customer and one to keep for your own records.

You can have sales pads imprinted especially for you, but this is an added expense. Rather than do this you can order a rubber stamp with your name and address on it and use it to print on the slips which you give to customers. Remember also your business cards and your guest book.

In addition to all the sales equipment, be sure to bring whatever you need for your personal comfort: some work or a book to amuse yourself during slow periods; some snacks and perhaps a lunch. If the show is outside, try to anticipate changes in the weather and provide for them.

WILL YOU DEMONSTRATE?

Directors often ask if you will demonstrate at the show. Some make it a requirement that you do so, others strongly recommend it, while others again are not concerned either way. Sometimes they will give you additional space if you are willing to demonstrate. If it is up to you to decide, you must consider how much trouble it will be and whether you can really get some work done.

Demonstrating can be formal or informal. At some shows there is a printed sheet or a listing of the specific times demonstrations will be given. These formal demonstrations usually draw a good crowd and you

Artisans demonstrating jewelry-making, belt-making

Painters at work in craft show displays

will have to more or less prepare beforehand. Often this type of formal demonstration is given at a central location, perhaps on a raised platform with chairs around where people can sit to watch. Hopefully after the demonstration some of the observers will seek you out at your booth. If the demonstration is held right at your booth, when it is over some will stay to buy.

An informal demonstration can be given whenever one or more customers stops at your booth. You may draw a crowd, especially if your demonstration is noisy and can be heard several aisles away. If it is spectacular, such as a glassblower working with fire, people are sure to gather.

Demonstrating can add to your sales—but there is no guarantee that it will. Some artisans feel that demonstrating definitely helps sales and heartily recommend it; others believe that you should not plan on added sales, and warn you to watch out for shoplifting while you are demonstrating.

Do guard against shoplifting. If you leave to demonstrate elsewhere, have someone watch your booth for you. If you are demonstrating at the booth, have someone help you to keep an eye on your work and make sales while you are busy.

Even if it does not add significantly to your sales, demonstrating is valuable in that it teaches customers more about your product and the art in general and gives them a better appreciation of it.

For some arts and crafts it is difficult to give demonstrations at the show. It may take more equipment than can conveniently be brought or there may be too many time-consuming steps to the process of producing a single item. If the process is a lengthy one, people are not likely to stay around. Try using photos or slides showing you doing each step as an alternative to a live demonstration.

DEALING WITH CUSTOMERS

When you are selling what you have made, you are not only selling the item but yourself. The personal relationship between you and your customer matters then, and your manner and approach can discourage or encourage a sale.

Your manner should be friendly, not haughty, and you should greet customers with a smile. If someone looks as if he wants to ask a question, ask if you can help him. If the customer is just looking and there seems to be an awkward silence, fill it with a "hello" and perhaps a comment on the weather, the show, or whatever seems comfortable. Put your customer at ease and encourage him or her to stay and browse.

Be helpful without being overbearing. Answer questions but do not offer information if the customer does not seem to want it. Often customers prefer to be left in peace to browse among your wares, to note prices on items they like and consider whether they really want to purchase them. In the lulls it is certainly acceptable to talk to your fellow artisans, but do not lose sales because a customer did not want to interrupt your conversation and could not wait until you finished the chat.

When making a sale be sure to handle the money very carefully. If you were starting a job as a cashier in a department store, you would receive training on exactly how to take money. Set up your own system and use it every time so that you do not make any mistakes. When the customer hands you the money, repeat the price of the item and the amount of the bill: "That will be $4.50 out of $10." Put the bill in a specific spot while you count out the change. If you put it immediately in with the rest of the money, and the customer says, "I gave you a $20 bill and you only gave me change for a $10 bill," you may not know whether this is true or not. When you have put the bill in a specific spot, there should be no question.

At shows you may be approached by shop or gallery managers who ask you if they might buy your work outright or sell it on consignment. Have your wholesale list available. Before agreeing to a selling arrangement try if possible to visit the shop, especially if you must work on a consignment basis. If the manager is buying outright such a visit is not as vital, though of course you would like to see where and how your work would be displayed.

AFTER THE SHOW

Once the show is over you should take a few minutes to evaluate it and perhaps commit some of your thoughts to paper for future reference. Note down how much and what type of items you sold. If it was a poor one, try to think what should have been changed. Suppose you blame the director for not getting enough publicity, then perhaps you will decide to avoid this show in the future or not to work with this specific promoter. If you feel that customers were buying in a lower price range than most of your items, then again maybe this is not the show for you, unless you can bring inexpensive items in larger quantity next year. Or perhaps there were too many other artisans selling products similar to your own. Again, better not come back unless the director changes his policy and limits the number in each type of work allowed.

You may feel that the particular location which you were assigned was

poor. If the show is worth coming back to, study the locations you would prefer so that you can request a different one next time, providing the director allows you any choice in the matter.

Next year when the new entry blank arrives, how will you remember what your evaluation of the show was? If you attend a good many shows it might be a good idea to organize some sort of information file about them. Write your comments and additional information right on the sheet the director sends you, which has already the vital information, including location and directions, rules and the name of the contact person. Alternatively, transfer all the vital information about each show into a certain format on index cards. In either case file the cards or sheets by the date on which the event took place. The following year you will have together the shows for each month so that you can see what you did and how successful you were, then make your plans accordingly.

Selling Through Shops and Galleries

Selling involves getting your product into the hands of the customer, whether by direct or indirect methods. If you are running a boutique or attending a show, you will be seeing your customers in person and selling directly to them; if you let someone else do the selling for you, you reach your customer indirectly through shops or a gallery.

There are many different types of shops, stores, boutiques, and galleries, and finding the right one or ones for you is vital to your success. Much will depend on what you have to sell. There is a big difference between the exceptional one-of-a-kind pieces accepted by a gallery and the production work sold by a department store. Also the volume of items to be sold through the various outlets varies greatly. Where does your work fit in? Where would it sell best? This chapter will try to get you started on finding the outlets for your work and setting up a mutually profitable relationship with them.

If you have been selling through shows and are now considering placing your work in shops and galleries, you will want to assess the advantages and disadvantages. One big advantage is that you will spend only a small percentage of your time on the selling process. Instead of hundreds of customers, who take up much of your time, energy, and patience, you will need to be in contact only with a limited number of professional buyers or perhaps just one gallery manager. A second advantage is that you can live anywhere within reach of the postal service. You do not have to be on the road a lot, so that your production can be much increased.

The main disadvantage, of course, is that your profit on each item will be smaller and you may have to increase production quite a bit to be in the same position financially as you would be if you were selling yourself.

Many artisans feel that shops and galleries are taking advantage of them because of the high mark-up on their items. In fact, most of these businesses do not make much money, and are often far less profitable than other types of shops.

The expenses of running a shop or a gallery are quite high. The more professionally it is run, the higher the expenses. Often the rent is expensive, as well as the heat and utilities. The shop has to pay for insurance, advertising, sales equipment, employee salaries, etc. Even if it takes 50

percent of the price of each item sold, the owner may have trouble surviving and making a small profit.

Shops and galleries are doing you, as an artisan, a service. They keep artistic and handcrafted items before the public in a way that a brief show or boutique can never do. They also display the items appropriately and help the public to develop a taste for beautifully made objects. Since they are open year round, they provide a stable marketplace for your work.

SELLING ARRANGEMENTS

There are two basic methods in selling your work through shops and galleries: consignment and outright purchase. The third method explained here is a hybrid of the two, known as guaranteed sales. In many instances you have no choice as to which one is used because the manager or buyer of the establishment defines the terms of the sale. You should know about all three, how they work, and the advantages and disadvantages of each so that you approach the selling arrangement knowing what to expect. Also you should be aware of the options in case there is a choice open to you.

CONSIGNMENT

Selling on consignment means that you leave your items in a shop and do not get paid for them until after they are sold. This method of sales has many disadvantages so be aware of them from the beginning. If you work with the wrong shops, the arrangement can be troublesome and virtually profitless and you may easily lose money.

If you are aware of the pitfalls and typical problems and approach consignment selling cautiously, however, it may prove a workable arrangement for you. Basically you are putting your merchandise in the hands of the shop owners on loan. If the manager is anxious to take your items on consignment, he may just be interested in filling his shelves with merchandise at no expense or risk to the shop. You will still own the items and the shop has not invested its money in them. If it had, the manager might be more anxious to sell them and recover his investment.

The risk is all yours. When the item does not sell, the store need only return it to you; if it becomes soiled or damaged, or even if it is stolen or destroyed by fire, the store may not reimburse you unless you have in writing the fact that the shop is responsible. (Even then you may have trouble collecting.) So choose the shops with which you consign very carefully.

In consignment selling you, the artisan, decide on the retail price of the

item. The store then takes a percentage of this price. If the price you set for an item is $6 and the store takes 33 ⅓ percent, you will receive $4 for your items. While this is the normal percentage in consignment selling, some shops take 25 percent or less. The percentage of the selling price you receive should be greater than if you were working on an outright purchase basis, because of the risk you have taken. If the consignment arrangement works out well with a specific shop, you do stand to gain financially.

As a beginner, consignment offers you a way to get started. While shops may be unwilling to buy new untested products, they may be prepared to give your work a chance on a consignment basis. Many shops may accept what you offer and give you a chance—by working on consignment you can try out a variety of small shops. Once your products prove to be good sellers, a shop manager is often willing to work with you on an outright purchase basis; in fact, he may be very anxious to do so in order to increase his profits.

If you are an experienced artisan and have enough orders to keep you busy, then you may refuse to sell on consignment. In some instances the shop manager may decide to order anyway and pay for your items outright; or he may offer to buy some pieces outright if you are willing to leave additional items on consignment.

The main problem in working with a consignment shop is that you may have trouble collecting your money. The shop may be poorly run and even go out of business. The reason many small shops ask to work on a consignment basis is that they do not have the money to purchase the items outright. If conditions get worse, then the store may not have enough money to pay everyone. It will pay its rent and those that supply large amounts of merchandise but the small suppliers like you can go unpaid.

Watch new or unstable shops very carefully. In order to be sure that your items are still safe and being exhibited properly, you may have to spend time and effort in going repeatedly to the consignment shop. For this reason, try to work with shops that are convenient for you; an arrangement by mail may be very unsatisfactory. Be sure to keep good records and check up immediately when a payment which is due does not arrive.

While consignment selling does have its disadvantages, there are certain times when you might consider it. Sometimes local charitable groups, perhaps one connected with the "Y," run consignment shops and you might want to support their projects by working with them. Certain very good shops are run on a consignment basis, and if you are sure

that they are well run and the percentage they charge is not too high, you may want to work with them. If they can sell a good volume of merchandise for you and are close by, working with them is all the more attractive.

An artisan who makes one-of-a-kind items may find that it is necessary to work on a consignment basis. Shops may be willing to buy production items which are proven sellers from you but unable to take a chance on buying more expensive items. Here you would have two different types of accounts: consignment and outright purchase.

OUTRIGHT PURCHASE

The majority of businesses work on an outright purchase or wholesale basis, that is, the store buys the items from its suppliers at wholesale prices, then adds on a selling cost and profit to arrive at a selling price. Actually with the exception of small craftshops and galleries, stores in general work on this basis. Once the store has purchased the items, it owns them and cannot get its money back from the manufacturer but only by selling the items to its customers.

With outright purchase your work is bought at a fixed price and you are paid within a certain period whether or not the work is sold. The store can ask any price it wants. Usually it marks up the item 100 percent or doubles the wholesale price: if the wholesale price is $2.50, the store may charge $5 or even more.

When an item is not selling well or some are left over at the end of the season, the shop may reduce the price and run a sale. The sale price is often close to the wholesale price so the retailer is just getting his money back—not covering selling costs on these sale items. Even though the item was sold at a reduced price this in no way affects the artisan, who has already been paid for it.

Selling by outright purchase is the most professional method of doing business, and is taken for granted in the majority of businesses. It has many advantages for you. Less bookkeeping is required on your part, and once a delivery is made, the bill should be paid in total within a specified number of days. (In contrast, if you leave items on consignment, the payments may dribble in over a long period of time.)

To sell outright, your prices on a wholesale basis must be low enough so that when the shop marks them up, the items will still sell. Furthermore, you must be able to produce your items in the large quantities which stores generally order when purchasing outright and deliver them when the shop wants them. The buyer is looking for consistency and reliability. He does not want to wait for delivery. Once he places an order he wants it soon. Your delivery should be quick and dependable.

GUARANTEED SALES

Another selling arrangement which is less widespread than the first two is the guaranteed sale. Here you are paid for your work by the shop within the specified period of time as with outright purchase; however, your responsibility does not end there. You promise that if what you have sold to the shop is not sold to a customer within a specified number of months, you will accept back unsold items as long as they are in good condition, and give the shop credit on these unsold items toward new items.

There are advantages to this type of arrangement for both the artisan and the shop manager. The artisan receives his money and does not have to wait for the sale of all of the items. The responsibility for the items is totally the manager's, and he cannot demand credit unless he returns them in good condition. The advantage to the manager is that he can try new items with the knowledge that if they do not sell he is not stuck with them but can get full credit as long as he keeps them in good condition.

TYPES OF OUTLETS

There are many different retail outlets for what you make. These vary greatly but can be roughly categorized, although you may be at a loss as to which category covers a specific establishment.

THE GALLERY

The word "gallery" is often used for establishments which present one-of-a-kind works, usually paintings but also prints and exceptionally fine handcrafted pieces. As a general rule, galleries sell their expensive one-of-a-kind works strictly on a consignment basis, but they may purchase less expensive prints outright.

A gallery may be run as a profit-making business or it may be sponsored by a wealthy group of people, called its "angels." The gallery usually handles a specific type of work, for example, only modern abstract paintings. A relatively small number of galleries are interested in crafts, while the majority deal mainly in paintings and prints.

The gallery often has a group of artists known as its "stable." It shows their work regularly and only rarely takes work from others. Usually the artist signs a long-term agreement with the gallery and works with it in all his marketing activities.

The competition to be accepted by a gallery is very keen. Of the many people who try to have their work sold in a gallery, only a handful succeed. The majority of galleries are located in big cities, especially New York, and the competition for acceptance by these galleries is very tough.

Your chance of having your work accepted by a gallery is slim, unfortunately. Galleries provide a small outlet compared with other shops.

In addition to what could be called true galleries, which feature only one-of-a-kind items, there are the places that call themselves galleries but are what we term "shops."

THE SHOP

All over the country in small towns and big cities there are shops which specialize in selling artistic and handcrafted items, and sell these exclusively or virtually so. Some always buy outright, while others work on a consignment basis; but many work partly on outright purchase and partly on consignment. They generally take the expensive items on consignment and buy the less expensive ones outright. They often ask to have new items on consignment but once an item proves to be a good seller they purchase outright.

The chances are that you will start by selling through some of these small local shops because they are the most suitable for items being made in limited quantities. These independent shops are often run by the owner/manager, who appreciates the items he is selling and may be very helpful to you if you are just getting started. Some specialize in one-of-a-kind handcrafted items, while others sell mainly production items. Sometimes the shop concentrates on a single type of handcrafted item or on the production of one type of craftsman or artist. Some shops sell their specialty to the complete exclusion of anything else; others will combine their specialty with a wide range of other items.

BOUTIQUES AND GIFT SHOPS

Another possible outlet for your work is the shop—perhaps called a boutique or gift shop—which deals with other merchandise in addition to artistic and handcrafted items. The term "boutique" can be applied to any number of shops, usually independently run. For example, one may sell chiefly clothing—often of an off-beat nature; in addition, it may sell a variety of accessories, including belts, pocketbooks, and other similar items. Because the boutique tries to offer items which are different, the pieces are often handcrafted.

Another type of shop which often combines handcrafted items with manufactured ones is the gift shop. If the manufactured ones are of high quality and tastefully chosen, the combination can work well; however, if handcrafted items are competing with very similar manufactured ones, the results may be quite poor for the artisans.

Florists often offer a variety of handcrafted pieces along with plants

and flowers—handmade plant hangers, and so on. Shoe stores carry handcrafted belts. These are only two examples of the many varied shops that may successfully sell handcrafted items as a side-line to another kind of product.

These small shops generally work on an outright purchase basis, but occasionally they ask an artisan to work on consignment temporarily—at least if his is a new type of item the shop has not carried before.

THE DEPARTMENT STORE

Department stores offer you another quite different market—usually a big one, because they are looking for items to sell quickly in large numbers. Of course there is great variety among department stores. Some specialize in discount items while others sell tasteful and expensive ones. The more expensive stores are the most appropriate for handcrafted items because they have discriminating customers who are willing to pay the necessary prices.

NON-PROFIT SHOPS

The non-profit or voluntary shop is run either exclusively or mainly by volunteers, and exists to help the artisan, especially the beginner. Such shops may be connected with a "Y" or call themselves a women's or handcraft exchange; or they may be connected with an art or craft association and run for the benefit of the members.

Because non-profit shops are geared toward helping the artisan, they will be more concerned about his needs. They are a good place for a beginner to start out.

Such shops are usually run on a consignment basis. However, you need not in general worry about leaving your items because the shops are scrupulously run by a group of volunteers dedicated to helping artisans. (Sometimes when items become good sellers they may be able to purchase these items from you outright.)

The percentage charged is often less than the usual consignment shop, that is, less than ⅓. Some shops charge 25 percent, others less. The percentage goes to pay the costs of running the shop, including rent, utilities, sales material, etc. If there is any money left over, these non-profit groups usually make donations to worthy causes or put it back into running the shop.

The shop may be run by a paid manager whose salary comes from the percentage charged. The salespeople in the shop are usually volunteers who donate their time to the cause. The manager too may be a volunteer.

Eye-catching displays in non-profit shops

If the shop is run by an art or craft association then the salespeople are the artisans whose work is being sold in the shop.

One typical non-profit shop is the Woman's Exchange in Westfield, New Jersey. This shop, run completely by volunteers, takes items on consignment from hundreds of consignors. Every Monday morning the line forms as people come with items for sale. A committee of three talks to each artisan discussing the items he has brought. If they think the items will sell they ask what prices the artisan is asking. While they are willing to give advice they always let the artisan make the final decision on the price. They tag each item and make out a receipt for the artisan listing the items he has left. Every two months each consignor who has had sales gets a check and a list of the items which have been sold. A note may be attached asking for more of a specific item.

FINDING THE RIGHT SHOP OR GALLERY

There are various ways to locate shops and galleries. From the beginning, you should set up a system to keep track of all the shops you have found. On index cards or sheets of paper in a looseleaf notebook, list all those you have contacted or may want to contact. If you find one accidentally, write down the name and address so that when you are ready to sell to it you have the necessary information at hand.

At first you may want to work with nearby shops so that you can visit and talk with the manager. In this case, where you live will have much to do with your opportunities for selling through shops and galleries—you will probably discover shops that sell artistic and handcrafted items by word-of-mouth, and may get some good leads on reliable shops from friends, neighbors, and relatives. If you can talk to another artisan who has worked with a specific shop, his recommendation will be especially helpful. Be sure to write down the complete information, along with the name of the person who recommended the shop.

If you attend art and craft shows or festivals, managers may ask you to sell through their shops or galleries; some shows have wholesale days specifically for shop owners. But rather than depending on chance or waiting for shop managers to approach you, you can actively search for appropriate shops and galleries. Remember as a general rule that people are more geared to buying artistic and handcrafted items in certain areas than in others; in college towns, for instance, there is a higher regard for arts and crafts. In certain areas of large cities (Greenwich Village in New York, or Harvard Square in Cambridge, Mass.), you may find quite a number of such shops, sometimes located very close together. These shops attract people from a wide radius who come specifically to the area to buy artistic and handcrafted items.

An attractive corner in The Woman's Exchange, Westfield, New Jersey

In wealthier suburban towns you will usually find one or more craft-shops; in small towns you are more likely to find a gift shop that handles artistic and handcrafted items as well as other gifts, greeting cards, wrapping paper, etc. In towns or cities with low income levels, the chances for success of a shop or gallery are poor unless the shopping area draws customers from the more affluent surrounding regions.

Another source of information about shops and galleries is the printed lists that are available. The *American Crafts Guide,* published by Gousha Publications, San Jose, California, is a directory of craftshops, galleries, and museums throughout the United States. This carries a state-by-state listing of shops by product: beads, batik, ceramics, craft shops and studios, glass, Indian crafts, jewelry, leather, woodcraft, and so on. The book has hundreds of listings, though of course it could not possibly include every shop in every state. It is revised periodically with additional listings to keep it timely; this guide is especially helpful because it not only lists the shops but tells something about what they sell. The American Crafts Council puts out a list of shops all over the country—mainly those which handle one-of-a-kind crafts and art work. This is available from the American Crafts Council, 44 West 53rd St., New York, N.Y., 10019.

Another possible source of information is the State Arts Council (see Resource Section C). Write directly to your state council and ask whether they have a list available of shops and galleries in the state. The Connecticut Commission on the Arts, for example, has a listing of over 100 galleries located in the state which is available to artisans on request.

A further source of information is the Yellow Pages of your phone book. Look under various headings; there is usually a category for "Art Galleries" but none for craftshops that sell completed items. Under "Craft" you will generally find shops that sell supplies. Try "Gift Shops," and check out those that look hopeful. If only the name, address, and phone number are given, it is hard to tell if the shop might handle handcrafts and artwork. Before driving any distance, call and ask if the shop carries such items. Also check your local newspaper: craftshops, boutiques, galleries, and gift shops sometimes place ads.

One more way to locate shops through which you might sell your work is to visit the business areas of nearby towns and cities and just look about for likely places. Go in and walk around those that seem the least bit hopeful. If you think your merchandising might fit in with what is being offered, ask the sales clerk whether the shop buys work from artisans.

Be selective if possible about the shops you deal with. Try to choose those which feature art and handcrafted items predominantly if not

exclusively. Visit them in person first if you can to determine whether the shop would be an appropriate one to handle your work. A large percentage of the failures by artisans to sell through specific shops is due to the fact that the artisans had not chosen the appropriate shops to carry their merchandise in the first place. Are the salespeople congenial, and knowledgeable about art and crafts? The displays attractive and well kept? Even after the relationship has been established, drop in occasionally, perhaps to deliver an order. If you see any problems or have suggestions to make, do so as diplomatically as possible so as not to alienate the manager.

Once you are established, do not over-extend yourself by trying to work with too many shops; it is much better to work with fewer shops that will sell more of your work.

Put top priority on reorders from the shops with which you have an established relationship. If you have as many orders as you can handle, refuse new ones. Keep the names of interested shops on file and contact them only when you are ready for more sales.

Invite the shop owners to visit your studio. By doing so they can learn more about your work to tell interested customers. They might be able to offer positive suggestions—ideas for new products often spring up in this way.

APPROACHING A GALLERY OR SHOP

The first time you go into a retail shop to ask the manager to buy your work will probably be very hard for you. Try to be as relaxed and pleasant as you can; you will find that most of the people you meet will be that way in response. If you have good work to sell, remember that by giving the shop a chance to sell your items you are helping it to make money. The situation is beneficial to both of you: you are not asking the buyer to do you a favor, but giving him a chance to make money by selling your work.

Try not to pay attention to individual rejections but accept a certain number of them as inevitable. Above all, timing is important. Shops do their buying months in advance. If your item is a Christmas one, do not expect the buyer to be interested in November; he ordered his Christmas items in July, August, and September.

In small stores the manager is generally the buyer. Simply walk into the store and ask to speak to the manager. If he is there and free, tell him what you have to sell, and try to show a sample immediately so that he can see how well designed and made your products are. For the buyer of a large department store, an appointment is usually necessary. Call the

buyer's office and ask when he or she sees people with merchandise to offer. Usually there is a specific time and place for this.

In presenting the items try to show them off to the best advantage. Make a traveling display that is easy to set up if this is practical. If you can bring an appropriate background on which to show your items, this will help to sell them. When small enough, attach them right to the background, which will also help them to travel better. For example, if you sell jewelry, cover a piece of cardboard with velvet fabric and attach individual items to this. Use good color combinations and contrast so that the pieces look good against the background.

For small items choose some method of coordinating what you present. You might group them by price, with all of the items under $5 together, those under $10 together, and so on; or by the materials used; or by the use, or color, or shape of the pieces.

If you are bringing a variety of samples with you, attach a large label to each item giving complete information on it. Where items are coded on the price list, put the code number on the label. If the item comes in different colors, list these on the label. Also put the wholesale price per item—or for small items the cost per dozen or whatever quantity you choose to sell. When a minimum limited number can be ordered, note that too on the label. Attach the label securely to the item, whether tied, pinned, or taped. If the buyer wants to look over the items again or show them to an assistant, all the information is right there.

Once your pieces are properly labeled, you must pack them up so that you can carry them easily. What you use to carry them is not important, but it *must* keep them in good condition. Also it is important that you can pack them into the carrier and take them out again swiftly. If the items are large, perhaps you can bring just one sample to show the quality of your workmanship. Bring photographs or slides of other pieces in case the buyer wants to see more samples.

Before going to see a buyer, bear in mind the questions he might ask and have your answers ready. When an artisan acts as though he is uncertain, the buyer may feel he or she is not competent or dependable and may not want to work with him.

First, decide on the prices you will ask. If you sell your production items, have your price list ready with both wholesale and retail prices listed. Where the items are to be sold in quantity—and those priced under $2 most likely will be—figure out the per-dozen price (or whatever other quantity is convenient).

In the case of large department stores you may need two different price lists. These stores have very high operating costs and therefore mark up

their merchandise more than 100 percent. If you want to work with them, you may need a second set of wholesale prices. The first set of prices would be for small shops that would be buying in modest quantity from you; the second for the very large orders you are likely to get from the big department stores.

Another question you should be ready to answer is whether or not you are willing to leave samples at the shop. A few buyers may ask you to do this; however, there is reason to suspect their motives. Sometimes they ask to hold your items overnight so that they can be copied. The buyer might send your items to a friend or a business acquaintance who immediately sets about making a pattern or copy. The next day when you return for them, you will not suspect what has been done. Sometime later if you go back to the shop you may be surprised to see copies of your items for sale.

Furthermore, a shop sometimes takes small orders, and when they sell very well, the manager gives samples to someone else to copy and produce for him at a lower price. This type of copying is very hard to stop. Of course, you will stop dealing with the shop and warn other artisans. If you belong to an arts and craft association, perhaps the group can help you put pressure on the shop to deal fairly with artisans.

The buyer might also ask if he can buy the exact items you have brought to show. When your items are one-of-a-kind, then certainly you will want to sell directly from your display. However, if you sell production items, it might be better to have him order these.

As far as reorders are concerned, you cannot automatically expect the buyer to call you and ask for more of your merchandise. This rarely happens. You must make the first move again by calling the store for another appointment. You might say that you have something new which you would like to show. If the buyer had a good experience ordering from you in the past, no doubt you will get another appointment and a further sale.

EXCLUSIVES

The buyer may ask you for an "exclusive"—or the right to be the only store selling a specific item or line of items within a certain geographic area. Some sophisticated, expensive shops work only on an exclusive basis; others never even consider exclusives. Most shops, however, fall somewhere in between. They do not want to have the same items that are carried by all the shops in the neighborhood; nevertheless, they do not try to limit you from selling to other shops. In giving an exclusive, be sure to stipulate its geographic limits and which items are included.

It is also very important that your exclusives have a time limit. You may agree to as short a period as a month, but no longer than a year. You could agree to an option, so that if after the period of time agreed to both parties are satisfied with the arrangement, it can be extended for mutual advantage.

SELLING THROUGH A GALLERY

Approaching a gallery is a different problem from approaching the buyer for a large department store. Usually the artisan appears in person at the gallery and asks for an appointment. A good time to catch the manager is late morning, when he or she may have time to speak to you. Since he may be willing to look at your work immediately, come prepared with about a dozen slides of work you have done. If the manager is interested he may ask you to leave the slides for further study.

Galleries generally operate differently from craftshops. One may accept your work and then ask you to pay part of the expenses for a show or opening; if so, be sure that you know exactly what you will be charged for. The expenses might include having a catalog printed and mailed out, purchasing advertising, and supplying refreshments for the opening. Before you agree to the opening, make sure that you understand what your financial obligations will be.

If your work is accepted by the gallery it will almost inevitably be on a consignment basis. Only some smaller pieces are bought outright from the artisan; expensive pieces are almost wholly on consignment. Be sure that the selling arrangements are clear to you, that you know what percentage will be retained by the gallery, and when you will get your money after a piece is sold. This information should be in the consignment form that you sign—if it is not, add it to the form while you are talking with the manager.

SELLING ON CONSIGNMENT

If you decide to place some of your work in a shop on consignment, discuss the arrangement thoroughly with the manager. In addition to establishing what percentage the shop will take, you must also agree on when it will forward your money. Some shops work very informally and ask you to come by whenever you can to pick up your money. This is a poor arrangement. It is unbusinesslike and wastes your time. Try to get the manager to send out checks on a regular basis. Many shops pay consignors regularly once a month, generally the first week of the month or at least by the 15th for the items sold during the previous month.

Another point on which you and the manager should agree is when you should come and remove the items which have not sold. Also discuss and put in writing who is responsible if something happens to your items to make them unsaleable. Some stores will agree to take the responsibility in case of theft, fire, or loss of your items; others will not agree to take any responsibility. If the manager refuses to be responsible, then you must decide whether to take the chance. Look around and see how the shop owner is handling the merchandise already in the store to give you some basis for a decision.

Find out who pays for the shipping if items must be mailed. Usually the artisan must pay if he is working on consignment, but some shop owners will split the cost. If the manager decides to send back items unsold after a certain period, say two months, then generally he would do so at his own expense.

Supposing that you have goods on consignment in several different shops, it is very important to keep good records. Get a receipt signed by the manager stating that the items were actually delivered. Keep these receipts in one place in case you need to refer back to one for proof that you delivered an item.

While you may be wary of forms, you will find that a good consignment agreement form can be most helpful. Sometimes the shop has a form which it will ask you to sign—or you can supply your own. What is important is that you both go over the form and agree to each stipulation before signing it. Putting terms in writing is a good idea and protects both parties. The form reproduced in Figure 23 was made up by the Guild of American Craftsmen. It not only specifies the terms under which the agreement is made but also makes it easy to keep track of each of the items placed on consignment. You may use this form as the basis for one you make up for yourself or order copies of it to use.*

The upper section of the form gives complete information about the shop and you. The phone number of each might be added after the name. To the right is a space marked "Agreement No." If the shop is numbering the forms, it could assign a number to each artisan and put this code number on each price tag for items from that artisan. Thus, if you are artisan "78," your items would be coded "78-1," "78-2," etc. As soon as one was sold the manager would know which artisan to credit with the sale, and which specific item was sold.

*Copies can be ordered from the Guild of American Craftsmen, Box 645, Rockville, Md. 20851. Fifty forms will be mailed to you postpaid for $2.50.

CONSIGNMENT AGREEMENT AND REPORTING FORM

I. NAME OF SHOP _Wonderful Things Gallery_
ADDRESS _106 Watchung Ave._
CITY _Medway_
STATE _Mass._ ZIP _02053_

NAME OF CRAFTSMAN _Paula Williams_
ADDRESS _97 Hillside Ave._
CITY _Dedham_
STATE _Mass._ ZIP _02026_

AGREEMENT NO. _84_
AGREEMENT DATE _7/8/76_

REPORTING DATES	AMOUNT PAID CRAFTSMAN
8/1	18.20

This consignment agreement is between the shop and the craftsman shown above. The shop agrees to display the consignment items properly and to maintain them in good, saleable condition for a period of _12_ weeks, or until _____ (date). The shop will receive _30_ % of the retail selling price of any item it sells.

II. ITEMS PLACED ON CONSIGNMENT

ITEMS PLACED ON CONSIGNMENT	RETAIL PRICE	DATE SOLD	AMOUNT DUE CRAFTSMAN	DATE PAID
1. daisy pocketbook (yellow)	10.	7/15	7.00	8/1
2. tulip pocketbook (red)	10.	7/20	7.00	8/1
3. daisy pillow	7.			
4. child's dress – green print	6.			
5. child's dress – orange print	6.	7/14	4.20	8/1
6.				
7.				
8.				

III. TERMS

a. The items listed may not be sold for less than the retail price indicated. If any are sold for more, the craftsman is to receive his share of the higher selling price.
b. If shipping is involved in getting the consigned material to and/or from the shop, the shop and the craftsman will share the cost of shipping equally.
c. Unless this agreement is renewed, the craftsman agrees to pick up any unsold items, or have them shipped to him by the shop, within 15 days after the termination of this agreement.
d. Any item which cannot be returned to the craftsman in perfect condition at the termination of this agreement will be considered sold and the craftsman will receive his share of the purchase price for it.
e. Beginning 30 days after this agreement, and monthly thereafter during the term of this agreement, the shop will report which items, if any, were sold, and will attach a check to the craftsman in payment of his share of the items sold since the last report.

Signed: _Billy J. Simms_ Date _7/8/76_ _Paula Williams_ Date _7/8/76_
FOR THE SHOP: NAME AND TITLE CRAFTSMAN

Figure 23. Copies of this consignment form are available from the Guild of America Craftsmen. Or you could use this form as a basis for making up an original one that fits your purposes better.

Below this are the reporting dates—the days on which the manager sent you a check and information on what had sold. The sentences below stipulate how long the shop will hold your items, and what percentage of the price it will take once they are sold.

The middle section of the form gives you room to list the items placed on consignment, and the price at which they are to be sold. You fill out this information. Once the items are sold the manager should fill in the next two columns, and when payment is made he can fill in the last column. Using this section should allow you to keep track of every item you have put on consignment in the shop.

The third section lists the terms under which you are putting your items in the shop. The first term guarantees that the items will be sold at the retail price you indicated or higher. This means that the shop owner cannot run a sale and include your items without your permission.

PAPERWORK FOR OUTRIGHT PURCHASE

When you sell through a shop or gallery, the management will expect you to use accepted business practices. The larger the store, the more formal the procedures. You will need to keep good records of your orders, deliveries, payments, and so on.

Business forms—including invoices, packing slips, and statements—are available and will make the process easier for you. You can buy these from stationery stores or local office supply stores, or by mail order from such companies as The Drawing Board (P.O. Box 505, Dallas, Texas 75221). These forms can be imprinted with your name and address, but you need not go to this expense. You can order a rubber stamp with your name and address and stamp it onto the forms yourself. At first having them imprinted is probably a luxury you can do without; as your business grows you will find it very convenient to have them printed.

ORDER FORMS

The first form used in the selling process is the order form, which you fill out as the manager or buyer tells you what he wants. You can get an all-purpose sales form. These are usually sold with two copies and an original fastened together (either with carbon paper between the layers or special pressure-sensitive paper for the copies). You keep one copy and give one to the buyer. If you are dealing with a small shop, the order you write up and have signed by the buyer will be the official order. In dealing with a large department store you may write up the order as you discuss it with the buyer; however, this is not the official order. The buyer will take a copy of your order and perhaps discuss it with a boss or

bring it to a sales meeting. If they decide to go through with this provisional order, you will receive an official purchase order confirming the purchase from the store. This form should have an official order number and a final date for delivery.

Three different dates may be on the order form. The first is the "date of order," that is, the date the buyer gives you the order. The next is the "date of shipment," that is, the date you have agreed that you will ship the merchandise. Be sure that you are realistic in estimating this date, because if you cannot fulfill your committment you may lose not only this order but any future ones from this store. The last date on the purchase order is the "cancellation date" that is, the date when the order can be cancelled if you have not delivered the items ordered. You should of course try to ship on the date appointed but you have until the cancellation date before the order is cancelled.

Another item which should appear on the purchase order as shown in Figure 24 is the shipping instructions, under the designation "Shipped via." Sometimes a specific delivery service is designated by the shop. If not, you can mail via parcel post, UPS, or truck—whichever you prefer.

Figure 24. The buyer may send you a purchase order to confirm your sale.

Be sure to get a receipt or certificate of mailing so that you have proof that you shipped the items.

In the lower section of the form in the quantity column, be sure to label your figure—is it dozens? The description may have to be cryptic, but be sure to put sufficient information so that both you and the buyer know what was ordered. "Unit price" is the cost of "each" or "dozen" or whatever quantity description is given in the quantity column. The final column showing the total cost is arrived at by multiplying the quantity by the unit price.

INVOICE

Whenever you send out an order, you should keep track of it by making out a form called an invoice. Large stores always require invoices, and for the sake of good records, you should send invoices to the small stores as well.

Like the order form, the invoice is usually made up so that there are three copies of it with carbon paper between the copies. Some of the large stores will ask for two copies of your invoice because their record system requires them. Send two copies and keep the last copy for your file.

The invoice is usually mailed separately and should be sent out the same day as the order so that it will arrive before the order does to warn the shop it is coming.

The invoice form (as shown in Figure 25) is similar to the purchase order but your name is written at the top instead of the company or store that ordered your merchandise. That name goes in the blank marked "Sold to." The invoice might also have a space marked "Shipped to." In this space you should fill in where you sent the order if it differs from the "Sold to." Sometimes a store will tell you to ship to one address but send the invoice to another. If the address is the same, merely write "Same" in this area.

The form will also have an Invoice No. When you begin to order forms printed with your name, you can request that the invoice numbers also be printed consecutively. Some invoice forms come with numbers already printed on them. Otherwise you can make up your own number and then number each subsequent invoice in order after it. It is customary to start with a four-digit number rather than the number 1.

Fill in the form with the quantity, description, unit price, and amount of the items you are actually sending. If there are more items on the purchase order than are being presently shipped, make out a second invoice listing these items when you actually send them.

An extremely important piece of information on the invoice is the pur-

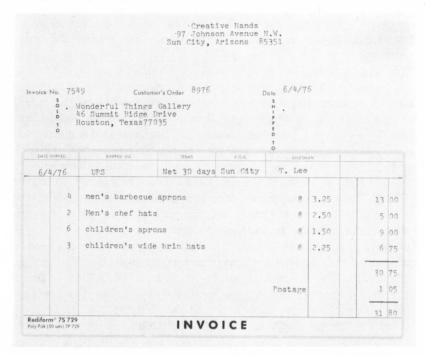

·Creative Hands
·97 Johnson Avenue N.W.
Sun City, Arizona 85351

Invoice No. 7549 Customer's Order 8976 Date 6/4/76

SOLD TO: Wonderful Things Gallery
46 Summit Ridge Drive
Houston, Texas 77035

DATE SHIPPED	SHIPPED VIA	TERMS	F.O.B.	SALESMAN		
6/4/76	UPS	Net 30 days	Sun City	T. Lee		

4	men's barbecue aprons	@ 3.25	13	00
2	Men's chef hats	@ 2.50	5	00
6	children's aprons	@ 1.50	9	00
3	children's wide brim hats	@ 2.25	6	75
			30	75
		Postage	1	05
			31	80

Rediform® 7S 729
Poly Pak (50 sets) 7P 729 **INVOICE**

Figure 25. You can buy invoice forms with duplicates to keep track of all of your orders.

chase order number. All the purchases made by a large store are identified by a purchase order number. You must have this number on the invoice and on any further forms you send in connection with this order so that the receiving department can find the original purchase order when the articles arrive. If there is no purchase order number, the order may be refused. For a very large store the form might also have a department number, that is, the number which tells whether the items were ordered by the gift department, the shoe department, etc.

A further item which appears on most purchase orders is "Terms." Often there is a space followed by "%" and another space followed by "days." The most common terms are "2/10/30" or "2% 10 days, net 30 days." What that means is that if the bill is paid within ten days, the shop can take a 2 percent discount. After ten days the full amount must be paid within thirty days. A variation of this is "2% EOM" (End of Month) which means that the discount of 2 percent is still good until the 10th of the month following that in which they were shipped.

While the discount procedure is a general practice with gift shops, it is

not normally practiced by artisans and you may choose not to do it. Instead you can say "Net 30 days," which means the customer has thirty days to pay.

If you want to receive payment sooner than thirty days you could make your terms "net 10 days" (the shop may be reluctant to agree to pay so fast). Or if this is a new account, you might ask instead for "C.O.D." (Collect on Delivery), which means that the shop must pay the delivery man. You can send your items via parcel post and the mailman will collect cash for the items when they are delivered. Be sure that the shop has the invoice before the shipment arrives so that it is certain to have cash on hand. If you ship UPS the driver will accept a check. Receiving "C.O.D." can be inconvenient for a shop, but it may have to continue to do so until it establishes credit. Another alternative for terms is "pro forma," which means the shop pays before you ship.

A point that you should have discussed with the buyer in addition to the terms of the sale is who will pay the shipping costs. Usually the shop will do this. On the invoice might be written "F.O.B."—meaning "Freight (or Free) on Board" and the name of a place. If the place is where you are, then the shop is paying the shipping; but if the place named is where the shop is located, you are paying this shipping to this point. Provided that the shop is paying shipping, add the parcel post or UPS charges to the total cost of the goods on the invoice.

PACKING SLIP

Quite similar in form to an invoice is a packing slip. The items to be filled out on it are the same. However, in listing the items you must put only those that are actually in the box in which you are enclosing the packing slip; so you might have several packing slips to cover all the items on a single invoice.

The function of the packing slip is to allow the receiving department in the store to check off the items you have sent and verify that they have arrived. The number on the packing slip will be the same number as on the invoice.

Sometimes if all of the items in an order are boxed in the same box, the packing slip is merely a copy of the invoice. Sometimes an extra copy is added to the basic three copies of the invoice so that the extra copy can be used for a packing slip. This extra sheet might be marked "Packing Slip" and the columns for prices blacked out since only the numbers and the listing of items are necessary on a packing slip. This slip, which verifies that the items arrived, can be matched up with the invoice and the bill paid. The packing slip can be enclosed in the box before it is sealed. An

alternative is to use a plastic packing list envelope (available from your office supply store); attached to the outside of the box, this brightly colored envelope, which is waterproof, says "Packing Slip Enclosed," thus drawing attention to it clearly.

SHIPPING YOUR WORK

If you are working with local shops you will probably deliver your orders rather than shipping them. When you do deliver in person or have a friend deliver, be sure to have the shop manager or salesperson sign that the items were received.

But when you ship items to the shop or store, it is a customary business practice to bill them for the cost of postage and for part or all of the cost of the materials you use to protect them in transit (packing charge). Be sure to pack everything very carefully, using materials which are strong and durable. Do not waste money on fancy or overly expensive wrappings. If anything is broken or damaged in shipment, your package may have been insured but you still have the problem and bother of collecting on the insurance.

Some items are obviously much harder to ship than others. Those that are fragile should be individually wrapped and the package labeled: "Fragile, Handle with Care." The outside of the box should have a shipping label with both your name and the shop to which it is going written in large clear print.

BILL OF LADING

One additional form you might need is a bill of lading. If you are shipping over 100 pounds to one shop, it will go via a trucking company. You can find trucking companies listed in the Yellow Pages, though you may have to call several before you find one that will handle your merchandise.

On the bill of lading—a form which you can buy from your local office supply store—the merchandise is listed so that the company can figure out the charges, depending on the type of merchandise you are sending. Give the original to the trucking company, keep one copy, and send one to the shop.

STATEMENT

A statement is another name for a bill. The invoice tells the person or store what you have sent or delivered; the statement asks the store for payment. Sometimes of course you will be paid when you deliver your

merchandise or within the thirty days stated on the invoice, in which case you are saved the trouble of making out a statement.

For all the invoices which have been mailed and payment not yet received, send out a statement at the end of the month. If a store owes you on more than one invoice, they can all be listed on the same statement. Again, forms are available from your office supply store.

RECORDS

There are many different ways of keeping track of who owes you how much; some are quite elaborate, needing an accountant to figure them out; others quite simple. Probably you will need only a very simple one. You might use your invoices to keep track of payments. Keep all your copies of invoices together. If they are bound in a book, fine; if not, figure out some method of keeping them together.

When a payment arrives, mark the invoice as paid by making an "X" through the invoice number, or using some other form of notation. Also note the date of the payment. If it is only a partial payment, you should record it as such on the invoice. Do not make your "X" through the number until complete payment has been received. Use your marked invoice at the end of the month, to make out the statements.

As your business grows you might have several orders from one store during a single month. Using the invoices to make out statements can be cumbersome, and you may want to turn now to a system known as "Accounts Receivable."

For this system you will need a separate form for each company you deal with. (Forms are available at office supply stores, along with the invoices, purchase orders, etc.) On the top of each form you will write the name of the company. On the sheet you keep a running total of the amount the store owes you. As you send out each invoice, record the invoice number and its date. Under the debit column, write the amount of the invoice. Carry this figure over to the balance column. When you receive payment for the invoice, fill in the date received and again record the invoice number. The amount you received should be recorded under credit. This amount should then be subtracted from the last balance and a new figure written in the balance column. If the bill has been paid in full, no money is owing to you and you should fill in the balance column with a straight line.

If you are ever in doubt about your addition or subtraction you can add all the columns. The debit minus the credit should give you the balance, as can easily be seen in Figure 26.

Which Craft, Inc.
46 Milltown Road
Possumtown, New Jersey 07077

Date	Invoice No.	Debit	Credit	Balance
7/2	5061	46.00		46.00
7/8	5078	20.00		66.00
7/25	5061, 5078		66.00	—
8/3	5110	15.00		15.00
8/25	5110		15.00	—

Figure 26. The accounts receivable is one system you can use to keep track of how much each shop owes you.

Figure 26 gives you a sample of what your accounts receivable form might look like. You sent out orders to the store on July 2 and 8, so the invoice numbers are listed and the amounts recorded in the debit column—the balance is $66. You received a payment on July 25 to cover these two invoices, so the invoice numbers are recorded, the amount listed under credits, and the balance is now zero. And so on.

The form will have three columns for figures. The first is the "Debit," which means the amount of money owed to you. The second column is the "Credit," which is the amount of money you have received. The last column, the "Balance," is a running account which tells you the net amount or exact amount owed to you at the time. This figure of course changes as you enter more debits and credits.

COLLECTING YOUR MONEY

The majority of stores you deal with will pay their bills without your bothering them. However, you may occasionally have trouble—especially with a store that is not doing well itself.

If you have sent out one statement and after a month the bill still has not been paid, you should send a second statement with the notation on it: "Past Due." If the store is nearby, you might want to make a quick phone call. Ask for the accounting department and inquire about the bill. Do not of course send any other items to the shop until the bill is paid. If your attempts to collect your money fail, you can threaten to take the shop to small claims court. Proceed carefully, as outlined in pages 67-68.

The best way to lick the problem of payment is to prevent it. Try to deal with reputable stores. If you are dealing with a new store or one far away from you, consider working on a C.O.D. basis.

There are a variety of ways of checking into a store's credit before you

deal with it. If they are honest and have nothing to hide, store managers will not be offended by the fact that you are checking on their credit before shipping them merchandise. It is customary business policy to ask for credit references.

One way to check up on a shop is to ask the manager to give you the names and addresses of two or three artisans who already sell through him. You can then check with these people to be sure that the store does indeed pay its bills. This is a common practice among artisans and can be very effective.

If you have a large business, you might want to set up a relationship with Dun and Bradstreet or another credit-rating firm. These services are expensive and you will probably want to get by without using them at first. Should you decide to use one, look in your phone book for the nearest office and call for further information.

Rather than checking credit, you may be able to get the shop to pay in advance or at least to give you a deposit when you take the order. You could promise your regular terms for reorders.

SALES REPRESENTATIVES AND WHOLESALERS

A sales representative is a person who goes out armed with samples of your products and travels from store to store trying to sell them. Usually he represents several producers. He gets orders for each of them and passes the orders back to them to be filled.

If you are a beginner in craft sales, this may sound like a very good way to sell your products, especially if you are not anxious to become involved in all of the details of selling. You feel that you would rather stay home, concentrate on producing, get the orders sent to you, and fill them as they arrive.

Stop right there! The first thing you should know about a professional sales representative is that he is not interested in a new untested line of products put out by a beginner. He will not be interested in selling what you make until you have proved that it is saleable and that you can produce enough of your product to make it worthwhile for the agent to handle the work. Before he works with you he wants some guarantee of the amount of business he will do selling your work. Therefore, you will have to do the selling yourself until you can prove to an agent that he would make a certain amount of money per month representing you.

Agents fall into two general categories: formal and informal. Your best friend might be a non-professional agent for you. If he or she is going on a vacation, he might volunteer to take some of your items and show them in shops he happens to visit. By all means deputize him to be

your agent but be sure that he knows exactly what to do. Arm him with samples, a wholesale price list, and any other sales material you have available, and promise him a small percentage (maybe 10% of the retail price) on any sales he can make.

Working with a professional agent is of course a completely different story. This person makes his living by selling items for other people; if your production is too small it will not be worth his time to deal with you. You must be able to show the representative that you can produce a large enough volume of items to make it profitable for him and that you will deliver what you promise when you promise it.

When you do have someone representing you, there are two basic ways you can arrange payments. In cases where you get paid by the shop or gallery, and then in turn pay a certain percentage to the person who got the order for you, this person would usually be called your sales representative. However, if the salesman pays you directly and sells your work collecting directly from the shops and galleries, he could be called a wholesaler, rather than a sales representative. Wholesalers and sales representatives who do a large volume of sales may have a staff of salesmen who travel from shop to shop making sales. They also may have showrooms in at least one if not more of the large merchandising centers, including New York City, Chicago, Los Angeles, and also perhaps Boston, Atlanta, and Minneapolis. Buyers for stores can go to these showrooms on purchasing trips and see the new products for sale.

With such a large operation the volume of sales for any one product may be very large—if you want to work with a wholesaler, your production must therefore be high. (For a low-priced item production will probably have to be by the gross.)

The percentage which a sales representative asks for an item varies with how difficult it is to sell. For those that sell in large quantities with frequent reorders, the percentage will be low, perhaps as low as 10 percent. For products which are difficult to sell and repeat orders infrequent, the percentage may be as high as 30. In order to use a sales representative your wholesale prices must be such that you can afford to pay him a commission. This too must be allowed for in your pricing.

Sometimes a sales representative finds you. At shows he may be looking for additional lines to complement those he represents. If he thinks yours would be a possibility he may approach you; he may see items you have made in a shop and ask the manager who you are and whether you might be interested in having a sales representative.

If no one approaches you, you can look for a representative yourself. One of the best sources of information is the shop managers and buyers

you deal with. They will know representatives who handle items like those you sell, and they will know who is effective, dependable, and honest. Other artisans may be able to advise you. Personal recommendations are your best bet. If you must use another source of contacts, be sure to check out the person carefully before dealing with him. You can advertise for a sales representative. At a show, especially if there are wholesale days, you could put a small sign on your exhibit stating you are looking for one. You could also advertise either in one of the marketing-oriented magazines listed in Resource Section D or in the trade journal for the type of merchandise yours might be sold with—for example, the gift trade.

Once you have found someone interested in becoming your sales representative, you must come to an understanding with him on certain basic points. Ask him for the names and addresses of three credit references and for the names of several artisans or companies he currently represents or has represented in the past. Check up on these before closing a deal.

Next, you should put in writing in the form of a contract the duties of each person and all necessary details concerning money and time. Discuss these details with the representative. If he is well established in business, he will tell you how he prefers to work and discuss with you any issues on which he is flexible. Before you sign the contract have your lawyer or accountant read it over carefully.

First decide exactly what percentage of sales the representative will take, how this percentage is to be paid, and exactly when. Discuss the number of samples of each item which the representative will need, and when such samples will be returned—or will they be charged to the representative, and if so at what price (usually at a discount from the wholesale)? This cost might be subtracted from his commissions.

If the representative has a showroom, find out whether you will be charged a fee toward operating expenses or overhead, this fee being over and above commissions. Will you be charged for any publicity or printed material the representative has made up about your products as part of his selling campaign?

Decide how often the representative is to forward orders to you. Be sure to figure out who will check the credit of the stores which are ordering, and if there is a problem collecting from any of these stores, how this problem will be handled. If you wish to reject an order, note that you may do so, notifying the representative within perhaps two weeks.

Sales representatives often cover a certain territory, and usually want to be the exclusive representative of your products in those states considered their territory. They often demand that on every order you re-

ceive from that territory, whether it comes through a show you attend or from a mail inquiry or whatever, they receive the commission. You may be able to get the representative to agree not to demand a commission on orders from other sources, although he may get a commission on orders in the future if he goes to call on the shop and gets follow-ups.

Spell out in the contract very carefully which territory the representative has on an exclusive basis and for which products, if he does not handle all of your items. Also be sure to set a time limit on the contract. You should stipulate a certain time at which it will lapse unless reviewed by you both and mutually extended.

Once you have secured your representative, you should send him as much material about your business as possible. Give him multiple copies of your sales material—including price lists, order forms, information sheets, and brochures, as well as slides, photographs, copies of any printed publicity available, etc. You will also have to send some samples of the items.

The representative will be interested in how large your production can be, and how quickly you can ship out orders. He will also want to know when you pay commissions. He might ask if and where you advertise your products, and whether you are willing to pay extra toward trade show and showroom costs.

Try to be as helpful as possible. After all, the situation should be mutually beneficial, and the more effective he is at his job the more orders you will receive. Tell him all about your items and how you make them so that he can answer any questions buyers might have. Describe the materials you use and their quality, and the process you use in creating your items.

Another way you can help him is to take care of the orders he sends promptly. Ship as soon as you can. And be sure to maintain the quality of your work so that the items you send are as good as (if not better than) the samples he carries.

When you get an order from your sales representative, it is a good idea to send a confirming order directly to the shop which has made the purchase. If there is a mistake in the order, the shop can let you know immediately. When the shop receives the confirming order they will know you are working on their order.

The confirming order may simply be a copy of your invoice. Type up the invoice, leaving out the shipping date. Take one of the three copies and stamp or write on it, "Order confirmed," then fill in the date you expect to ship. If you list the shipping date the store will have some idea when to expect the merchandise.

Once the order has been shipped and accepted by the store, you will be

expected to pay the sales representative. You could arrange to make payments to the representative by the 10th of the following month for all orders shipped the month before.

Keep in close contact with your representative, and find out how buyers are reacting to your work. If orders are coming in slowly, find out why. See what advice the representative has for you concerning new products, new trends in buying, and so on.

If things are not going well, you may have to end your relationship with the sales representative. Perhaps the arrangement has not proved profitable to either of you, in which case by mutual agreement you may terminate it.

Mail Order

Mail order is growing in popularity as a way of selling artistic and handcrafted items. Large organizations, not only commercial enterprises but also non-profit organizations like museums, are putting out full-color multi-page catalogs with a myriad of beautiful artistic and handcrafted items for sale. At the other extreme, individual artisans are sending out mimeographed copies of their price list, illustrated perhaps with line drawings, to a few dozen names on their mailing list of customers who have bought from them in the past. Between these two extremes lie many, many people who are trying to sell handcrafted items by mail.

While some artisans began their business selling by mail order, many others have found that mail order sales have been a natural outgrowth of the other marketing methods they have used.

If you are an artisan with an established business and you have a line of products with some proven good sellers, then perhaps mail order would be a good way to increase your sales. If you are a beginner in craft sales, start out cautiously with mail order because this type of selling has many pitfalls. Mail order selling is a complicated business, highly competitive and potentially disastrous. You will not become a success overnight, despite those ads that promise you instant wealth by selling through mail order.

Building up a mail order business takes time and patience, and it is certainly not for anyone who is looking for instant profits. Mail order selling also requires a great deal of organization. You can very easily waste a whole lot of time with little or no return for your investment.

In mail order you must be willing to wait for profits and not expect high ones in the early stages of your business, otherwise you will be discouraged and quit. Initially this is a very costly way of making sales because advertising, printing, postage, and mailing lists can all be very high, nonetheless the effort and investment will probably be worthwhile in the long run so long as you are willing to continue over a period of time.

If you want to sell your products directly to customers through mail order you have two alternatives. Either you can advertise (perhaps in a magazine), or you can conduct a direct mail advertising campaign by sending out a brochure or printed advertisement of some kind directly to potential customers. Both alternatives are costly.

Because a mail order business is so risky it is a poor idea to try to go into it full time from the beginning—especially if you are trying to support yourself from it. Instead, it is better to start off part time with no expectation of immediate profits. You need time to do research on the most effective methods, and this research in turn takes time.

ADVANTAGES AND DISADVANTAGES

Mail order does offer a variety of advantages. It gives you an opportunity to build up a very good business for yourself which you can carry on part time if you wish. It might be an especially appropriate method of sales if you live in an area where the chance for retail sales is poor, or if you cannot reach shows or get out to do other types of selling.

Mail order opens up a huge potential audience for you: anyone who receives and can send mail is a potential customer. Furthermore, you can work with a fairly short line of items.

Another advantage is that you need a minimum of space and equipment to run such a business—a typewriter, a worktable, chair, and storage shelves are all you need, and even these can be second hand.

Mail order can be very profitable if you work hard, proceed intelligently, and are lucky. As a producing artisan you do have a somewhat better chance for success than others starting out because you control the source of your supply of goods. You are not dependent on others for what you sell and can adapt your production to your mail order business. Also you can offer custom service and personalize products if you wish.

However, the disadvantages of mail order selling are considerable. A major one is that running a mail order business is very time-consuming. If your business becomes a large one, you may have little time left to produce because you will be so busy with the secretarial details and with wrapping and mailing. Tom Aagerson, who publishes the Candle Mill Village catalog which does a large mail order business, says: "To start a mail order business is to give up your own crafts work and become a publisher and manager. It takes up to five years to make a profit, and it takes time and capital, but is a real investment in the future."

A second major disadvantage of mail order selling is that the customer cannot see the item until he actually orders it. Artistic and handcrafted items are best appreciated when they are seen at close range, and photographs are a poor substitute here.

KEEPING YOUR BUSINESS LEGAL

To start a mail order business you should not need a license or permit; however, if your state collects sales tax, the sales tax office will want to

hear from you. In most states you are required to collect sales tax only on those items which you sell to people within your own state; any out-of-state orders are not taxed. (See page 103 for more information about sales tax.)

If you are doing business in your own name you will have no problem opening a bank account or getting the mail for your business. Assuming you decide to do business with a company name, then you must register it with the county as explained on pages 60-61. Also alert your post office so that you receive the mail. You can get a post office box if you wish but this is not necessary; in fact a street address seems more personal and therefore appropriate for your type of business.

In addition, in order to keep your business legal you should not make claims about your products in advertisements which are not true. The Federal Trade Commission is concerned about truth in advertising in magazines and newspapers and has strict rulings on this.

Send off your orders as quickly as possible. If an order is unduly delayed, the customer may think he is being cheated as non-delivery of goods is the most common complaint against mail order houses. The impatient customer may complain to the local post office and an investigation could follow.

WHAT PRODUCTS SELL BY MAIL ORDER?

Production items are most commonly sold by mail order; one-of-a-kind items are only sold this way under unusual circumstances.

To do well with mail order sales you really need a line of items because it is in the repeat sales that you make your profit. If you are planning to insert an advertisement in a magazine or newspaper, you will probably be featuring a single outstanding item and offer a brochure at minimum charge. Therefore you need this one outstanding product—a good seller and one that will grab the attention of the reader. Remember that this item represents you and your entire line.

Both your line of products and your featured piece should have certain characteristics if they are to be good mail order items. One of the first requisites is that they should be unique, different—something that is not commonly available. Customers do not want to bother to address an envelope, make out a check, and then wait for something to arrive unless it is different from what they can buy at their local department store.

In fact, one of the most important requirements for something to sell well by mail order is that it is unique. Certainly unusual handcrafted items which are original in design fulfill this qualification. Since repeat sales are very important to you if you are in the mail order business, you

need to consider whether your products are likely to lead to repeat sales. If the customer has found that one gift bought from a mail order source has been a success, he may want to order again when another gift is needed.

Other aspects of your products will encourage repeat sales. If the workmanship, design, and quality of the materials please the customer, then you are likely to get a repeat sale. If you carry a line of related items, then you may get repeat sales. Perhaps you sell jewelry and a customer who has bought a pin might later want to order earrings to match.

Another qualification for the item featured in your advertisements is that it should ship well. You will hope to be sending out many of them so they should be easy to pack and mail safely. Before you advertise, check out how you will package your item and how much it will cost to mail it. Many claims for damages can wreck your business. If the item is fragile or hard to wrap, it is a poor selection.

A further consideration is price. Needless to say, the higher the price of an item, the fewer you will sell. If a customer is paying a high price he generally wants to see the thing before buying it. Items in the $2-$15 range are usually good sellers; those priced higher tend to meet with sales resistance.

However, in your brochure you can list pieces in a wide price range. If the customer has already ordered from you, he would be much more amenable to ordering a higher-priced item because he knows the type of quality you deliver.

A further qualification for the item you choose to feature is that it should be easily captured in a photograph or lend itself to a brief written description—just a few words must make it interesting and desirable. The item may be fantastic when you actually see it but if it does not photograph well then it will not be a good mail order product. If it depends on color for much of its appeal, you may not be able to sell it successfully through mail order because your budget probably will not allow you to buy a full-color advertisement. The quality of the materials and workmanship will not be evident in a photograph, nor will the texture. Rather, the overall shape and form must be sufficiently appealing in the picture.

SETTING YOUR MAIL ORDER PRICES

Before you send out your first flier or insert your first ad in a magazine or newspaper, you will have to decide on the prices you are going to charge. Probably you have already been selling through other channels and have established a firm set of wholesale prices. But the cost of selling

by mail is higher than other methods. You have to consider not only the obvious costs of advertising or direct mailing but also the amount of time spent in preparing advertisements or brochures, answering letters, wrapping orders, etc. Then you will also have overhead costs. Even if you work at home you should still include a percentage of your expenses for utilities and such as overhead. You do want to make a profit on your business.

Your price structure will be different than that for other types of selling. For mail order the price might be divided into three parts: (1) the wholesale price of the product; (2) the cost of advertising; and (3) wages, postage, overhead, wrapping supplies, and profit. All three must be taken into consideration when you set your price.

Once you have tentatively decided on a price, compare it with similar products selling by mail order. If your price seems too high, try to see where you can cut back; but do not sacrifice quality and workmanship, because it is these two qualities which will stimulate repeat orders—the vital ingredient of mail order success.

Do not forget the cost of postage. Some companies ask a certain percentage of the total order to be added for postage and handling; others supply a postage chart. To use this you must first figure out the weight of the items ordered, then find this weight on the postage chart to get the proper amount to send. Some companies instead give postage paid prices, that is, the postage is already included in the price. This method does make the prices of the items seem higher and the customer does not see the true cost of the postage. You can use whichever you wish but be sure to remember the cost of postage when you make up your advertisements and order blanks.

ADVERTISING YOUR PRODUCTS

In order to get mail order customers you may try to obtain free publicity in newspapers and magazines. It is possible to get free editorial mention, but you cannot plan your mail order business around this—such free mentions are really a big bonus. Send out press releases as suggested on pages 46-49. If you mention to the editor that you will be starting an advertising campaign in his magazine and have ordered several paid advertisements, your chances of getting free publicity are even better.

One excellent way of getting free publicity is to have your products featured in a "catalog of catalogs." *The Whole Earth Catalog* seems to have started the popular trend and catalogs continue to be published. The Pequot Press, Inc. (Old Chest Road, Chester, Conn. 06412), pub-

lishes the *New England Catalog.* Publisher J. Chandler Hill says that the catalog is an "excellent source of free advertising for the craftsmen and many have written to us to ask how to be reviewed in it." If you are interested in having your work in such a catalog, write to the publisher and enclose a flier or brochure about your products. He will let you know what to do from there.

You can advertise your mail order product through the radio or television. Both are costly so that they are used mainly by large-volume ventures. One possibility which you might consider is advertising on the radio on a "per inquiry" (P.I.) arrangement. There are a variety of radio stations all over the country which are willing to grant you advertising time in return for a percentage of your sales. Usually this advertising is aired late at night.

Once the product has been explained to the radio audience, orders are solicited—to be sent in to the radio station itself. When the orders arrive, the station takes its commission which usually runs about 40 percent; the rest of the money is sent on to you and you mail the orders out. These radio stations reach the small towns and rural populations which often respond well to such advertising. You could ask a radio station to work with you on this basis, but listen in yourself first to see which stations in your area use this type of merchandising. Write a letter to the Advertising Department, including some information and a photograph of your product. Explain what commission you are willing to give and whether you will offer listeners a money-back guarantee.

While you may decide to give radio a try, magazines are the most popular medium for mail order advertising. Newspapers also carry such advertising, sometimes in a "Shopping Guide" in the Sunday magazine section or Sunday supplement.

To be successful in mail order advertising you must know the market to which you want to sell. What kind of person would be most apt to buy the merchandise you are offering? If you are going to advertise in magazines, find out which ones your typical customer reads; for example, if you want to sell to teenagers, then you must use the magazines they read.

In choosing the magazine in which to advertise, don't stop at those with which you are already familiar, but look for others which will cover the audience you wish to reach more efficiently and at the least cost. Look for appropriate magazines in the *Writer's Market* or through the *N. W. Ayer Directory of Newspapers and Periodicals.* (Your local library may have these reference books or perhaps others which list magazines.)

What you are looking for is the publication that can reach the audience best suited for your product at the least expense figured on a per-reader

basis. Much of course will depend on what you intend to sell and in what quantity. If you are interested in selling handmade items in very small quantities, you might consider inserting classified advertisements in magazines like *Stitch and Sew, Popular Handicrafts and Hobbies,* or *Olde Time Needlework* (see Resource Section E). These magazines, published by Tower Press, offer classified ads to handcrafters at less than 10 cents a word.

However, if you want to sell on a larger scale you will most likely use display advertisements. Do some careful research to find out which publications would be best for your product. Proceed slowly, as the decision which magazine to use is crucial and may mean the difference between your success and failure in mail order sales.

When you have narrowed your choices down to perhaps three or four, consider these carefully. Look very closely at all the mail order advertising they carry and analyze it. Try to obtain several copies of the magazines in question. Often your local library will have back issues available and may let you borrow these. Or you can write to the publisher and ask for sample copies, mentioning that you are interested in advertising in the magazine.

See if there are ads for merchandise similar to your own. Watch a particular ad and see if it is repeated from one issue to the next. Ads that are constantly being repeated must be successful. Choose a publication which carries a good deal of mail order advertising, especially if it has products similar to your own. Such a magazine is probably a good vehicle for you.

Study these ads for the price ranges of the items being offered. Is one item advertised and a catalog offered? Read the copy or wording carefully and analyze how the ad is put together.

If you have analyzed the three or four magazines you chose at first and found none were just right for you, continue looking until you have found several others that you think would really sell your product and analyze these. When you have found several good possibilities, send a letter to the business offices of the magazines you are considering. Ask for rates and information about advertising. By return mail you will receive a rate card which explains the various size ads available and the cost of each. The card will also give you the closing dates for each issue, that is, the date on which the magazine must have the advertisement copy for the specific issues; in many cases this closing date is months ahead of publication.

The rate card will also tell you about the mechanical requirements of the magazine: what size your material should be and what you should

submit. Most publications will set the type for your advertisements and submit a proof for your approval. Some charge a small typesetting fee.

In addition to this information on the rate card, the magazine might also include information on its readership. Some magazines do extensive research to find out about their readers. They will be able to give you their circulation figures and might be able to tell you what percentage of the readers has ordered by mail and how frequently. Sometimes they can break down the figures into categories so that you know what percentage of readers has ordered the type of merchandise you are selling.

Once you have all this information you are ready to prepare your advertisements. If you have a choice between taking one larger ad or several smaller ones, multiple exposure is better, so choose the smaller ads. If your ad is well designed and clever, a small one can be as effective as a much larger one—especially if it is a real eye-grabber. Try to advertise in the same magazine at least three times a year with the same or a similar ad. Usually magazines have a discount rate for three ads in successive issues. Customers who see the same ad repeated from one issue to the next gain confidence in it and may order.

Time your ad for the peak selling season for your product. The cost for advertisements is the same for every issue. If you are selling a Christmas item and most of your sales are in November and December, place your ad in the October, November, and December issues. You will notice that these issues of many magazines are often the largest because they carry so much pre-Christmas advertising.

PREPARING YOUR ADVERTISEMENT

When preparing your mail order advertisement, look carefully at the ads in the magazine you have chosen. You can learn more from a thorough study of these than you can in any other way. You may decide to advertise just one specific product on which you give full details, including the price and ordering instructions. Usually you would choose your best selling item.

The copy or wording of your advertisement is very important. If possible, catch the reader's attention in a provocative headline which gets him to read the rest of the message. This selling message should be as succinct, brief, clear, and fully descriptive as possible. As soon as what you are selling is clear, call for action on the part of the reader. Ask him to send in promptly to purchase the item being offered. Choose your words carefully and write and rewrite until you have said the most you can in the fewest, most convincing words. Include such information as the size and shape of your product, as well as how to use it. State what

colors it is available in as well as explaining its quality of design and workmanship. Stress the fact that it is handmade. Do not make exaggerated claims but don't be too modest either. In addition to the wording in your ad, you may be able to incorporate a photograph or line drawing which presents the item as attractively as possible. The best quality photograph is important because much of the clarity of the photo may be lost in reproduction. Be sure to send a black-and-white photo if your ad will be in black and white.

If you can offer a catalog free or at minimal cost, you will get replies from people who are interested in what you have but not ready to buy it, or who are interested in something like it but not the exact product being offered.

Before your ad actually appears, make sure that you have enough stock to cover possible sales. You should arrange to have ready at least enough stock to cover the cost of the ad.

Do not expect immediate results, however. The first few ads may not even pay for themselves. Some people order immediately; many others delay. Some ads will draw a response for a long period of time. Do have your ad appear in several consecutive issues—many people will decide to order only after they have seen it two or three times. If your orders from the first ads cover the cost of the advertisements, consider yourself extremely lucky.

HOW EFFECTIVE IS YOUR ADVERTISING?

With most types of advertising you cannot tell exactly how effective they were; but in mail order advertising, you can figure out exactly how many replies each advertisement pulled. From this you can tell which of several different publications you may be using is the most effective. You can compare the effectiveness of different advertisements and compare the results from different months.

If you have inserted several different advertisements, you will want to know which replies came from which magazines. There are several ways to cue or key the responses. In the case of a coupon which the customer fills out, you can put a number or letter somewhere on the coupon that tells you which ad the coupon came from. Or a department number or letter can be included in the address. Or you can cue the address any way you wish as long as you can tell which advertisement the person had in hand when ordering. Often the customer is told to ask for "Catalog B," or whatever. In fact there is only one catalog but the letter indicates which ad the customer was using.

Check how other mail order companies key their replies. Their keying

system will be very obvious once you are aware of it. Often the initials of the magazine are given, or the month and year, and sometimes both. If you are looking at *Creative Crafts,* a mail order ad may ask you to write to "The Calico Cupboard, Dept. CC277." The keying system indicates the initials for the magazine, followed by the month (2 for February) and the year.

Once you have stopped getting responses from a specific ad, total up the inquiries and sales and determine how much it cost per inquiry and per sale. Then you can see if this cost is in line with your price.

You can only hope to break even on the ad, and (as I said before) if you do so the first few times you advertise you will be very lucky. The real reason you are advertising is to develop a mailing list of satisfied customers to whom you will send your brochure along with the single item they bought from the advertisement. In the ad, offer to send a brochure free with the first order or free or at minimal charge to anyone interested enough to ask for it. Your real profit should come in the repeat sales from satisfied customers.

DIRECT MAIL

Another comparable way of selling your products is by direct mail, that is, by sending a letter, flier, brochure, or price list directly to the customer. To do this you must first decide to whom you are going to send the material, and then prepare it. There are professionals to help you with both jobs.

MAILING LISTS

You could try a shotgun approach and send a copy of your brochure to everyone in the phone book. However, this would spend a lot of money on postage and printing with little result because you are sending to people who never order by mail or are not interested in handcrafted items. How can you find the people who are interested and do order by mail?

You could develop your own list—for example, by asking customers at shows to sign your mailing list. This method takes much time and effort but the response from such a mailing is likely to be much higher than that from a list of potential customers obtained in any other way.

One alternative is to get professional help. Mailing list companies operate in large cities all over the country; you can find them listed in the classified section of your phone book. Or write to the Small Business Administration for their Small Business Bibliography Number 29—National Mailing-List Houses (see Resource Section G).

These mailing list houses have many different lists of names and addresses in numerous classifications—by income level, by profession, by ownership of specific cars, etc. The cost of any list depends on how selective it is. The more selective and specialized, the higher the cost.

Several kinds of business arrangements can be made with these mailing list houses. You can rent or purchase a list. If you pay a lesser sum, you rent the list once; or you can pay more and get a copy to use however you wish. If you are renting it you are only supposed to use it the number of times you negotiate for. To check up on use, the mailing list house might add a few phony names so that if you try to use the list without paying they will be alerted.

Sometimes the mailing list house will not allow you to actually see the list of people to whom your material will be sent. Instead they may ask you to give them the material—they will attach mailing labels and put it into the mail for you.

The lists are usually sold at so much per name or per thousand names. You might pay $25 per thousand names to use a list once. Some mailing houses will not only try to sell you their mailing lists but to interest you in their other services. They may have a full service business, which handles the lists and also prepares and prints the fliers and catalogs, folds them, puts them in envelopes if necessary, and addresses them; in short, they do the whole operation for you. While this complete service is much more expensive than merely renting a list, it may be worthwhile for you, especially if you are very busy with production. Obviously you must weigh the cost against the savings in time and effort.

YOUR OWN MAILING LIST
The life blood of any mail order company is its mailing list. By developing your own list of satisfied customers you are building up your business. For the first purchase any customer makes from you, if you are very lucky you will break even. Your profit lies in the reorders you will get from this person. Your costs for the first sale are so high because you had to go out to get this business, whether through direct mailing or an advertisement. Therefore keeping your mailing list organized and accurate is vital if you are to have a successful mail order operation.

Your list can be organized in various ways. If you keep each name on an individual card, you can record contact information on it. You might keep two different files, one with names of customers who have actually bought products from you and the second, a list of people who have not yet ordered.

On the cards you could record information about the customer,

including where you got the name. Figure out a code so that you can quickly enter the names of the various magazines you might have advertised in, or the other sources of names. You could also mark the card when you send out a mailing, and when you have sent out several mailings with no response, you might remove the name from your list. Once a person has made a purchase from you it is a good idea to keep his name on your list even if he does not respond to several mailings. He has bought from you in the past and there is a good chance he will do so again.

Envelopes or catalogs can be written out individually or typed. You can buy gummed labels in sheets in stationery stores and put carbon paper between the layers of labels, making several copies at once. Some copy machines have special label paper; if the copy machine will copy on any paper, you can use actual mailing labels.

To automate your work further you could have addressograph plates made up—these flow through a machine and do your addressing for you. There are a variety of different devices for making address labels; check on these with your office supply store or printer. Remember, however, that using a mechanical system makes your mailing look mass-produced. Some customers will automatically toss out any such mail without even looking at it. The personal handwritten address does have an advantage in getting the customer to open up your mail.

It is important to expand your mailing list constantly. Ask customers for the names of friends, relatives, and neighbors who might be interested in receiving your brochure. Keep the names of everyone who buys from you in person. Perhaps you could exchange mailing lists with another artisan because customers who buy one type of handcrafted item are usually interested in another. If you can get copies of club membership lists these might be added to your mailing list, especially if the type of person who belongs to the club is likely to be interested in handcrafted items.

PREPARING YOUR MAILING

When you are going to send out a piece of direct mail, you want it to be as effective as possible because you are investing so much time and money in getting it into the hands of prospective buyers. You might send a letter, a brochure, or a flier; but no matter what you send, it should be written to sell.

The most important point you want to make to your customer is that he should act *NOW*. This immediacy is crucial. If he puts down your flier and does not act on it right away, the chances are he will not act on it to-

morrow either. By providing an order blank, perhaps a return envelope for him to put it into, plus all the information he needs to order, you are making it as easy as possible for him to choose and decide.

Before he can order, however, the piece of mail you send must get his attention. Unless you can catch his interest he may toss your valuable mailing piece (valuable to you at least) into the wastebasket with the rest of his junk mail.

You can use many techniques to grab his attention. Since yours is a handcrafted business, it is appropriate that your mailing piece have a rustic, non-commercial look to it. It might stick out of the pile of slick full-colored fliers simply because it is simple and primitive. Your customer will realize that he is dealing with an individual—not an impersonal corporation. But don't make it look so primitive that he is reluctant to order because he is afraid you cannot comply.

Your brochure can be printed by a commercial printer, with all the text in very professional-looking typeface, or it can be hand-lettered. Tell your prospective customer immediately what you have for sale and then gently try to give him a push to actually order. Perhaps you will use the gimmick of the limited offer. If you say that the offer is good only until a certain date, he might act now rather than miss out on the opportunity.

YOUR CATALOG

If you are going to sell your work by mail order you will presumably have some sort of catalog which you send to prospective customers. The catalog has many advantages over a single ad in a magazine in that it can present many more items and give far more complete information. You can explain your colors and styles, and present items in a wide price range. The catalog is a good supplement to the advertisement because if the customer has ordered an item offered in the ad and was pleased with his purchase, he will be positively disposed when looking at your catalog.

A catalog can be anything from a full-colored multi-page booklet to a single sheet. The costs, of course, vary considerably with the type of booklet you offer.

Before planning your catalog in detail, check the format with your printer and see how you might save printing costs. Also check how you will mail it. Will you need an envelope? How much will the postage be?

If you sell wholesale to stores as well as by mail order you can save money if the catalog is multi-purpose, aimed at mail order customers as well as shop managers. Your catalog could have suggested retail prices and you could have a separate wholesale price list. Or you include no prices within the catalog itself but provide separate retail and wholesale

price lists. Then you can have revised copies of the price sheets printed up as often as the prices change but use the same basic catalog continuously. This method saves you money over a period of time because you can have more catalogs printed up without changing the content. The initial preparation cost of the catalog is the same whether you have 100, 1,000, or a million copies printed. The more you order, the less the catalog will cost per copy.

In your envelope along with the flier or brochure you might enclose a return envelope. You can get return-postage envelopes printed on which you pay the postage only after they are delivered back to you (regular first class postage rate plus a few cents for the handling fee). Check with your post office for details. While the order costs you more if you pay return postage, the return envelope can act as that added boost that makes people prepare their orders and get them off to you. Once the orders are ready they do not even have to look for stamps.

Organize the printed material you have made up to send out to prospective customers very carefully. Think about how you intend to mail it. Try to plan it so that it will fit into a standard-size envelope. If you have to have envelopes specially made for your fliers or brochures they will be much more expensive than the standard-size envelopes that are readily available in quantity. Also be sure to check on the weight—try to keep mailing costs in mind.

In sending out a mailing to a group of prospective buyers you are probably wondering what type of return to expect—how many people are likely to respond to your mailing? You may be shocked to find out that the national average is about 2-3 percent. If your list is very specialized you can do better than this, perhaps 5-10 percent, but by no means can you expect half or even a fourth of the people to whom you are mailing your brochure to respond with an order. When you think about this probable return on your mailing, you will have some idea why selling by mail order is so expensive.

WHOLESALING TO A MAIL ORDER COMPANY

You may decide to sell outright to a mail order house which includes your work in a catalog they publish. In this case they will worry about advertising, mailing lists, etc. You need only send or deliver your products to the mail order company and collect your wholesale price.

An alternative is to work with a mail order company through a "drop ship" arrangement, which involves their selling your product but your mailing it directly to the customer. This is most commonly done with items that are to be personalized.

Your product might appear as one item in a large catalog. When the distributor of the catalog receives orders for your product, he makes up a gummed shipping label with his return address and the name and address of the customer. On receiving the label, you merely paste it onto your wrapped product and mail it.

The advantage to the mail order company is that it does not have to stock or even handle the merchandise. You will of course have to pay a percentage of the retail price to the catalog company, but you will not be venturing the large amount of money necessary to advertise or conduct a direct mail campaign, but instead paying a percentage of each actual purchase.

To arrange outright purchase or a drop ship agreement, write to a catalog company giving them information about your products. If you have appropriate photographs, these will be helpful. Once you have made an agreeable arrangement, you must produce enough items so that they will be available as the orders are received. Delays in shipping reflect badly on the catalog company. The producer of the catalog should be able to suggest an approximate number to you.

One catalog that includes handcrafted items is published by the Candle Mill Village (In-the-Old-Mill, Bennington, Vermont 05201). This has a special section entitled "The American Craftsman" where handcrafted items are shown. The items are presented in photographs and then described, with the name of the craftsmen.

The catalog is put together by Tom Aagerson, who encourages artisans to write to him if they have items which might interest him because he needs new items all the time. He says: "We often receive unsolicited catalogs, samples or visits (we like this best). If we decide to feature the item in our catalog, we purchase from the craftsman at wholesale prices on standard commercial terms, usually 2%/10 days/net 30. We indicate beforehand how many pieces we need and when they should be delivered—usually within four weeks. Some craftsmen deliver in person, others ship via UPS. To produce the catalog takes time so we decide on a new product four months in advance before the catalog is mailed to our customers."

A CATALOG FOR ARTISANS
Artisans can also sell their items by mail order through *The Goodfellow Catalog of Wonderful Things* (P.O. Box 4520, Berkeley, Calif. 94704). The catalog is published by Christopher Weills, who explains: "We have spent considerable time getting it started," and certainly the catalog bears evidence of much loving nurture. It contains

hundreds of sepia photographs of some of the most tasteful handcrafted items you will find. They are beautifully designed and made, and would be an inspiration to almost any artisan. Leafing through the catalog is an education on how to photograph handcrafted objects.

The Goodfellow Catalog is rich with ideas and alive with concern for what is artistic and handcrafted. In fact, it is meant to be more than a catalog for selling purposes. As Jon Stewart, the editor, puts it: "We hope to make this as much a forum for information exchange as a medium for moving tools from maker to user."*

The catalog could not possibly contain the work of every artisan interested in selling through it, so some method of selection had to be created. According to a flier, "The basis of selection will be photographs submitted by the artists and craftsmen of their work. From these photographs we will select those whose work reflects originality, beauty and professionalism."

In addition to photographs, the artisan is asked to submit a brief description of his work—along with such information as the physical dimensions, colors, sizes, shapes, materials, and so on. He or she is also asked about the maximum number available of a specific item and the estimated delivery time.

Once selected to participate in the catalog, the artisan pays nothing, but gets thousands of dollars of advertising free. He commits himself to fill orders for the products exhibited in his photographs for a year or more after the catalog is printed. Therefore the professional reliability is one of the most important factors in determining whose work is to be included in the catalog.

Working with the catalog can be excellent for the artisan. His work is featured in a quality publication and seen by many people. He does not have to go out to shows or put his work out on consignment. Instead, every piece he sends out has been purchased.

The catalog is updated periodically and sold all over the country. It has received excellent publicity in many newspapers and magazines and the reviews have been very positive.

YOU AND THE POST OFFICE

If you are sending out many pieces of mail, especially at one time, you should be aware of the various types and classes of mail. You can save by using what is termed "third class mail" instead of first class if you are

*Jon Stewart, "Using the Catalog," *The Goodfellow Catalog of Wonderful Things* (Berkeley, Calif.: Temporary Gymnasium Press, 1974), p. 3.

sending merchandise or printed matter that weighs over 1 ounce. One warning about third class postage—it is not as fast as first class, though the delay may not be significant except during the heavy Christmas rush.

You can use third class mail no matter how many items you are sending. If you are sending at least two hundred pieces of mail (or 50 lbs.) at one time you can use the lower third class bulk rate. To use this rate you must deliver your envelopes to the post office separated by zip codes, tied in bundles, and marked accordingly with all envelopes facing the same way.

If you will be doing much mailing, you may want to pay an annual fee for a permit which allows you to have the postage printed right on your envelope with your return address. You will pay for the envelopes you mail this way by certified check at the time of mailing.

Since you are selling by mail, keeping your mailing list up to date and accurate is very important because you lose money in every mailing for every address that is incorrect. Correct your list whenever you find that an address is out of date. You will in fact constantly be making corrections because it is estimated that 15-20 percent of the population moves each year.

First class mail is expensive but it does have several advantages. It is faster, and the envelope looks more important if it has first class postage on it. You might use first class for small mailings or a mailing to a highly selected list of customers. If the customer has moved, his mail will be forwarded to a new address when the post office has one listed; where there is no forwarding address, the envelope will be returned to you at no charge, and you can make the adjustment in your mailing list.

If you make a large mailing and use third or fourth class mail this type of mail will be disposed of if the address is incorrect, unless you specify on the envelope that you are willing to pay for its return. You might write, "Return Postage Guaranteed" on it, and will then be charged at the applicable third or fourth class rate when a piece is returned to you. Or you can state on the envelope, "Forwarding and Return Postage Guaranteed," in which case you will be charged if the piece of mail must be forwarded from one post office to another.

Another option is to write, "Address Correction Requested" beneath the return address. If the piece of mail is being forwarded, you will be sent a card informing you of the new address.

One way to correct your mailing list without sending out material is to record individual names and addresses on postcard size cards—one name to a card along with your name in the corner. For a small fee these will be returned corrected.

SHIPPING PACKAGES

Once you receive an order it must be packaged and shipped to the customer. There are three different shipping methods you might use. The most obvious is through the post office; next comes the United Parcel Service (available in most states); and for large packages you may have to use a trucking service.

At first you will probably ship through the post office by parcel post. There you are charged according to the weight of the package and where it is going. The maximum weight is 40 pounds. If the items you are shipping are expensive or fragile it is a good idea to insure the package; only if you insure it can it be traced.

For packages sent by parcel post the delivery time varies considerably. Sometimes it is fairly fast but often—especially during the Christmas season—it can be very slow.

An alternative to sending your packages through the post office is to use the United Parcel Service, which delivers to all states except Alaska. Many businessmen will tell you that UPS is the more efficient and less expensive way to ship. The cost depends on the weight of the package and where it is going, with the maximum weight of a single package set at 50 pounds.

To use UPS you can bring your packages to a UPS depot; but usually most businesses, if they do a significant amount of mailing, have an arrangement with UPS so that the driver stops regularly to pick up packages right at the business location. The business has signed a contract with UPS and pays a small weekly fee for the pickup service.

Every shipment made through UPS is automatically insured for $100 (for a small fee this insurance can be increased). Every shipment can be traced. Shipping by UPS is usually much faster and more dependable than parcel post.

The third alternative, the trucking company, you might use only if you have large shipments. For small shipments trucking companies are usually too expensive; you will need them only when you are shipping over 100 pounds to a single address in one day. You can find trucking companies in the classified section of your phone book.

Most of your orders from customers will be prepaid. Some however will ask you to send an item C.O.D., Collect on Delivery. This takes more bookkeeping so you may be reluctant to do it, but may decide to do so rather than lose an order. Both the post office and UPS will cooperate with you in shipping C.O.D.

WRAPPING THE PACKAGE

Once you receive the customer's order, you have the responsibility for wrapping the purchase so that it will arrive safely. You want your products to get to the customer in the best possible shape so that he will be satisfied and order again.

There are various products on the market for use in packaging: corrugated cardboard cartons, mailing envelopes, foam packaging material, string, gummed paper, etc. Remember that the cost of these materials adds to the cost of the item. If you are offering a single item in an advertisement, you want a quick, efficient way to wrap it because you will be repeating the process so often.

Once you have a sample of the product you are going to sell through your ad, you might consult a local supplier of corrugated cartons to see if you can obtain just the right carton. Make up a test package, and if you are going to send it by parcel post, bring it to the post office to find out exactly how much it will cost you to mail it to various parts of the country. The postal clerk may be able to give you some advice on your packaging. If you plan to ship by UPS, check with them.

For reorders from your catalog, you will need a variety of sizes of boxes. At first you might get these free from local supermarkets or liquor stores; but as your business grows you may find it much more efficient to buy new cartons from a local supplier.

In addition to cartons you will also need some packing material. Old newspapers are probably the cheapest and most universal form of stuffing material. You can purchase a foam stuffing material which is very light in weight but this will add to your packing costs.

Be sure to stuff the box well so that nothing gets broken. Wrap each delicate item individually. You will have to experiment to find the best method of packing for your type of work—the one which gives the items the best protection with the least added weight, at the least cost.

Before you close the box, remember to enclose a copy of your catalog and a new order blank for regular customers. If you are shipping to a shop, be sure that you have enclosed a packing slip, unless you intend to put it on the outside of the package in a plastic envelope.

Once the carton is stuffed, you must close it and tape it securely. Gummed tape which is reinforced is an excellent way to do this. For the outside of the box you will need a gummed address label properly filled out. You can purchase these with your name printed on them or stamp it on with a rubber stamp.

If you are taking the package to the post office, the clerk will weigh it for you. If you have UPS service, you must weigh the package and write the weight on it.

HANDLING COMPLAINTS

One of the decisions you have to make in running a mail order business is how you will handle the complaints which come in. The problem may in no way be your fault. Perhaps the package you so carefully wrapped and sealed was terribly mishandled in transit and looked as if the mailman sat on it before he delivered it. If you insured it you may be able to get some satisfaction from the post office but this can be a long process, very costly in time. It may be easier to replace the item yourself.

Customers may also complain if what they received is not what they thought they had ordered. People just do not read advertisements very carefully and may order something you are not selling. Or a customer may not feel that what has arrived is up to his expectations.

You may decide that since good will is important, you will make a money-back guarantee part of your advertisement and your catalog, and allow customers to return items with no questions asked. Actually, the people who will ask for their money back are few. The fact that you offer a money-back guarantee may increase your orders, as some of those who hesitate to order may do so if they know they can get their money back when they are not satisfied.

"GRANDMOTHER'S TOYS"

Some artisans use mail order as their exclusive or main marketing method. Many others use mail order to supplement their sales through different channels.

One person who uses mail order for the majority of her sales is Betty Winslow of South Woodstock, Connecticut (Box 246). She calls her business "Grandmother's Toys," and she sells a line of beautifully handmade dolls which she has designed. She sells over twenty-four different dolls which are stuffed and clothed, and average about 17 inches tall. She has a "Senior Citizen" knitting away sitting in her rocking chair, a cave man and woman, a farmer and his wife, clowns and some mountain folk, as well as some two-headed dolls.

"Grandmother" decided to start selling her toys by mail order after a friend gave her a paperback copy of a book which told how to sell through the mail. She says, "The suggestion I felt would bring me the greatest number of inquiries and hopefully sales went something like this—create an item that will sell for $2 or less and offer it by mail order in a good nationally known magazine or newspaper."

She decided to do just this and choose *Yankee* magazine, which has a circulation of over half a million a month. When she found out how much it would cost to place an ad she was somewhat frightened at the gamble, but she was determined to give it a try for six months. She says, "I offered Freddy Frog for $2 postpaid. It was a cloth toy 12 inches in length, filled with bird seed, which could be posed twelve ways. When Freddy seemed to have saturated the market, I introduced Maybelle Mouse, for the same price."

This advertising campaign did well for her. Two things were happening at once, she explains. "The small toy was paying for the advertising and at the same time the ad was bringing in many inquiries for a brochure mentioned in the advertisement. These requests then led to more rewarding orders." She offered the first brochure at ten cents and then later at twenty.

At one time she had a professionally printed brochure which had drawings of some of her toys; however, she found that the cost of the brochure was out of proportion to the small price she was charging for it. She decided that since hers was a home industry her brochure need not look so professional. She now has a mimeographed two-page brochure with a colored cover sheet printed with her return address. She staples to each brochure a photograph of one of her dolls. She takes these colored pictures and has them printed up in quantity.

Her paid advertising has been supplemented by some free publicity. She says, "My toys have been given great free advertising unsolicited by me. *The First New England Catalog* offered me free space which I accepted. Several newspapers asked to do stories on me. The local library gave me a one-man show where my display was changed every week for six weeks. The television station from Hartford, Connecticut, did a very special five-minute show about me."

With this free publicity as a bonus and all of the paid advertising in *Yankee* plus mailing brochures, Grandmother has built up a business that keeps her very busy.

Cooperative Ventures

The artisan working on his own faces a variety of problems: trying to locate good shows, buying materials at wholesale prices, collecting money from shop owners, and so on. One means some artisans have used to attack these problems is to band together in cooperatives, guilds, and associations.

This last chapter on cooperative ventures is included to provide a possible solution to some of the problems in selling which have been noted in earlier chapters. If you can get an effective group organized with fellow artisans, your selling efforts can be much more effective. The whole process of being a selling artisan can be much more pleasant for you as part of a group whose members really care about each other's welfare.

This chapter tells you about some of the ways artisans have united for mutual benefit and gives you examples of projects to stimulate your thinking about how to work cooperatively. Since the possibilities are so many and the ways of organizing so varied, they cannot be exhaustively discussed here. Instead, some specific examples point out a few of the routes that have been taken. You will have to decide what is possible and best for you in your particular situation.

A CRAFT COOPERATIVE

Exactly what type of group you form depends on those who will be involved. The terms people use for various groups differ. The word "cooperative" or "craft cooperative" is applied mainly to low-income groups. While the members themselves may have formed the group on their own initiative, in many cases an outside agency or person saw the need and then gathered interested, needy people together to train them and help them sell their work.

Many such groups were started during the 1960s—some with help from the Office of Economic Opportunity, which saw in crafts a way of boosting the local economy. Often the members joined the group because of real economic need. They usually worked together on the same products so their group could sell a definite line of items.

Cooperatives have been started among Indians and Eskimos, blacks in the South, senior citizens, and mountain folk of Appalachia. A number of these low-income people already practiced a craft and the cooperative merely gave them an outlet for their work. Many more had to be trained

by the cooperative before they could produce. Usually the people who participate in a cooperative are very dependent on it and market their work only through their group.

A GUILD

In contrast to these craft cooperatives are the guilds or associations whose members are self-supporting and each independently operates his business. The term "guild" evokes the image of the medieval guild—a group of independent craftsmen with its own standards for membership, apprentice programs, etc. The members of a guild may be part-time or full-time artisans who were already producing before joining the group. Such people usually had other means of support or else their art or craft gave them adequate support before joining the group. Members of a guild are normally more independent than those in a cooperative, and market on their own as well as with members of their group.

A further distinction might be made between a guild and an association. In many areas of the country there are groups termed "art associations" and "art and craft associations." Often the emphasis in the activities of these associations is on display and awards. Since these groups are similar to what are termed "guilds," in this chapter associations are included when the term "guild" is used.

This chapter then will deal with guilds and cooperatives with the above distinctions in mind. But no matter what the terminology or the specific arrangements, all of the groups are artisans working together to solve mutual problems and reach common goals, and the benefits arising from such membership can be numerous—depending of course on just how effective the group is.

If you wish to organize a guild or a cooperative, this chapter will give you some ideas on how to go about doing this. However, since each group is different you have to weigh the suggestions in light of your own circumstances.

GETTING ORGANIZED

If after reading this chapter you feel that you would like to start a guild or cooperative, you should first realize that this is not an easy job. It involves much work before a functioning group can be effectively organized and in operation.

The type of organization you decide to form will depend on the needs and wishes of the artisans involved. A group can be organized to the point that it has its own building, with a sales room, craft rooms, and

mailing rooms. At the other extreme, it can be so loosely formed that artisans only occasionally get together to help each other. Between these extremes lie many possibilities.

Before you begin, you should get some idea of the sort of organization you plan and look for people who might like to join such a group. Talk to as many artisans as possible, telling them about the benefits of organizing a guild or cooperative. Make a list of those who show interest. Each artisan can probably suggest several more names for your list.

Read about cooperatives and apply what you read to the group you might organize. There are government publications available on the subject of cooperatives in general and craft cooperatives in particular. Order these and read them over—you will find them listed in Resource Section G under the Department of Agriculture, which has been very interested in both farmers' cooperatives and craft cooperatives, and has issued numerous helpful booklets for both.

Hold an organizational meeting inviting everyone who showed an interest in forming a cooperative or guild. Tell the artisans what you have learned; let the group discuss the possibilities and see if they would like to try working together.

MEETINGS

If the artisans decide that they would like to form a guild or cooperative, then they fix a regular time to meet. Guild members might decide to have one meeting a month on the most convenient day or evening. Cooperatives may meet more often, especially if the members are working closely together.

At first the group might meet in the homes of members. However, as the membership grows large the group will have to meet in a public place. Since the group is a non-profit one, the local library, church, or public school might allow the use of one of its rooms at no cost. Find a convenient location for members to gather and then ask permission of the library director, clergyman, or principal involved.

The regular monthly meetings should provide an opportunity for sharing information among the members. The guild might decide to put on a show, establish a buying service for materials, run a workshop, start a retail shop—all these projects and others can be planned and discussed and later evaluated at the meetings.

Meetings should be scheduled so that members have informal time to talk as well as a formal meeting. Several meetings may be necessary before the organization really takes shape and the leadership is elected. In the meantime members are getting to know each other and learning from each other.

In addition to formal meetings the group might also have informal get-togethers, perhaps a picnic or a party. Members might bring their families so that the husbands and wives not involved can get a better idea of what the group is all about and perhaps even contribute when their help is needed. At such festive occasions members will get to know each other better. They will have the feeling of really belonging to a group of people who care about each other and are willing to help each other—which is what a cooperative or guild is all about.

Members should be encouraged to come to every meeting because the monthly meetings should become the core of the organization. After a short time the group will probably set up the rules by which to operate and elect a group of people to take over as officers. This set of rules might be formally written down as a constitution. Sometimes a group also establishes a monthly newsletter, to be mailed to all members between monthly meetings, in order to keep in touch even more effectively.

Once the organization begins to take shape, it will want to establish an identity for itself. Everyone might be asked to suggest a name, which could include a geographical reference to indicate where the members are from. The group could use the word "guild," "association," or "cooperative" in its name, or the word "artisans" or "craftsmen" might be incorporated. Once the name is chosen, the group should also vote on a symbol or logo to be used on everything it has printed, including newsletters, stationery, show announcements, and so on.

THE CONSTITUTION

No matter how well the people involved in your guild or cooperative seem to get along with each other, it is still a good idea to have some rules of operation so that everything will continue to go smoothly. The rules of operation might be written into a constitution which defines who can be a member, who shall be the officers, how they shall be elected, etc.

Several members might be appointed to a constitutional committee, which will meet to write the constitution. The committee should be as balanced as possible so that the variety of opinions within the large group is expressed; it should also reflect the membership, with full-time as well as part-time artisans, men and women, experienced and new artisans.

The job of this group will be to write a set of rules which the membership will accept and which will work effectively. Once these rules have been put down on paper, the membership at large should be presented with the tentative constitution. Any sections which the committee could not agree on should be discussed by the whole membership.

Each member of the guild or cooperative might be given a copy of the

tentative constitution several weeks before it is to be discussed so that everyone has a chance to read it and pick out any statements he or she thinks should be discussed further.

Once the members have discussed the constitution, ironed out any problems, and voted it in, then each member who wishes to join thereafter should be given a copy of the constitution so that he will understand the rules of the group before joining.

The constitution first should define the goals of the group. While increasing sales may be the main purpose for most members, other aspects should also be included. Sharing and cooperation among members of cooperatives and guilds are important goals which should be mentioned. Also the group should have an educational purpose. It should hope to educate the public in general about arts and crafts, aim to increase the knowledge and appreciation of each member for the artwork and crafts done by the others, and try to help each artisan improve his own work.

Entrance requirements for the guild or cooperative should be specifically defined by the constitution. There might be more than one type of membership. If certain standards are to be applied to the work of individuals in order to attain a specific type of membership, then these requirements might be defined in the constitution.

The leadership of the group should be very precisely defined by the constitution. The term of office of members of the executive board should be stated, as well as the election procedure. The officers might include the traditional president, treasurer, recording and corresponding secretaries with the usual duties assigned to these officers. In addition, the group might want to have a publicity chairman, who would handle all press releases, posters, fliers, and paid advertising. This same person or another person called the historian might maintain a scrapbook of press releases, printed material, and general publicity which appears in magazines and newspapers.

The group may elect to have a program director who would arrange the monthly meetings. This person might arrange to have a speaker or panel discussion by members, or whatever else the members want. A membership chairman can be elected to gather information about members, take attendance at meetings, greet new members when they come to their first meeting, and encourage other artisans to join the group.

If the group wishes to conduct shows itself, one of the officers might be a show director, in charge of arranging for these events. If the group is to have a monthly newsletter, then the editor of this publication should also be included as an officer. And if it has its own retail shop, one of the officers should be the shop director.

This group of officers might hold executive meetings as needed to help set a course for the group as a whole. Each member of the group at large might be encouraged to take one of these executive posts for a period of time so that everybody gets a chance to share in the leadership duties of the organization.

NEWSLETTER

While the membership might have a monthly meeting, a newsletter which arrives between these monthly meetings can be very helpful for keeping in touch. Inevitably some members will be absent from meetings. The newsletter is an excellent way to catch up on the main items they have missed. A newsletter can also include personal details about members—who is sick, who has won a special award, etc. Such information serves to bring the members closer together as people.

Cooperatives might use the newsletter to tell members about orders received from shops, supplies that have arrived, new products which they could work on, and so on. Members of a guild can use the newsletter to give information on shows they have attended and those that are coming up. Everyone can be asked to turn in such information to the newsletter editor. He then compiles a list of shows with all the necessary information, including time and place, type of show, cost of participation, entrance requirements, and contact person. This information can be organized by date and presented in the newsletter. If anyone has further details about the show, particularly how successful it has been in the past, this can be added.

The newsletter could also contain reports on shows which have already taken place. One or more of the members might be regular reporters who participate in and/or attend shows and report on them for the newsletter.

Since many of the guild members may be interested in selling through shops, the newsletter might carry information about shops in the area that are interested in artistic and handcrafted items. In addition to its location, hours, and the manager's name, such items could also say whether the shop buys outright or insists on consignment, and what percentage of the price is retained by the shop.

Everyone in the group should be encouraged to submit information of general interest for the newsletter. The officers can write progress reports as needed which are included in the newsletter. They could tell members about subjects to be discussed at the next meeting so that people come prepared with suggestions and information. While some information might be shared at meetings, the material already presented in the newsletter will not have to be dictated and copied down, which leaves more time for discussion.

The newsletter will have to be printed, perhaps using a ditto, mimeograph, or spirit duplicating machine. If no such machine is readily available, then this will be one of the first pieces of equipment which the group buys together. If a used machine can be purchased, the cost should not be too high.

RUNNING A SHOW

One of the projects which the guild can engage in is running its own arts and crafts show. While members may participate in shows run by amateur groups or professional show directors all year, the show(s) run by the group should be special. For some members whose production is not too large it might be the only show in which they participate.

The advantages of such a show are numerous. The group can plan the event together so that it is an excellent high-quality production. As many members as possible should participate in the show itself and in preparations for it. Members will get to know each other better and will grow in the cooperative spirit by working together. Every participant might be required to serve on a committee concerned with some aspect of the show, including display, finances, publicity, entertainment, etc. Experienced members can be asked to help those who are new at participating in shows.

If more members want to participate than can be accommodated, then some equitable system of choosing participants should be set up. Perhaps the group will have a special "Showing Membership" which the members of the guild must earn in order to take part.

The group can do an excellent job on publicity. The publicity chairman should concentrate on obtaining as much free publicity as possible (see Chapter 3 for suggestions). Each member can help by trying to arrange for a feature or photo story in his own local newspaper. The group might also decide on some paid advertising in carefully selected places. They could have a flier printed up and ask each member to distribute as many copies as possible.

All the arrangements for the show can be made to suit the artisan-participants. If they want strolling musicians, they can have them. They can also plan other entertainments to add to the festive atmosphere, and a "help yourself" coffee table for artisans.

Financially, of course, the benefits of having the participants themselves run the show are tremendous. Each participant might pay a small fee to cover expenses; this will be far less than the members would pay to a director running such a show. As a non-profit, educational group they can probably arrange to use their site free, especially if they emphasize the educational and professional quality of their work.

While running their own shows may be very important to the guild members, this should not be their only activity. The group might settle for running two quality shows a year (some large groups may be able to handle even more). Shows, though important, should not overshadow the other benefits which the guild can bring.

A SHOP OF THEIR OWN

If either a cooperative or a guild becomes very strong, the members may decide to have a shop of their own which will act as a permanent showplace for members' work and provide continuing sales all year long.

Since the shop is run by the members it can be on a non-profit basis. The only commission a member pays from the selling price of his work is a small percentage, which would go toward covering the actual operating expenses. Members would have control of the shop. One person would have to be in charge and make the day-to-day decisions, but the policy decisions should be made democratically by the group.

The members might run the shop themselves, each person giving a certain amount of his or her time. Or if the group so decides, they might hire a manager who would be paid to run the shop. This has the advantage that members are left free to produce their items while the manager runs the shop professionally.

The shop can also be a source of wholesale orders if members so desire. In this case it can become a wholesale showroom where other shop owners visit and buy.

Another possibility is a mail order project which can be handled through the retail shop. The group produces a mail order catalog which they then send out to a mailing list pooled from all the members. They could also get orders by advertising and arranging for free publicity. Again, the members would only have to pay the actual selling costs—the mail order business could be run on a non-profit basis.

THE BENEFITS OF A COOPERATIVE

Because cooperatives are usually made up of low-income people, the special benefits they offer to members differ somewhat from those a guild offers to its members, who are usually self-supporting.

The cooperative gives its members an opportunity to learn and to earn. Often it supplies training and helps members to improve their skills and abilities. Without the cooperative, most of its members would not be involved in craft work or in selling what they have made. In fact, many of them might be on welfare rolls. The cooperative, then, can help them to retain their self-respect by allowing them to become independent and self-supporting.

The cooperative provides a market for people who would not otherwise be capable of doing their own marketing. Members may even develop their craft and marketing skills to the point where they no longer need the support of the cooperative. While some members will continue to be dependent on the cooperative, others with their new skills can go out and get a job or start their own crafts business and become independent artisans.

By helping its members to earn a steady income, the cooperative helps to upgrade the economy of the area. One important difference between a cooperative and a guild is that the cooperatives are often funded by an outside agency. The money is usually used for initial expenses and to subsidize some of the marketing costs—including the help of marketing and handcraft specialists. However, a viable cooperative should reach a break-even point, a time when the outgo is balanced with the income. At that point the cooperative is self-supporting, can continue on its own, and is truly bringing money into the area. Now it will have a potentially profound effect on the area as well as on the individual member.

OZARK OPPORTUNITIES

One cooperative which has greatly benefited its many members is Ozark Opportunities—a large cooperative composed mainly of senior citizens living in the Ozark Mountains of northern Arkansas. This cooperative, which has over three hundred registered participants, has been marketing a wide range of items for its members.

Many of the members are organized locally into small groups, each of which functions as it wishes. Some get together for quilting bees and produce beautiful quilts together. Others work in small groups or alone at home on a variety of products, including traditional dolls made from wood, apples, acorns, peanuts, or cornshucks. Some weave baskets with strips cut from the white oak tree, a traditional craft to the area. Stuffed animals, braided and hooked rugs, are further items produced by members of the group.

Ozark Opportunities was started by Esta Taylor, who saw a need for people in the area to make money to supplement their meager incomes. She was able to get a grant for the project from the Office of Economic Opportunity, and started this program aimed at developing the economy of the impoverished Ozark mountain area. She served as the marketing and curriculum specialist for the group and helped to develop the different items which participants might choose to make.

Announcements were made in the newspaper, and those who were originally recruited as members soon recruited others to become part of

the program. Many of these people had some craft skills but others needed training. Mrs. Taylor did much of the training herself, then she trained VISTA volunteers, who in turn taught the participants in the program. Courses in basketweaving, doll making, woodworking, and other crafts were set up in public buildings and private homes. Once the participants began to turn out their products, Ozark Opportunities started to market them.

The cooperative sells whatever the members make as long as the items are of good quality. The group has several of its own retail sales outlets staffed by producing members. It also has built up a mail order business. For this phase of its operation certain standard items were developed which members could make, and these items are included on fliers sent out to mail order customers. The cooperative also sells wholesale. Mrs. Taylor, who had a business of her own with sales outlets all over the country, made these markets available to the cooperative and also worked to develop more accounts.

Through publicity, in both the local press and national magazines, many interested customers have found the cooperative and the sales volume has grown. In addition to the money the members have earned, they have gained more—a self-respect and a sense of usefulness which has meant a lot to many of them. The cooperative has helped some people to break the chain of poverty and removed them permanently from the local welfare roles.

THE BENEFITS OF A GUILD

A cooperative can profoundly affect its members by giving them the opportunity to learn and to earn, and a guild can do the same. However, before joining, most of the members of a guild already know their craft and many are earning on their own. The guild helps them to make their efforts more effective.

One way a guild member benefits is by buying materials and equipment with others in quantity at wholesale prices. There may be a problem because of the diversity of crafts; however, if the group is large, quite a number of materials are commonly needed and the group can set up its own buying service. In a small guild perhaps only a few artisans will need the same materials—these people can get together and order on their own, having met through the guild and discovered their common need.

Another benefit of belonging to a group is that members are in a better position as far as participating in shows run by professional and amateur show directors. They can find out about the shows from fellow members at meetings or through the newsletter. They can speak to members who

have participated in the show before or worked with this director before. If there is a poor director in the area, members can get together and agree to boycott his shows until he improves them.

When a member has a legitimate complaint about a specific show, he can join other members and talk to the show director. Because they come as members of a larger group rather than individuals, the director will pay more attention to them. The guild members can also negotiate together to participate in shows. They can assure the show director of the quality of the work to be shown. They might be able to arrange to have a group of booths together and perhaps get a discount rate on them.

Many women's clubs and other organizations want to sponsor art and craft shows. The guild can negotiate to provide all of the participants for a smaller show; or it can send a group of artisans to participate with others in a large show. The sponsoring organization then must provide the site, make other necessary arrangements, and above all arrange for sufficient publicity to draw a good crowd to the event.

Another way the guild can help the artisan is through efforts to educate the public generally about the value of artistic and handcrafted items. These efforts should create a better climate in which the artisan can sell his work.

The guild can arrange for lectures and demonstrations in schools and libraries, or for organizations like girl scouts, women's clubs, church organizations, etc. The guild might be a liaison between those requesting and its own artisan-members who are willing to demonstrate and teach.

Still another way a guild can aid its members is by getting publicity for them as individuals. It can help them to arrange for feature stories in their own local newspapers. It might also embark on a publishing venture of its own.

One organization which has done this for its members is the West Virginia Artists and Craftsmens Guild, which has published a paperback called *Profiles of the West Virginia Artists and Craftsmens Guild.* *

In over 140 pages this book presents the members and the work they do. Each artisan has a page or a half page in which to give his story. There are many black-and-white photographs, as well as line drawings of sample items and of the artisans themselves. Many artisans tell something about the tradition of the work they do and how long they have been involved with it. The book has much educational value. It is actually a fascinating peek at the traditional crafts of Appalachia and how they are being carried on today by active artisans and craftsmen.

*Available from P.O. Box 331, Parkersburg, West Virginia 26701.

There are traditional crafts like applehead dolls, dulcimers, candles, and quilts; some of the craftsmen are handweavers, spinners, and whittlers.

The book says what each artisan sells and gives his complete address. The Foreword encourages readers to contact artisans if they are interested in buying specific items from them.

Profiles has several purposes. As James B. Spicer says: "This book is not meant solely as an order catalog; we hope that new contacts and friends and a wider understanding of crafts and the people who make them will result. This is the first central illustrated source of arts and crafts information of this scope devoted exclusively to the people of West Virginia."*

THE HANDCRAFT GUILD OF CENTRAL JERSEY

The West Virginia Artists and Craftsmens Guild has been in operation since 1963; it has over six hundred members. A much younger organization is the Handcraft Guild of Central Jersey, which was founded in 1975. This explanation of how it was started and continues to grow may inspire you to start a similar organization in your area.

The Handcraft Guild of Central Jersey was started by Betty Carpenter, Joe Silva, and five other artisans who saw the need for such an organization in their area. They gathered as many other interested artisans as they could find and at the first meeting the group decided to continue to meet on a monthly basis. More and more artisans joined as the months passed. They elected officers and assessed themselves dues.

The members of the newly formed group differed greatly amongst themselves. Some were experienced artisans who had years of experience behind them and sold thousands of dollars worth of items each year; others were owners or managers of craftshops; others again were experienced craft teachers. In contrast, although they knew their craft, some of the members, perhaps more than 50 percent, had never sold anything before and never participated in a show.

The group chose the "Handcraft Guild of Central Jersey" as their name; however, they soon outgrew its geographic limitations as more and more members joined from farther away. In addition they choose a sign or logo which consists of two hands and some of the tools used in craft work. They decided that members should each make a large copy of this logo using their own craft techniques and then use this large shield as

*James B. Spicer, "Compiler's Foreword," *Profiles of the West Virginia Artists and Craftsmens Guild* (Parkersburg, W.Va.: West Virginia Artists and Craftsmens Guild, 1974), p. 5.

part of their display—whether they were involved in one of their own shows or participating in shows run by others. They also decided to have business cards printed with the logo. They ordered folded cards with the logo on the outside and a blank space inside where members could print or type their own names and addresses.

They organized a monthly newsletter immediately to disseminate information that members were pooling, describe what was decided at the last meeting, and outline what would take place at the next.

The group had not been meeting long when the members decided that they wanted to run their own craft show. The president, Betty Carpenter, and the show chairman, Barbara O'Malley, were in charge. With fear in their hearts but assurance in their voices they approached the manager of the Brunswick Square Mall and assured him they would have at least fifty craftspeople in the show and that it would be a fine, professional affair. He agreed to let them have the show at the mall the following September without having to pay a fee.

These two women worked long and hard making arrangements. They knew that if the show were a failure the group would be discouraged and might fall apart; but if it were a success, the members of the guild would realize that they could work together and they would have an exciting and effective guild.

The women knew they had their work cut out for them. Not only must they plan the show and initiate all the necessary publicity; they also had to get the artisans ready to participate. Each monthly meeting was devoted to some aspect of preparing for the craft show. One of the first subjects the group discussed was sales tax; everyone who wanted to sell at the show must have a sales tax number. Exactly how to apply for such a number was discussed and all those who did not have one were asked to apply immediately.

Display is extremely important—several meetings were devoted to talking about how to set this up. Betty Carpenter says, "We wanted the show to look as professional as possible. After all we had promised the mall management a professional show and if we did not produce one, we would probably not be invited back there again next year. In fact, we might not be invited anywhere if our show were poor. We tried to figure out what members showing for the first time would need to know and then tell them and answer all of their questions."

Some of the experienced members of the group brought in sample display equipment and props made out of inexpensive or free materials. Members were urged to get busy preparing the items they would sell and have their displays ready.

Betty explains, "We gave them suggested ways of keeping track of their inventory. We explained to them about handling customers. We wanted the show to be educational so we asked everyone to bring something to work on so that customers could watch as the craftsmen worked. We also set up a schedule of demonstrations as well as arranging for entertainment."

The guild members decided that everyone would wear colonial costumes. Some of the members resisted this suggestion and tried to get the membership to change its vote. Finally all agreed to do this.

While the preparatory meetings were going on, the show chairman was asking participants to sign up for the show. Not many were signing up and Betty and Barbara were getting worried. After all their work, perhaps the majority of the members were not really interested in participating. But the time came closer and closer, more members joined the guild. Between the new and older members suddenly there were more than enough participants.

The day of the show arrived. There were still a few last-minute problems to be ironed out but everything seemed to be going well. The booths set up by the artisans were very attractive and professional, as were the items they had for sale. The artisans were outstanding in their colonial costumes. Customers at the mall flocked around the booths and made many purchases. Puppet plays, musket-firing demonstrations, and singing groups were some of the entertainments which kept the crowd around.

The mall management was more than pleased with the show. The manager expressed his pleasure verbally and also wrote a letter of thanks afterwards complimenting the guild on the show they had put on. More important than his praise was the fact that he signed up the group for another show the next year.

The members of the guild were thrilled with their own show. Many of them had all but sold out—everyone was very happy with the sales. Two women who had never sold at a craft show before sold over $1,000 worth of their products in the two days of the show.

Members came to the evaluation meeting enthusiastic and itching for another show. Betty knew that the success had welded the group into a really strong one which would continue. While she was pleased with their enthusiasm, she had to remind them that staging their own shows was not the only goal of their organization. The group would have to decide over a period of time and experimentation just how many really successful shows they could present in a year.

For members interested in participating in more shows the guild would

disseminate information about local shows. It could also make arrangements with local non-profit groups to participate as a guild in their shows. Later, perhaps, the guild could open its own retail show. In the meantime the group continues to grow rapidly, helping its members to develop a market for their work and to educate the public about crafts.

OTHER COOPERATIVE VENTURES

In addition to forming craft cooperatives and guilds, there are other ways artisans can and have worked together for their mutual benefit. They may unite just for a short period or to do one type of marketing together. A group of artisans can get together and run their own exhibition and sale—if it is successful perhaps it will become an annual event. Artists have found it advantageous to set up their own cooperative galleries; craftsmen have found cooperative arrangements whereby they participate in a studio and/or retail shop quite helpful.

The final sections of this chapter will tell you a little about some of these cooperative ventures to get your thinking started. How might you benefit by working with others? What arrangements would benefit you and them?

A COOPERATIVE EXHIBITION AND SALE

To run an exhibit and sale, only a small group of people is actually necessary as long as each one has a number of items to sell. Artists might get together for an exhibition of paintings; craftsmen in different media might work together to present an interesting show.

The group must find a place to hold the exhibit, advertise it or issue personal invitations, then set it up and run it. Read over Chapter 6 on running a boutique. Much of what is said in that chapter can be applied to running a cooperative exhibition and sale. The main difference between the two is that a group rather than an individual is running the event. Also the event will probably be staged in a public place rather than a home, although that is not strictly necessary.

One group of artisans who banded together to have their own exhibit and sale are five art teachers of the East Brunswick, New Jersey, school system. Every year for the past seven years they have rented a small banquet room in the Ramada Inn for a one-day showing and sale of their work which they call the "Designers 5 Craft Show and Sale."

The jewelers Roy and Elayne Risley are the main organizers of the event. Also involved are Diane and Thom Claxton, weavers; William Murphy, printmaker; Valerie Rabinskas, potter; and Larry Butler, pho-

tographer. Each person in the group pitches in to do the necessary work. One makes up news releases and sends them to the local newspapers; another designs the brochure which the group has printed up. Each person receives 150 or so of these brochures and mails them out to their own mailing list of people—those to whom they have sold before as well as any other people they think might be interested in coming to the show.

The members pay a fee to cover the costs, including the rent for the room, the merchant's license which the town requires, and other expenses of the event. Each stays with his work to make sales. Since the show takes place every year near Christmas, it has developed a following of people who look forward to attending. In just one day from 9 a.m. to 9 p.m. the artisans sell quite a few of their items.

COOPERATIVE GALLERIES

Because working together benefits all, groups of artist have banded together in recent years to set up their own galleries and run them as they wish. They decide together about the location, rules of operation, financial arrangements, and so on. Sometimes they take turns doing the detailed daily work, but usually, once the gallery is operating, they hire a manager who takes on this day-to-day managerial work although they still maintain control because they remain the ones in charge.

The galleries are generally run by a group of twenty to twenty-five artists who take turns to have one-man shows. With this number each can have a show about every second year, and occasionally participate in group shows. If a space opens up when an artist-member leaves, the rest of the members choose the artist to replace the one who has left; in this way the artist has control over with whom he works. The items shown at the cooperative gallery are mainly those of the members, though occasionally they may show the work of others.

The cooperative gallery can function financially in a number of different ways. The members share costs—usually either by paying a flat monthly fee or by paying all of the expenses when their own shows are on. These expenses should be more than compensated for by the fact that the artist receives more for each painting sold. A regular gallery will normally charge the artist 40 percent for its commission; in a cooperative gallery the artist usually pays less, perhaps about 25 percent.

With a cooperative gallery the artist has more control over his shows. He generally pays his own publicity, as he would with a regular gallery, but can decide for himself how much he wants to spend, what type of brochure he wants, and what other advertising to do.

The idea of a cooperative retail enterprise has been used by craftsmen

as well as artists. Whereas with painters the emphasis is on the one-man show, the weaver, the potter, the silversmith, and other craftsmen seldom have one-man shows. Instead, the majority show and sell their work along with the work of others, sometimes in a cooperative studio-shop.

A COOPERATIVE STUDIO-SHOP

Artisans at work attract people to a shop to watch and to buy. The idea of the studio-shop is to have both workshops where the artisans can be seen at work and a sales area where their work can be bought. If a number of artisans are involved in the studio-shop, then several can always be on hand working.

Rather than having one-man shows like the cooperative gallery, the studio-shop would probably show pieces made by each of the participants. The shop can offer its customers a variety of work because artisans with different skills are involved; it may also buy from other artisans not involved in the studios and resell through the shop.

The studio-shop may be controlled by the artisans themselves or it may be run by a manager. The second arrangement offers advantages to the artisan. He will be much freer to produce because many of the secretarial and sales details can be handled by a manager skilled in this type of work. The central bookkeeping system will spare him from having to keep all his sales records and do all the billing himself. If there is a good sales force handling his work, he might get many commissions from interior designers and so on.

As with the other cooperative enterprises mentioned in this chapter, many different specific arrangements can be made. The Craftsmen of Chelsea Court will give you an idea of one direction this sort of effort can take.

THE CRAFTSMEN OF CHELSEA COURT

The Craftsmen of Chelsea Court is an organization which has two locations in Washington, D.C. (2909 M St. and 2551 Virginia Ave.), and one in Kansas City, Missouri (2540 Grand Ave.). These shops are run by a corporation with a board of directors, including a merchandising/marketing expert, an attorney, a designer, and a financial expert.

"The philosophy behind the Court," says Maxine Brown, one of the managers, "is that professional artists-craftsmen who have spent years studying and working in their medium should be allowed to work at their crafts while others more qualified to do so carry out the roles of merchandisers, salesmen, bookkeepers, and advertising experts."

Most of the artisans who work at Chelsea Court are university-trained and have a B.A. or M.F.A. Some have done graduate work in their field if the craft is taught on the university level as are ceramics, metals, and sculpture. Other craftsmen like the stained-glass artisan have learned from working with master craftsmen.

At the Court these artisans can devote 90 percent of their time to their work and a staff of professionals takes care of most of the details of marketing. The management staff includes two buyers, who help resident artisans in pricing their work, two bookkeepers, a manager for each of the three shops, and a staff of sales clerks.

Professional staff members work with local interior decorators and designers as well as with architects in order to create commissions for the artisans. They also obtain as much publicity as possible for each artisan. They place feature stories in local newspapers and advertise on the radio, set up interviews on local TV and radio programs, and arrange for personal appearances at schools and colleges. All this publicity brings people to the retail store to buy the artisan's work and adds to the reputation of each artisan.

At each of the three locations the Court provides studio spaces to the artisans for which they pay either a commission or a modest rent (according to which of the three shops they are in). When the artisan comes to work at the Court, he signs a contract to work for a minimum of six months; most artisans renew the contract and stay longer. The artisan agrees to produce saleable work on a professional basis, fulfill all commissioned work, and also be in his studio for a minimum of thirty hours a week.

The Court displays this work in a special retail area in each shop. It helps the artisan to price the work and takes care of all sales for him. It keeps accurate inventories of his work and gives him a statement each week, together with a check which reflects sales. As a rule the artisan retains 65 to 75 percent of the selling price. The Court also attempts to get wholesale orders for the artisans if they wish them.

The Court sells not only the work of its resident artisans but also that of designer-craftsmen from all over the country. These include more than 150 professional artisans, mainly glassblowers, silversmiths, and potters. The work of the resident artisans supplements the work of these artisans from whom the Court buys outright at their wholesale prices. Both one-of-a-kind and production pieces are sold in the shops. The residents usually produce the one-of-a-kind pieces while the work of the outside artisans is mainly production.

Chapter Eleven

Resource Sections

A. VOLUNTEER LAWYERS

Advocates for the Arts
Carla Greene—Director
Law School
Room 2467C
University of California
Los Angeles, Calif. 90024
(213) 825-3309 or (213) 825-4841

Charles B. Rutenberg, Esq.
Arent, Fox, Kintner, Plotkin &
 Kahn
Federal Bar Building
1815 H Street, N.W.
Washington, D.C. 20006
(202) 347-8500

Lawyers for the Creative Arts
Cindy Rosenberg—Director
111 North Wabash Avenue
Chicago, Ill. 60602
(312) 263-6989

Volunteer Lawyers for the Arts
 Massachusetts
William J. Rose—Director
14 Beacon Street
Boston, Mass. 02108
(617) 723-3262

Harry Devlin, Esq.
Pettit, Higgins & Devlin
235 East Broad Street
Westfield, N.J. 07090
(201) 232-2323

Volunteer Lawyers for the Arts
Freda Mindlin, Administrator
36 West 44th Street, Suite 1110
New York, N.Y. 10036
(212) 575-1150

Leonard DuBoff, Assistant Pro-
 fessor
Lewis & Clark College
Northwestern School of Law
Portland, Oreg. 97219
(214) 748-9312

Jay M. Vogelson, Esq.
Steinberg, Generes, Luerssen &
 Vogelson
2200 Fidelity Union Tower
Dallas, Tex. 75201
(214) 748-9312

B. ART AND CRAFT SHOW DIRECTORS

This is a list of show directors arranged alphabetically by the name of the director or the name of his business. Some are widely known by both names so each is listed and the cross reference given. (See Chapter 7 for further details.)

Albright, Lorraine
See D & B Shows

American Crafts Exposition
Rudy Kowalczyk, Director
P.O. Box 358
Rockport, Mass. 01966

230

American Fairs
Michael Warfield, Director
302 Easy St., N. 6
Mountain View, Calif. 94043

American Society of Artists, Inc.
700 N. Michigan Ave.
Chicago, Ill. 60611

Art-Craft Association
Gordon Gattone, Director
114 Evergreen Ave.
Woodlynne, N.J. 08107

Art Enterprise
Manfred Schiedeck, Woody
 Woodhead, Directors
3294 Desertwood Lane
San Jose, Calif. 95132

Art Promotionals of Michigan
Field Art Studio
2646 Coolidge
Berkley, Mich. 48072

Art Shows Assn., Inc.
Don Swann, Jr., Director
475 Blackshire Rd.
Severna Park, Md. 21146

Art Ventures
Margaret Kanner, Director
669 Cambridge Rd.
Redwood City, Calif. 94061

Artists Unlimited
Tela Dubin, Director
11702 Mentone Rd.
Silver Spring, Md. 20906

Artspo International
Box 630546
Miami, Fla. 33163

Bar'n'Dor Associates
Barbara Reeder and Dory Mann
131 Paradise Drive
Berlin, N.J. 08009

Barger, Constance L.
2006 No. North
Peoria, Ill. 61604

Barnes, Sandy
903 Calle Cortita
Santa Barbara, Calif. 93109

Beam, Paula
See Creative Artists and Crafts-
 mens Shows

Bel-Aire Arts
Tony Spranzo, Director
7120 Galli Drive
San Jose, Calif. 95129

Berkley, Elaine and Henry
79 Lawrence Park Crescent
Bronxville, N.Y. 10708

Braese, Mrs. Jerry
3819 Winthrop Ave.
San Ramon, Calif. 94583

California Artists
2260 Vallejo
San Francisco, Calif. 94123

Cochran, Glenn
P.O. Box 182
Berkeley, Calif. 94701

Collete, Thelma
1805 Wesley Drive
Reno, Nev. 89503

Cook, Warren
See General Expositions

Creative Artists and Craftsmens
 Shows
Paula Beam, Director
12303 Kosich Ct.
Saratoga, Calif. 95070

Creative Artists Group
Bea Griffin, Director
3432 Tourmaline Drive
Carson City, Nev. 89701

D & B Shows
Lorraine Albright, Director
Box 335
Colon, Mich. 49040

Diehl, Kay
Kay Diehl Art Shows
20620 N.W. 2nd Court
Miami, Fla. 33169

Double D. Enterprises
13600 St. Clair Drive
North Huntington, Pa. 15642

Drury, Judy
See Theme Events, Ltd.

Dubin, Tela
See Artists Unlimited

Elhoff, Edward
66 Oswego St.
Baldwinsville, N.Y. 13027

Enterprises in Art
Maggi Thorn, Director
430 David Crt.
San Francisco, Calif. 94111

Exhibition Enterprises
Pauline Zlotolow, Director
P.O. Box 7064
Louisville, Ky. 40299

Falken Art and Craft Shows
Kay Falkenhagen
10714 Carver Drive
Cupertino, Calif. 95014

Fandorf, Julie
2320 Sunnside Ave.
Westchester, Ill. 60153

Francette
2860 S. Ocean Blvd., Apt. 410
Palm Beach, Fla. 33480

Franks, Mrs. Donna
7798 Ironwood Dr.
Dublin, Calif. 94566

Freelands National Arts, Crafts
 and Hobby Shows
Clarence M. Freeland, Director
2918 Martel Dr.
Dayton, Ohio 45420

Full Sail Productions, Inc.
Don Gaiti, Director
940 President St.
Brooklyn, N.Y. 11215

Gaiti, Don
See Full Sail Productions, Inc.

Gameral, Harriet
See Showtime

Gattone, Gordon
See Art-Craft Association

General Expositions
Steve Kyle and Warren Cook, Directors
Suite 417, Claremont Hotel
Oakland, Calif. 94705

Gilpin, Lee
See Master Artists Expo

Griffin, Bea
See Creative Artists Group

Grimaldi, Mario
16 Fire Island Ave.
Babylon, N.Y. 11702

Gromosiak, John G.
743 Harshman Rd., Apt. #23
Dayton, Ohio 45431

Harper Gallery Promotions
Jan Messinger
4800 Chicago Beach Drive, 1012 Tower
Chicago, Ill. 60615

Harris, Jinx
R.F.D. #1, Box 1535
Auburn, N.H. 03032

Hasbrouck, Marion
311 Linda Mesa Ave.
Danville, Calif. 94526

Henry, Sylvia
See S.H.E.

Herbie Productions
13900 Shoemaker Ave.
Norwalk, Calif. 90650

Howard, V.
Box 631, 17707 E. Wagner Lane
Linden, Calif. 95236

Immergluck, Natalie
6807 N. Kedvale
Lincoln Wood, Ill. 60646

Isis, Jessica
316 N.W. 35th St.
Ft. Lauderdale, Fla. 33309

J & R Productions, Inc.
June and Ron Richardson, Directors
P.O. Box 456
Bedford, Mass. 01730

Jurissen, Etta
124 Idlewild Rd.
Edison, N.J. 08817

Kanner, Margaret
See Art Ventures

Kapp, Al, and Lene Koener
21 Fowler Ave., Rt. #2
Peekskill, N.Y. 10566

Kelley, Judy
Box 61
Rome, Ill. 61562

Kelly, "Uncle Milt"
1435 Burning Tree St.
Sarasota, Fla. 33580

Klein, Iris G.
4617 W. Main St.
Skokie, Ill. 60067

Kowalczyk, Rudy
See American Crafts Exposition

Kregger Shows
Sally Jo Kregger, Director
P.O. Box 433
Orangevale, Calif. 95662

Kreneck, Jim and Linda
4707 Whirlaway Dr.
Delville, Tex. 78617

Krygowski, Sylvia
See Promotion Management Assoc.

Kyle, Steve
See General Expositions

L & D Promotions
14903 N.W. 7th Ave., Suite C
No. Miami, Fla. 33168

Mary Lehner
5241 Pinecrest Ave.
Richmond, Va. 23225

Logan & Associates
John E. Logan, Director
110 S. Commercial
Branson, Mo. 65616

Mall Marketing
4 Cutting St.
Winchester, Mass. 01890

S.H.E.
Sylvia Henry, Director
404 Jefferson St.
Massapequa, N.Y. 11758

Schiedeck, Manfred
See Art Enterprise

Showcraft International, Inc.
291-295 Washington St.
Westwood, Mass. 02090

Showtime
Harriet Gameral, Director
80 Far Brook Drive, Box 162
Short Hills, N.J. 07078

Spranzo, Tony
See Bel-Aire Arts

Sunrise Promotions
5734 Mildred St.
San Diego, Calif. 92110

Swann, Don, Jr.
See Art Shows Assn., Inc.

Theme Events Ltd.
Judy Drury, Director
3440 Clay St.
San Francisco, Calif. 94118
or
1526 No. Fairfax Ave.
Los Angeles, Calif. 90046

Thorn, Maggi
See Enterprises in Art

Timberlake, Joyce
3821 Silina Dr.
Virginia Beach, Va. 23452

Tor Enterprises
615 South "H" St.
Lake Worth, Fla. 33460

Vogeney, Roe
See Roe Vogeney Art Exhibits

Wade, Judy
See Pro Arts

Warfield, Michael
See American Fairs

Western Artists Productions
P.O. Box 5244
Ventura, Calif. 93003

Woodhead, Woody
See Art Enterprise

World Art Shows
Joerg and Paula Noack, Directors
Jo and Don Palmer
7021 Cerritos Ave.
Stanton, Calif. 90680

Zlotolow, Pauline
See Exhibition Exterprises

C. STATE ARTS COUNCILS

The following is a list of state arts councils. These agencies differ greatly from state to state. Some are extremely active as a source of information and as an advice center; some are a source of funding for individual artisans and for groups. Many publish newsletters. A good many have available lists of shows, shops, and galleries, information on educational facilities, and listings of local organizations within the state.

Write to your state arts council for information, or contact the national organization (listed first) to which all of the state arts councils are affiliated. Remaining councils are listed alphabetically by state.

Associated Councils of the Arts
1564 Broadway
New York, N.Y. 10036

Alabama State Council on the Arts
 and Humanities
322 Alabama St.
Montgomery, Ala. 36104

Alaska State Council on the Arts
Fifth Floor MacKay Bldg.
338 Denali St.
Anchorage, Alaska 99501

Arizona Commission on the Arts
 and Humanities
6330 North 7th St.
Phoenix, Ariz. 85014

Arkansas State Council on the
 Arts and Humanities
400 Train Station Square
Little Rock, Ark. 72201

California Arts Commission
808 "O" Street
Sacramento, Calif. 95814

Colorado Council on the Arts and
 Humanities
Room 205, 1550 Lincoln St.
Denver, Colo. 80203

Connecticut Commission on the
 Arts
340 Capitol Avenue
Hartford, Conn. 06106

Delaware State Arts Council
601 Delaware Avenue
Wilmington, Del. 19801

District of Columbia Commission
 on the Arts
Room 543, Munsey Bldg.
1329 "E" St., N.W.
Washington, D.C. 20004

Fine Arts Council of Florida
Department of State
The Capitol Building
Tallahassee, Fla. 32304

Georgia Council for the Arts
Suite 706, 225 Peachtree St., N.E.
Atlanta, Ga. 30303

Hawaii—The State Foundation on
 Culture and the Arts
Room 310, 250 South King St.
Honolulu, Hawaii 96813

Idaho State Commission on the
 Arts and Humanities
P.O. Box 577
Boise, Idaho 83701

Illinois Arts Council
Room 1610, 111 North Wabash
 Ave.
Chicago, Ill. 60602

Indiana Arts Commission
155 E. Market St., Suite 614
Indianapolis, Ind. 46204

Iowa State Arts Council
State Capitol Building
Des Moines, Iowa 50319

Kansas Arts Commission
166 W. 10th St., Suite 100
Topeka, Kans. 66612

Kentucky Arts Commission
400 Wapping St.
Frankfort, Ky. 40601

Lousiana Council for Music and
 Performing Arts
611 Gravier St.
New Orleans, La. 70130

Maine State Commission on the
 Arts and Humanities
State House
Augusta, Maine 04330

Maryland Arts Council
15 West Mulberry St.
Baltimore, Md. 21201

Massachusetts Council on the Arts
 and Humanities
14 Beacon St.
Boston, Mass. 02108

Michigan Council for the Arts
1200 Sixth Ave.
Detroit, Mich. 48226

Minnesota State Arts Council
100 East 22nd St.
Minneapolis, Minn. 55404

Mississippi Arts Commission
301 North Lamar St.
Jackson, Miss. 39205

Missouri State Council on the Arts
Room 410, 111 South Bemiston St.
St. Louis, Mo. 63117

Montana Arts Council
Room 310, Fine Arts Building
University of Montana
Missoula, Mont. 59801

Nebraska Arts Council
8448 West Center Rd.
Omaha, Neb. 68124

Nevada State Council on the Arts
560 Mill St.
Reno, Nev. 89504

New Hampshire Commission on
 the Arts
Phoenix Hall
North Main Street
Concord, N.H. 03301

New Jersey State Council on the
 Arts
27 West State Street
Trenton, N.J. 08625

New Mexico Arts Commission
State Capitol
Santa Fe, N. Mex. 87501

New York State Council on the
 Arts
250 West 57th Street
New York, N.Y. 10019

North Carolina Arts Council
Department of Cultural Resources
Raleigh, N.C. 27611

North Dakota Council on the Arts
 and Humanities
North Dakota State University
Fargo, N. Dak. 58102

Ohio Arts Council
Room 2840, 50 W. Broad St.
Columbus, Ohio 43215

Oklahoma Arts and Humanities
 Council
1140 N.W. 63rd, Suite 410
Oklahoma City, Okla. 73116

Oregon Arts Commission
494 State Street
Salem, Oreg. 97301

Commonwealth of Pennsylvania
 Council on the Arts
503 North Front Street
Harrisburg, Pa. 17101

Rhode Island State Council on the Arts
4365 Post Road
East Greenwich, R.I. 02818

South Carolina Arts Commission
1205 Pendleton St.
Columbia, S.C. 29201

South Dakota State Fine Arts Council
108 West 11th Street
Sioux Falls, S. Dak. 57102

Tennessee Arts Commission
Room 222, Capitol Hill Building
Nashville, Tenn. 37219

Texas Commission on the Arts and Humanities
202 W. 13th Street
Austin, Tex. 78701

Utah State Institute of Fine Arts
609 East South Temple Street
Salt Lake City, Utah 84102

Vermont Council on the Arts
136 State Street
Montpelier, Vt. 05602

Virginia Commission on the Arts and Humanities
1215 State Office Bldg.
Richmond, Va. 23219

Washington State Arts Commission
1151 Black Lake Blvd.
Olympia, Wash. 98504

West Virginia Arts and Humanities Council
State Office Building No. 6
1900 Washington Street East
Charleston, W. Va. 25305

Wyoming Council on the Arts
200 West 25th St.
Cheyenne, Wyo. 82002

D. PERIODICALS WITH MARKETING INFORMATION

In the last few years the number of periodicals aimed at the artisan who is trying to market his work has mushroomed. Here is a list of such publications which may help you. If you are interested in subscribing to any of them, write off directly for further information.

Art Workers News $6/yr.—bimonthly; add $1 for membership
The Foundation for the Community of Artists
32 Union Square East
New York, N.Y. 10003

A newspaper for the artisan not only in New York but anywhere, with articles of interest to all on such subjects as health hazards, living quarters for artisans, the work of the state arts councils, women in the arts, etc. This publication has a page with opportunities (grants, teaching positions, workshops, etc.), and also a forum for discussion of subjects of interest to artisans in its "Feedback" column. The paper is written and edited by artisans very concerned with the plight of all such workers and takes a strong political stand for the artisan.

Artisan Crafts $8/yr.—quarterly
Barbara Brabec, Editor
Box 398
Libertyville, Ill. 60048

The main purpose of this magazine is communication. It has much information for artisans on new books and publications, new products, craft happenings, etc. It also has a column of opportunities for artisans and keeps you posted on government activities concerning the arts.

Artist and Handcrafter Information Service $5/yr.
P.O. Box 253
Burke, Va. 22015

This service is operated solely for and by artists and handcrafters. It supplies listings of shows telling who, when, where, and the cost, as well as previous attendance figures for some shows. Also included are helpful hints and critiques of shows, and money-making ideas.

The Artist Magazine $7/6 issues
817 Ringwood Avenue
Pompton Lakes, N.J. 07442

This magazine aimed at both the beginner and the professional contains articles on aspects of work, including information on making prints, working with water colors, doing sculpture, carving, framing, etc. It also aims to help with marketing through its informative columns on art shows and galleries.

Artweek $8/yr.—sample copy 50¢
Cecile McCann, Editor
1305 Franklin St.
Oakland, Calif. 94612

Published forty-five times a year (weekly September through May and biweekly in June, July, and August) this magazine covers the best of contemporary West Coast art, crafts, and photography as art. Every issue has news and information useful to artists, craftspeople, and photographers according to the editor Cecile McCann, who says, "We routinely review and discuss events in the crafts field just as we do other art areas."

Many black-and-white photographs illustrate its coverage of contemporary gallery exhibits on the West Coast or in other parts of the country featuring West Coast artists and craftsmen. It has an extensive calendar of exhibits in museums and galleries in California and Seattle and also features a calendar of international, national, and regional competitions, festivals, and sales in which readers can participate.

Margaret Chaiet $2/yr.
22500 Vanowen St.
Canoga Park, Calif. 91304
 You can order from Margaret Chaiet a booklet with state, county, and regional art fairs which lists the dates, places, and people to contact.

Colorado Art Shows News $10/yr.—quarterly, with monthly
P.O. Box 609 supplements
Littleton, Colo. 80120
 This publication lists shows in Colorado and adjoining states.

Frank Cox $6/yr.—monthly; sample copy $1
3980 8th Ave. #309
San Diego, Calif. 92103
 This list covers art and craft shows in Florida and Georgia. The shows are listed by date, with the location and registration chairman, the amount of awards, closing dates, fees, and type of work to be included.

Craft Connection $6/yr.—quarterly
A Midwest publication of the Minnesota Crafts Council
Tom Barry, subscriptions
900 Fairmount Ave.
St. Paul, Minn. 55105
 Covering the twelve Midwest states, this quality publication is sponsored by the Minnesota Crafts Council which is a non-profit educational organization. The magazine is automatically included with a $10 membership in this organization. Many fine black-and-white photographs illustrate it. The publication has excellent articles as well as a long list of events. It also contains much news of organizations for artisans and reviews exhibits.

Craft Dimensions Artisanales $10/yr.—bimonthly; inc. membership
Canadian Guild of Crafts sample copy $2
29 Prince Arthur Ave.
Toronto, Ontario M5R1B2 Canada
 This high-quality publication, which covers the art and craft scene in Canada, is written in English with a summary in French. It is published by the Canadian Guild of Craft—a non-profit organization—and carries an extensive schedule of exhibits, shows, sales, and opportunities for artisans. Articles of interest not only to Canadians but to other artisans cover specific exhibitions, projects, artisans, and art and craft work.

Crafts Fair Guide $10/yr.—bi-annual
Box 9132
Berkeley, Calif. 94709
 This guide to shows in northern California should be a help to any

artisan in that area because it tells what really happened at each show this year so you will know what to expect next. The evaluations are done by artisan-subscribers who rate various aspects of the show on a 1-10 scale. The number of artisans rating as well as their comments are given for a clear indication of the success and problems of each show.

The Crafts Report $15/yr.—monthly
116 University Place
New York, N.Y. 10003

This monthly newsletter lists craft shows, shops, and galleries, explaining what type of item they want for resale. It also lists teaching opportunities and has brief pieces on successful artisans, shops, etc.

Craft Horizons $12.50 yr.—bimonthly; inc. membership
Rose Silka, Editor-in-Chief single copy $3
American Crafts Council
44 West 53rd St.
New York, N.Y. 10012
This is the official publication of the American Crafts Council. It provides coverage of new work and technical innovations, with articles on how-to for specific crafts, pieces on specific craftsmen, and reviews of shows, plus many excellent black-and-white photographs.

It has an annual travel and study directory for students, as well as extensive reviews of gallery exhibitions and shows and a calendar listing future shows and competitive exhibitions all over the country. *Craft Horizons* describes new shops and galleries, reports on national conferences, reviews books, and has advertising for supplies and workshops. In the classified ads the working craftsman can find opportunities for selling and craft outlets.

The Craftsman's Gallery $8/yr.—quarterly; inc. membership
Seymour Bress, Editor and Publisher
Box 645
Rockville, Md. 20851
Published by the Guild of American Craftsmen, and aimed at promoting an appreciation of one-of-a-kind gallery craft items as well as quality production pieces, this magazine carries articles of interest to selling artisans. In attempting to help members of the Guild both directly and indirectly in selling their work it discusses methods of selling, as well as specific shops and galleries and how they operate.

The major part of the publication, which encourages a high level of craftsmanship, is devoted to black-and-white photographs of specific juried items made by members. These items are presented in large clear photographs—the only disadvantage being a lack of color. For each item the name of the craftsperson, the size of the item, and the materials used

are given. Almost all the items are for sale. Anyone interested in purchasing an item or requesting a custom order from an artisan need only contact the Guild. Customers are encouraged to write in about commissions and the Guild will put them in contact with a specific craftsman who can handle the commission.

Festival, USA 90¢/yr.
Superintendant of Documents
U.S. Government Printing Office
Washington, D.C. 20402
 This listing of over eight hundred events held throughout the United States includes many which involve arts and crafts. The festivals are listed by date and many are described briefly. Jackie Clarke (Sales Promotion Materials Manager, U.S. Dept. of Commerce, U.S. Travel Service, Washington, D.C., 20230) suggests if you are interested in one of the events listed, "just write to the Chamber of Commerce of the city or town in which the event is held." Of if you have an event to be listed, write directly to her.

The Goodfellow Review of Crafts $6/12 issues—bimonthly
P.O. Box 4520
Berkeley, Calif. 94704
 This crafts review is of special interest to artisans in California because of its listings of shows in that state; however it also carries listings of national shows. The magazine keeps artisans informed about the *Goodfellow Catalog of Wonderful Things* (see Chapter 9). It has general articles of interest to all artisans, as well as columns for needleworkers, fiber artists, quilters, stained-glass artists, etc., and also presents information on other publications, special shows, and other articles that reflect the life-style and lives of craftspeople.

Handcrafters' News $14/yr.—monthly
808 High Mountain Road
Franklin Lakes, N.J. 07417
 A monthly newsletter telling artisans where and how to sell their work. It gives detailed requirements from high-quality shops and galleries and includes information on other marketing opportunities for artisans. Also information on supplies.

Highland Highlights $5/yr.—monthly
Southern Highland Handicraft Guild
15 Reddick Road
Asheville, N.C. 28805
 The official newsletter of the Southern Highland Handicraft Guild—a non-profit organization of over 2,000 people living in the Southern Ap-

palachian Mountains—this publication carries news of members plus articles of interest generally to artisans on merchandising, production, accounting, and other aspects of craftsmanship. It reports on national fairs and exhibits, and has a craftsman's calendar of events.

Mid-West Art $5/yr.—monthly
Gary Pisarek, Publisher
2025 E. Fernwood Avenue
P.O. Box 4419
Milwaukee, Wis. 53207

Illustrated with numerous photographs this magazine covers many shows in the Midwest, as well as exhibits in galleries and museums. It also contains other information of interest to artists and craftspeople. A section on "Where to Show" alerts artists and craftsmen to events in which they might like to participate and gives full information.

Midwest Art Fare $7.50/yr.—monthly
Bill Jacobsen
Box 195
Garrison, Iowa 52229

This show listing is by Bill Jacobsen and his wife, who make and sell original cloth and wooden toys. A few years ago they started mimeographing a list every month listing the shows in their area, and sending these lists out to artisan friends. Now their list goes out to hundreds of artisans.

The monthly list covers nearly every art and craft show in the whole upper Midwest, including Iowa, Illinois, Minnesota, Wisconsin, North and South Dakota, Missouri, Nebraska, Indiana, and Michigan. For each show they list entry information and fee, and comment on the quality of the show if they have attended other years.

Bill says, "In short, I try to provide artists with what I as an artist need in terms of information on shows in time to enter them. I feel one of the main advantages of my list is that it is monthly or current. The list each month includes not only the shows for the next month but for several months thereafter so that artists can use this list to plan ahead."

National Calendar of Indoor/Outdoor Art Fairs $7/yr.—quarterly
National Calendar of Open Art Exhibitions $7/yr.—quarterly
Henry Niles
5423 New Haven Ave.
Fort Wayne, Ind. 46803

According to Mr. Niles, "Prior to 1969, the artists and craftsmen had a difficult time making a living. Before I published the first calendar I sent a form letter to all the state art councils telling them I would take the bull by the horns and do something to help the artists and craftsmen."

These two calendars are the result of Mr. Niles's commitment to help.

The National Calendar of Indoor/Outdoor Art Fairs contains listings of shows all over the country, organized by dates, including the name and location of the event, entry fee, and the name and address and phone number of the contact person. Art and craft events of all types are listed and a separate section is devoted to events scheduled by professional show directors. Another section gives an annotated list of publications useful to artisans.

In the *Calendar of Open Exhibitions,* events are listed giving complete information as above, and also the amount of awards to be given at each exhibition plus its special requirements. This calendar includes a section on fellowships and graduate study abroad with complete information on these grants.

In addition, Mr. Niles has available a sizeable list of qualified judges for shows. This is free on request to all persons needing the service.

Near North News $5/yr.—weekly
Sylvia Zappa, Managing Editor single copy 15¢
26 E. Huron
Chicago, Ill. 60611

This weekly newspaper covers the near north area of Chicago from the downtown loop to 2800 North, from lake to river. The editor says, "The majority of our subscribers live in that area; however, we have a good many going to suburbs and out of state purely for the art fair column which encompasses the entire Chicago area and some Indiana, Michigan and Wisconsin fairs." A generous section of this newspaper is devoted to "What's Happening"—a column by Sylvia Zappa which includes a long listing of fairs and arts and crafts events with dates and phone numbers or addresses for further information. It is an excellent source of information for artisans in the Chicago area.

New York State Craftsmen/Bulletin $15/—monthly with membership
P.O. Box 733
Ithaca, N.Y. 14850

This monthly bulletin comes with membership in the New York State Craftsmen. It lists shows, courses, competitions, publications, etc. It is of interest mainly to New York artisans but would be helpful to others.

Ozark Mountaineer $3.50/yr.—monthly
Clay Anderson, Editor
Branson, Mo. 65616

A delightful magazine which captures the local color and flavor of the Ozarks and is considered by artisans in the area to be their "bible." It contains listings of shows and often has articles on local artisans and events. Excellent reading for anyone interested in the area.

Regional Art Fair List $5/yr.—quarterly
Nelson Brown
Box 136 Rt. #1
Stockholm, Wis. 54769

Nelson Brown, editor of this list, is a man quite knowledgeable about art and craft shows. He has been an active artist in the art fair circuit in the upper Midwest for over five years, doing about twenty fairs a year. He says, "I am constantly exposed in my travels to a variety of criticisms, suggestions, ideas and questions, tips and information that I try to pass on to others through my list."

He lists over two hundred fairs in the upper Midwest area, giving not only the dates, place, and contact person, but such information as whether the show is juried and if so specific requirements, the deadline for entry, categories of work to be included, and how many artisans and customers attended last year if this information is available.

In addition Mr. Nelson offers a "Reader Service." Anyone who receives his list can request previous lists (50¢ each) and also write to him for information on fairs submitted after printing. He will also answer questions about specific fairs, about fair sources in other parts of the country, or about anything else he can pertaining to art fairs.

Scan (Southern Crafts and Arts News) $6/yr.—bimonthly
Jere Aldridge, Editor and Publisher sample issue $1
Route 14, Box 571
Cullman, Ala. 35055

This newsletter, published for artists and craftsmen as well as shop owners and the general public interested in arts and crafts, contains listings of shows and fairs in the Southeast mainly, but its coverage is expanding. Jere Aldrich, the editor and publisher, says, "Our publication at present is covering the area east of the Mississippi River from the Great Lakes to Key West."

In addition to complete information on a long list of shows, each issue contains general information for artisans as well as photographs and cartoons. Each issue gives the shows for several months in advance so that subscribers can map out their shows beforehand and apply in time to those they wish to enter.

Sunshine Artists $8/yr.—Monthly
Stan Bianco
Sun Country Enterprises, Inc.
Drawer 836
Fern Park, Fla. 32730

This magazine presents hundreds of show listings from all over the country, though the greatest number are from the South. The magazine also reports on many shows with "audits" or evaluation of their future potential.

In addition, reporters from all over the country send in reports from their area discussing poor as well as good shows. The magazine is a sounding board for artisans in its letters to the editor. Show directors, too, often write in. Anyone refuting a statement there is given space to answer.

The magazine has regular columnists and is illustrated with the work of its readers. "Le Gallerie" presents the work of painters and "Caravan of Crafts" the work of craftsmen. The magazine's staff is committed to helping artisans to sell and often takes a strong stand on issues; for example, it refuses to list shows of promoters against whom many complaints have been lodged.

Tri-State Trader $6.75/yr.—weekly
Thomas Mayhill, Editor and Publisher sample free
P.O. Box 90
Knightstown, Ind. 46148

If you want to try selling your products at flea markets or antique shows, this is an excellent source of information for shows in Ohio, Kentucky, Indiana, Michigan, Illinois, western Pennsylvania, West Virginia, Tennessee, and Wisconsin. This newspaper has articles on antiques and old crafts as well as extensive listings of shows plus advertising.

Westart $6/yr.
Bud Pisarek, Publisher
P.O. Box 1396
Auburn, Calif. 95603

This newspaper-format publication covers art and craft events in the West Coast states of California, Oregon, Washington, Arizona, and Nevada. According to the publisher, Bud Pisarek, it has a circulation of several hundred outside these states also.

The newspaper has articles of general interest to artisans. It has features on current and future exhibits of arts and crafts and photographs of works in these shows. It also prints lists of winners in open shows.

Advertisements are many and interesting, as many fairs and festivals advertise for artisans to participate. Probably the most interesting pages to the artisan looking for a market are "Time to Show," which lists fairs, festivals, shows, and exhibits. The publisher offers space on these pages without charge to non-profit groups of all kinds; commercial ventures are charged a small fee for the space. These ads tell where, when, and whom to contact for each show, as well as the fee involved and who may participate.

Women's Circle Homeworker $3/yr.—bimonthly
Betty Dufresne, Editor
Box 428
Seabrook, N.H. 03874

How to make money at home is the theme of this bimonthly magazine, which presents how-to articles as well as many case histories of artisans and other successful people in business for themselves.

The Working Craftsman $6/yr.—quarterly
(formerly *Craft/Midwest*) sample issue $1.50
Marilyn Heise, Editor
Box 42
Northbrook, Ill. 60062

Formerly called *Crafts/Midwest,* this magazine was started to serve primarily the upper Midwest, but subscriptions and advertising became virtually international and so the name was changed. The aim of the magazine is to provide the best possible assistance in the business of being a successful craftsman, teacher, student, shop owner, or supplier. It provides important news and information about trends, sources of supply, and other ideas. A new-products page discusses new materials and equipment for artisans; a "Keeping Up" column presents a potpourri of information of interest to artisans. "Selling as a Professional"—a column by Michael Higgins—presents comments and advice from his over twenty-five years of experience as a producing and selling craftsman.

The magazine reviews new crafts books and alerts readers to new publications. A list of exhibits and events tells readers where they can show their work. The magazine is illustrated with black-and-white photographs and has outstanding articles on a variety of subjects on individual craftsmen, on shows, successful shops and galleries, and other subjects of general interest to all artisans. In short, this is an outstandingly professional magazine for anyone interested in crafts and marketing.

E. ART AND CRAFT PERIODICALS

Here is a list of art- and craft-related magazines which can help keep you up to date in your field. Some are available on the newsstand; your local library may have copies of others. For further information, including the cost of subscription or sample copy, write directly to the addresses given.

American Artist
One Astor Plaza
New York, N.Y. 10036

American Candlemaker
P.O. Box 22227
San Diego, Calif. 92122

American Folklife
R. D. #2
Oley, Pa. 19547

American Home Crafts
641 Lexington Ave.
New York, N.Y. 10022

Americana
1221 Ave. of the Americas
New York, N.Y. 10020

Art Material Trade News
119 West 57th St.
New York, N.Y. 10028

Art News
750 Third Ave.
New York, N.Y. 10017

Arts and Activities
8150 N. Central Park Ave.
Skokie, Ill. 60076

Arts Magazine
23 East 26th St.
New York, N.Y. 10010

The Bead Journal
P.O. Box 24C47
Los Angeles, Calif. 90024

Better Homes & Gardens Christmas Ideas
1716 Locust St.
Des Moines, Iowa 50336

Ceramic Arts & Crafts
Scott Advertising & Publishing
 Co.
30595 W. 8 Mile Rd.
Livonia, Mich. 48152

Ceramics Monthly
1609 Northwest Blvd., Box 4548
Columbus, Ohio 43212

Ceramic Review
5 Belsize Lane
London NW3 5AD England

Ceramic Scope
Box 48643
Los Angeles, Calif. 90048

Ceramic World
5905 Phinney Ave. N.
Seattle, Wash. 98103

Ceramics
Duncan Ceramic Products, Inc.
5673 East Shields Ave.
Fresno, Calif. 93727

Counted Thread Society of
 America Newsletter
3305 S. Newport St.
Denver, Colo. 80222

Craft Horizons
16 E. 52nd St.
New York, N.Y. 10022

Craft, Model & Hobby Industry
 Magazine
229 West 28 St.
New York, N.Y. 10001

Creative Crafts
Box 700
Newton, N.J. 07860

Decorating and Craft Ideas Made
 Easy
1001 Foch St.
Fort Worth, Tex. 76107

Design Magazine
1100 Waterway Blvd.
Indianapolis, Ind. 46202

Early American Life
P.O. Box 1831
Harrisburg, Pa. 17105

Embroidery
73 Wimpole St.
London W1M 8AX England

Exhibit
P.O. Box 23505
Fort Lauderdale, Florida 33307

Fiber News
Handweavers Guild of America,
 Inc. (Illinois Reg.)
Naomi Towner, Art Dept.
Illinois State University
Normal, Ill. 61761

Fibernews
7201 Flora Morgan Trail, P.O.
 Box 619
Tujunga, Calif. 91042

Flying Needle
National Standards Council of
 American Embroiderers
12920 N.E. 32nd Place
Bellevue, Wash. 98005

Fusion (U.S.)
American Scientific Glassblowers
 Society
309 Georgetown Ave.
Gwinhurst, Wilmington, Del.
 19809

Gems and Minerals
P.O. Box 687
Mentone, Calif. 92359

Gems, the British Lapidary Maga-
 zine
84 High St.
Broadstairs
Kent, England

Glass Art Magazine
P.O. Box 7527
Oakland, Calif. 94601

The Glass Workshop
482 Tappan Road
Northvale, N.J. 07647

Good Housekeeping Needlecraft
959 Eighth Ave.
New York, N.Y. 10019

Hand Weaver and Craftsman
220 Fifth Ave.
New York, N.Y. 10001

Hobbies
1006 South Michigan Ave.
Chicago, Ill. 60605

Hobbies & Things Magazine
30915 Loraine Rd.
No. Olmstead, Ohio 44070

Hobby Potpourri
6531 Riverton
North Hollywood, Calif. 91606

Hobby World
5905 Phinney Ave. North
Seattle, Wash. 98103

The Instructor
7 Bank St.
Danville, N.Y. 14437

Interweave
2938 N. Country Road, 13
Loveland, Colo. 80537

Lady's Circle Home Crafts
Lady's Circle Needlework
21 West 26th St.
New York, N.Y. 10010

Ladies' Home Journal Needle &
 Craft
641 Lexington Ave.
New York, N.Y. 10022

Lapidary Journal
P.O. Box 80937
San Diego, California 92138

Make It With Leather (formerly
 The Craftsman)
P.O. Box 1386
Fort Worth, Tex. 76101

McCall's Needlework & Crafts
McCall's Christmas Annual
230 Park Ave.
New York, N.Y. 10017

National Carvers Museum Review
7825 S. Claremont Ave.
Chicago, Ill. 60620

National Needlework News
2165 Jackson St.
San Francisco, Calif. 94115

National Sculpture Review
250 East 51st St.
New York, N.Y. 10022

Needle Arts
Embroiderers Guild
120 East 56th St., Room 228
New York, N.Y. 10022

Needlepoint News
P.O. Box 668
Evanston, Ill. 60204

Nimble Needle Treasures
The Quilters' Quarterly Magazine
Box 1082
Sapulpa, Okla. 74066

Nutshell News
1035 Nowkirk Drive
La Jolla, Calif. 92037

Olde Time Needlework Patterns &
 Designs
Tower Press, Inc.
Box 428
Seabrook, N.H. 03874

Open Chain-Newsletter for Thread
 Benders
632 Bay Road
Menlo Park, Calif. 94025

Pack-O-Fun
14 Main St.
Park Ridge, Ill. 60068

Popular Ceramics
6011 Santa Monica Blvd.
Los Angeles, Calif. 90038

Popular Handicraft & Hobbies
Box 428
Seabrook, N.H. 03874

Profitable Craft Merchandising
News Plaza
Peoria, Ill. 61601

Quilter's Calendar
P.O. Box 270
Mill Valley, Calif. 94941

Quilters Newsletter
5315 W. 38th Ave.
Wheatridge, Colo. 80033

Rock & Gem
16001 Ventura Boulevard
Encino, Calif. 91316

Rug Hookers News and Views
North St.
Kennebunkport, Maine 04046

Shuttle, Spindle & Dyepot
1013 Farmington Ave.
West Hartford, Conn. 06107

Souvenirs and Novelties
20-21 Wagaraw Rd. Bldg. 30
Fairlawn, N.J. 07410

Stained Glass
3600 University Drive
Fairfax, Va. 22030

Stitch and Sew
P.O. Box 428
Seabrook, N.H. 03874

Studio Potter Magazine
Box 172
Warner, N.H. 03278

Sunset Christmas Ideas and
 Answers
85 Willow Rd.
Menlo Park, Calif. 94025

Today's Art
25 West 45th St.
New York, N.Y. 10036

Treasure Chest
411 Warren
Phillipsburg, N.J. 08865

Woman's Day Needlework Ideas
Woman's Day Knit and Stitch
1515 Broadway
New York, N.Y. 10036

Woman's World Family Crafts
575 Madison Ave.
New York, N.Y. 10022

Wool Gathering
Elizabeth Zimmerman
Babcock, Wis. 54413

Workbasket
4251 Pennsylvania
Kansas City, Mo. 64111

Workbench
4251 Pennsylvania
Kansas City, Mo. 64111

F. BOOKS FOR THE SELLING ARTISAN

In the last few years the number of reference works and books aimed at the selling artisan has grown tremendously. Here are some you might find useful.

Associated Council of the Arts, *et al.,* sponsors. *The Visual Artists and the Law.* New York: Frederick Praeger, 1974. This enlightening study of legal matters, written by lawyers for the arts, covers copyrights, tax problems, the artist's relationship to his gallery, his publisher, and the museum, etc.

American Crafts Council, compiler. *Contemporary Crafts Marketplace.* New York: R. R. Bowker, 1975. A reference work listing by state over 1,000 galleries and shops, plus organizations, suppliers, calendar of events, bilbiographies, etc.

Bealer, Alex. *The Successful Craftsman: Making Your Craft Your Business.* Barre, Mass.: Barre Publishers, 1975. The author treats twenty-three different crafts, giving a general introduction to each with comments on supplies, and how to produce and sell.

Beryle, Milton K. *Selling Your Art Work: A Marketing Guide for Fine and Commercial Artists.* Cranbury, N.J.: A. S. Barnes, 1975. Marketing information for artists; also helpful for craftsmen, with chapters on art shows, packing, shipping, etc.

Blumenthal, L. Roy. *The Practice of Public Relations.* New York:

Macmillan, 1972. This book first defines public relations and then discusses various types, giving necessary how-to information.

Boyd, Margaret. *Mail Order Crafts Catalog.* Radnor, Pa.: Chilton, 1975. A reference volume giving over 1,500 companies, stores, and individuals that sell craft materials by mail order with information about their catalogs. Indexes cross-reference material by supplier's name, category, and state.

Brabec, Barbara, ed. *Artisan Crafts Guide to the Crafts World.* Reed Springs, Mo.: O. & E. Enterprises, 1975. A reference work listing craftsmen, shops, supplies, services, and other categories, with lively copy and valuable information.

Chamberlain, Betty. *The Artist's Guide to His Market.* New York: Watson-Guptill, 1970; revised, 1975. Organizer of the New York Art Information Center, the author is very knowledgeable about selling art work and gives many practical suggestions covering such topics as pricing, finding a gallery, exhibiting, and publicity.

Clark, Leta. *How to Make Money with Your Crafts.* New York: William Morrow, 1973. Written by a designer with much marketing experience, this book covers various forms of selling, including shop, galleries, shows, and by mail order.

Colin, Paul, and Deborah Lippman. *Craft Sources.* New York: M. Evans, 1975. This catalog gives detailed information on books for a variety of crafts. It also includes listings of suppliers, as well as craft magazines and schools.

Coyne, John, and Tom Heber. *By Hand: A Guide to Schools and Careers in Crafts.* New York: E. P. Dutton, 1974. This is a guide state-by-state to hundreds of college programs, art centers, workshops, craft cooperatives, and apprentice programs, with information on the type of instruction and its value to beginners and advanced students. Also essays on craft communes, starting a craft business, etc.

Cooper, James D. *A Woman's Guide to Part-Time Jobs.* Garden City, N.Y.: Doubleday, 1963. In addition to discussing basic approaches to job finding, the author discusses direct selling and how to make money at home. The book is especially appropriate for mothers returning to the job market.

Garrison, William E. *Selling Your Handcrafts.* Radnor, Pa.: Chilton, 1974. A jewelry craftsman tells about selling and teaching crafts.

Genfan, Herb, and Lyn Taetzsch. *How to Start Your Own Crafts Business.* New York: Watson-Guptill, 1974. Experienced leathercraftsmen tell about marketing from their experience. This book is especially strong on the financial and production aspects.

Glassman, Judith. *New New York Guide to Craft Supplies.* New York: Workman, 1974. Over seven hundred retail and wholesale sources of supplies for a variety of craft categories in the New York area, including Connecticut and New Jersey, are listed with complete contact information. Not only the commodities but the spirit of each shop are captured by this delightful guide.

Glassman, Judith. *National Guide to Craft Supplies: The Craft Yellow Pages.* New York: Van Nostrand, 1975. Hundreds of different sources of mail order craft supplies from all over the United States and even some foreign countries are explored with complete information on obtaining catalogs. Included are the size and price of the catalog, whether the company sells retail or wholesale or both, terms of sale, and a brief description of the merchandise available. Also lists of bookstores, organizations, museums, and galleries, fairs, periodicals, places of instruction, and a bibliography.

Hart, Robert G. *How to Sell Your Handcrafts.* New York: McKay, 1953. An old book but one with information that is still very useful today on pricing, promoting, selling through shops and by mail order, etc.

Howard, James E. *How to Use Mail Order for Profit.* New York: Grosset and Dunlap, 1963. Practical and basic information for anyone interested in selling by mail order. The book is informative, well written, and useful.

May, Marian, ed. *American Crafts Guide.* San Jose, Calif.: H. M. Gousha, 1973. This directory lists hundreds of galleries, craftshops, museums, schools, and colleges that teach arts and crafts throughout the United States state by state with information about each.

Mirow, Gregory. *A Treasury of Design for Artists and Craftsmen.* New York: Dover, 1969. A collection of designs: many paisleys, florals, and geometrics, and also some folk designs, which can be copied without asking permission.

Nelson, Norbert N. *Selling Your Crafts.* New York: Reinhold, 1967. For the craftsman who wants to sell in quantity wholesale or retail or through mail order this book will be helpful.

Norris, Robert B., ed. *Let's Have a Craft Show.* Storrs, Conn.: Connecticut Guild of Craftsmen, 1973. A booklet with information on running a crafts show and the Connecticut Guild of Craftsmen.

Polking, Kirk, ed. *Artists Market.* Cincinnati, Ohio: Writer's Digest, 1974. A reference book which tells you about paying markets for designs, art galleries, craftshops, art competitions, schools, etc.

Roberts, Catherine. *Make It and Make It Pay.* Boston: Houghton Mifflin, 1949. An old book which covers a variety of crafts and has a chapter on merchandising.

Rosenbloom, Joseph. *Craft Supplies Supermarket.* New York: Scribners, 1974. This directory of supplies, tools, materials, and equipment for craftspeople and hobbyists gives information on over 450 companies, saying what products these companies handle, and giving general information about the company and complete information on ordering a catalog. It is indexed by subject and by company.

Van Zandt, Eleanor. *Crafts for Fun and Profit.* New York: Doubleday, 1974. The book presents many colorful photographs of handcrafted items. Marketing is covered in five pages.

Weaver, Peter. *You, Inc.: A Detailed Escape Route to Being Your Own Boss.* Garden City, N.Y.: Doubleday, 1973. If you are working for the establishment and want to get out on your own, this book is a must for you. Written by a person who did just that, it has much helpful and practical down-to-earth information, psychological encouragement, and very good advice on all aspects of starting a business of your own.

Wettlauffer, George and Nancy. *The Craftsman's Survival Manual.* Englewood Cliffs, N.J.: Prentice-Hall. 1974. These full-time potters have given practical suggestions and information for anyone who wants to live by their craft. The book is well written and very useful.

Wheeler, Geoffrey. *How to Succeed in Crafts.* New York: Hobby Publications, 1973. Written by the editor of *Craft, Model and Hobby Industry Magazine,* this comprehensive book is aimed at those interested in a retail business selling craft supplies. The first section gives a good introduction to merchandising craft supplies, and the second has articles on popular crafts for which the store would be selling supplies.

Wood, Jane. *Selling What You Make.* Baltimore, Md.: Penguin, 1973. Handwritten and decorated, the text mainly concentrates on the craftsman who sells through shops.

G. GOVERNMENT PUBLICATIONS

Department of Agriculture. Crafts and cooperatives have been the special interests of the Farmers Cooperative Service of the Department of Agriculture. This government bureau has published some booklets which will be of interest to you if you wish to start a crafts cooperative. Some are directed specifically at farm cooperatives, but much of the information included can be applied to craft cooperatives.

You can obtain single copies of the publications listed below by writing to: Publications, Farmer Cooperative Service, U. S. Department of Agriculture, Washington, D.C., 20250.

Cooperatives—Distinctive Business Corporations—FCS Information 65, C. H. Kirkman, Jr.

Cooperatives in the American Private Enterprise System—Educational Aid 5, C. H. Kirkman, Jr.

Co-ops—A Tool to Improve and Market Crafts—Reprint 363 from News for Farmer Cooperatives.

How to Start a Cooperative—Educational Circular 18, Irwin W. Rust.

Improving Management of Farmer Cooperatives—General Report 120, Milton L. Manuel.

Manager Holds an Important Key to Co-op Success—FCS Information 74, C. H. Kirkman, Jr.

Members Make Co-ops Go—FCS Information 72, C. H. Kirkman, Jr.

Sample Legal Documents: Legal Phases of Farmer Cooperatives—FCS Information 66.

What Are Cooperatives? FCS Information 67, C. H. Kirkman, Jr.

Internal Revenue Service. You can get some interesting booklets from the Internal Revenue Service which will help you in preparing your income tax returns. Most of these are free. Request them from the nearest office of the IRS (you can find the address in your booklet of personal income tax forms). The following publications may be of interest to you. Most are updated yearly but their number designation remains the same.

334 *Tax Guide for Small Business*
463 *Travel, Entertainment and Gift Expenses*
503 *Child Care and Disabled Dependent Care*
505 *Tax Withholding and Declaration of Estimated Tax*
506 *Computing Your Tax Under the Income Averaging Method*
508 *Tax Information on Educational Expenses*
527 *Rental Income and Royalty Income*
528 *Information on Preparing Your Tax Return*
529 *Other Miscellaneous Deductions*
533 *Information on Self-Employment Tax*
534 *Tax Information on Depreciation*
535 *Tax Information on Business Expenses*
538 *Tax Information on Accounting Periods and Methods*
540 *Tax Information on Repairs, Replacements and Improvements*
552 *Recordkeeping Requirements and a Guide to Tax Publications*
560 *Retirement Plans for Self-Employed Individuals*
566 *Questions and Answers on Retirement Plans for the Self-Employed*

Superintendent of Documents. Some of the booklets prepared by various government bureaus are available from the Superintendent of Documents, U.S. Government Printing Office, Washington, D.C. 20402.

Blunt, William W., Jr. *The Potential of Handcrafts as a Viable Economic Force.* U.S. Dept. of Commerce, Economic Division Administration, 1974.

Counts, Charles. *Encouraging American Handcrafts: What Role in Economic Development?* Prepared for U.S. Department of Commerce, Economic Development Administration, Washington, D.C.: Government Printing Office, 1966.

Counts, Charles. *Encouraging American Craftsmen.* Report of the Interagency Craft Committee. Washington, D.C.: Government Printing Office, 1972.

Seymour, William R. *The Cooperative Approach to Crafts.* FCS Information 78. U.S. Department of Agriculture. Farmer Cooperative Service. Washington D.C.: Government Printing Office, 1971 (Reissued in 1972 as Program Aid No. 1001.)

Seymour, William R. *American Crafts—A Rich Heritage and A Rich Future.* U.S. Department of Agriculture. Farmer Cooperative Service. Program Aid No. 1026. Washington, D.C.: Government Printing Office, 1972.

Small Business Administration. The Small Business Administration has many publications to help you. Most are free and some are very inexpensive. Here are specific publications that may be of assistance to you. Request them from your nearest SBA office.

Management Aids
32. *How Trade Associations Help Small Business*
46. *How to Analyze Your Own Business*
49. *Know Your Patenting Procedures*
52. *Loan Sources in the Federal Government*
80. *Choosing the Legal Structure for Your Firm*
85. *Analyzing Your Cost of Marketing*
111. *Steps in Incorporating a Business*
176. *Financial Audits: A Tool for Better Management*
193. *What is the Best Selling Price?*
200. *Is the Independent Sales Agent for You?*
206. *Keep Pointed Toward Profit*
208. *Problems in Managing a Family-Owned Business*
210. *Records Retention: Normal and Disaster*
213. *Selecting Employee Benefit Plans*

Small Marketers Aids
25. *Are You Kidding Yourself About Your Profits?*
71. *Checklist for Going into Business*
96. *Checklist for Successful Retail Advertising*
108. *Building Repeat Retail Business*
109. *Stimulating Impulse Buying for Increased Sales*

111. *Interior Display: A Way to Increase Sales*
113. *Quality and Taste and Sales Appeals*
118. *Legal Services for Small Retail and Service Firms*
121. *Measuring the Results of Advertising*
126. *Accounting Services for Small Service Firms*
131. *Retirement Plans for Self-Employed Owner-Managers*
142. *Steps in Meeting Your Tax Obligations*
144. *Getting the Facts for Income Tax Reporting*
152. *Using a Traffic Study to Select a Retail Site*

 Small Business Bibliographies
 1. *Handicrafts*
 2. *Home Business*
 3. *Selling by Mail Order*
15. *Recordkeeping Systems—Small Store and Service Trade*
20. *Advertising—Retail store*
29. *National Mailing-List Houses*
31. *Retail Credit and Collections*
46. *Woodworking Shops*
53. *Hobby Shops*

Index

Index